THE THAMES AND HUDSON MANUALS

GENERAL EDITOR: W. S. TAYLOR

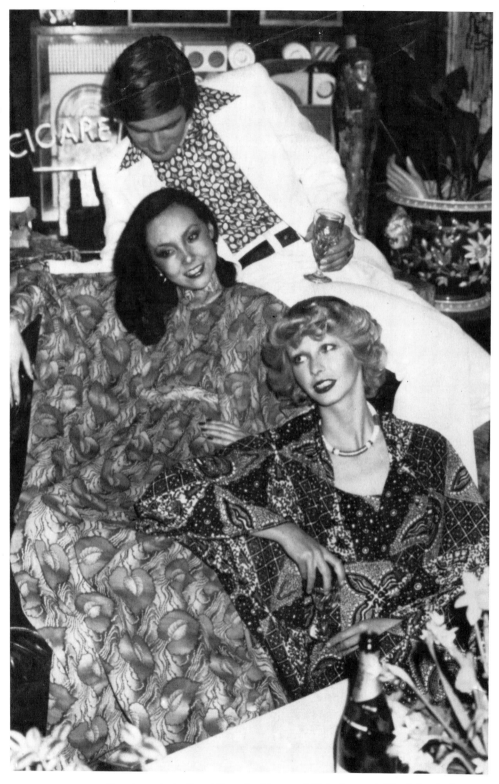

Two dresses in the Tootal 'Samedi soir' range of fabrics (1975–76). The designs in this range were all genuine West African print styles (see p. 130) but printed on 'Robia' voile or fine cotton in fast colours for the European high fashion market.

Joyce Storey

The Thames and Hudson
Manual of Dyes and Fabrics

with 121 illustrations in colour and black and white

Thames and Hudson

THE AUTHOR'S THANKS are due to the following for courteous help with illustrations: Miss Judy Barry (p. 139, top), Mrs Diane Godfrey (p. 51, top), Mr Hannay, of Bayer U.K. (p. 51, bottom), Ciba-Geigy AG, Basle (p. 52, and p. 87, top), Sublistatic SA (p. 122), Wardle Fabrics Ltd (p. 87, bottom); and, from among her students, to Miss Moira Dickens (p. 158, centre), Miss Rebecca Drayson (p. 158, bottom), Miss Andrea Hill (p. 140), Miss Alison Howitt (p. 122, top right) and Miss Pamela Robinson (p. 122, top left, and p. 158, top).

Printed and bound in Singapore by CS Graphics

Contents

Introduction

When I was asked to write a *Manual of Textile Printing* (published in 1974) I decided that because textile printing was such a vast and complex subject it would be advisable to deal in as detailed a manner as space allowed with the mechanical side only – 'the various devices, tools and machines used to create pattern in dye on cloth' – and to make the many other aspects the subject of a second volume. The present volume, therefore, covers what I have called the chemical aspects of textile printing – fibres and fabrics; preparation of cloth for printing; dyes and thickening agents; special printing techniques; cloth finishing – and in so doing tries, in a necessarily brief manner, to complete the textile printing story.

Each of the subjects covered is highly specialized, taking one into the fields of chemistry and chemical technology where great advances have been made over the last 40–50 years and are still being made. The textile designer and design students are little more than laymen in this specialized world, but even so they must try to attain a reasonable understanding of all areas which impinge on their work. To this end I have tried to write as simply as possible on all sides of the subject that seem to me to be important.

I hope that the book will be considered helpful and interesting, and that those people who have been kind enough to say they appreciate my *Manual of Textile Printing* will not be disappointed.

This brings me once again to the point of first thanking collectively all those people who have been so kind and interested and who have given help so generously, making the formidable task not only bearable but enjoyable. I hope also that they will be tolerant of the result. Once again I sincerely hope that if I inadvertently leave out anyone's name they will not attribute it to lack of appreciation but understand that, having worked on the book over a fairly long period and covered a wide field, I have simply mislaid a name I recorded.

This time I must single out three people for special thanks. They are Mr Roy Ewing of Tootal Ltd (African Printing Division), for much help and advice on dyestuffs and their application and special printing techniques; Dr W. Shaw (late of Strines Printing Co.), for help on all aspects but

particularly on cloth preparation; and Mr Sam Leach (Wardle Fabrics) for information on cloth preparation and finishing. Not only did these three give me much unstinting help but each also, by his help and appreciation, gave my occasionally flagging morale a boost.

I am very grateful to all the people and organizations listed below for much help in a variety of ways – for allowing me to interview them, for showing me round factories and workshops, for gifts or loans of technical and other literature, for permission to take photographs, and for many other kinds of help: the International Cotton Council; the National Cotton Council of America; Kirkpatrick of Ballyclare Ltd; the International Silk Association; the International Wool Secretariat; ICI Fibres; Monsanto; Bayer Fibres; Du Pont de Nemours; the Directors of Tootal Ltd; the managers of Strines Printing Co., A. Brunnschweiler UK, and Texicon; Mr Geoff Turner of Wardle Fabrics; G. V. Lowe and others at Arthur Sanderson & Sons Ltd; Mather & Platt Ltd; Samuel Pegg Ltd; Mr Henderson and Mr Berry of Hoechst UK Ltd; Mr Hannay and others of Bayer Dyestuffs Ltd; Mr Russell and many others at Ciba-Geigy UK Ltd and Ciba-Geigy AG Basle; BASF; Sandoz Ltd; ICI Organics Division; the Clayton Aniline Co. Ltd; Alginate Industries Ltd; Mr Peter Shaw of Ellis Jones Ltd; the Blandola Co. Ltd; CPC (UK) Ltd; Tennants Textile Colours Ltd; L. B. Holliday Ltd; Yorkshire Chemicals Ltd; the Harris Tweed Association; Sublistatic SA Geneva; Dawson International Ltd; Mr C. Brookes of David Evans Ltd, Crayford; and Mr V. Bakansky of the Society of Dyers and Colourists.

I would also like to thank all the many friendly and helpful people I met in numerous printworks and engravers in all parts of France, Italy, Austria and Switzerland; Madame Jacqueline Jacqué, the Conservatrice at the Musée de l'Impression sur Etoffes, Mulhouse; and the Director of Manchester Polytechnic for giving me leave of absence to take up the generous study grant from the Goldsmiths Company.

My thanks also go to Mr Bagwan Goswami and Mr Arthur Gillibrand, technical staff at Manchester Polytechnic, for help in setting up equipment for photography; to Mrs Audrey Hunter for typing the manuscript; to Mr Stephen Yates for photographing some fabric samples and Mr Terry Waddington for making many visits and spending much time in photographing the industrial processes, samples and other subjects. Finally, once again I am grateful to Mr W. S. Taylor and the staff of Thames and Hudson for friendly and patient help.

1 Fibres and fabrics

Cotton production, illustrated in Diderot's *Encyclopédie*.

Before we can begin to consider the application of colour and pattern to fabrics by printing, we must first consider the various types of fibre from which the fabrics to be printed are made. The final printed fabric and its style in general are influenced by many factors: the character of the design itself; the market for which it is intended and therefore its ultimate cost; the type and quality of cloth that is to be printed on; the dyestuffs or pigment used; and particularly the actual fibre from which the cloth is made.

Obviously the cloth itself is very important – whether it is dress or furnishing weight; whether it is coarse or fine, thick or thin, smooth or highly textured, opaque or transparent, a pile or flat fabric – but far more important than all these, from a printing point of view, is the fibre or fibres from which the cloth is woven or knitted. If this is not known, and treated correctly, printing will be impossible, because each type or class of fibre needs its appropriate class or classes of dyestuff for dyeing and printing.

Fibres are of three main types:

CELLULOSE	PROTEIN	MAN-MADES	
		REGENERATED	SYNTHETICS
cotton	silk	*cellulose protein*	
linen	wool	viscose (none	Nylon
jute		acetate made	Terylene
		now)	Acrilan etc.

Broadly speaking, all cellulose fibres (including the regenerated fibre viscose) can be printed with directs, vats and reactives; all protein fibres with acids and basics; while synthetics can take disperse dyes (specially created for the once-difficult acetate fibres) and modified basics. Nylon, because the fibre contains some of the same chemical groups as do protein fibres, can also be printed and dyed with acid colours.

COTTON

Wild or cultivated cotton has been used as a textile fibre for several thousands of years and India is generally considered

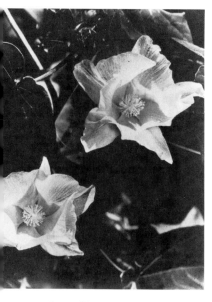

Cotton blossom.

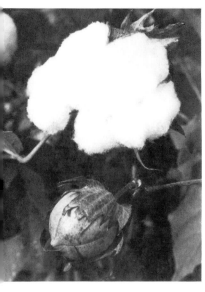

Cotton bolls, before and after opening.

to be the birthplace of cotton cloth, a fragment about 3,000 years old having survived. However, some authorities claim that it is likely that cotton was known in Egypt as long ago as 12,000 BC even before linen was known; in Europe it is believed not to have been woven till as late as the tenth century AD in Spain. Certainly the earliest reference by Herodotus, in 445 BC, is to Indian cloth. 'There are trees which grow wild there, the fruit of which is a wool exceeding in beauty and goodness that of sheep. The Indians make their clothes of this tree wool.' Cotton was not only referred to as wool but also (by others) as producing 'bunches of wool out of which the natives made linen garments' – to quote one of Alexander's admirals, writing in 327 BC. This confusion of terms has been continued into our own language: we talk of 'cotton wool', and the word for 'cotton' in German is *Baumwolle*, 'tree-wool'. The Indians, many hundreds of years ago, were capable of weaving incredibly fine cloths, particularly muslins, although their equipment was obviously fairly primitive. When Indian cottons were brought over to Europe by travellers in the sixteenth and seventeenth centuries they were more highly thought of than even the silks and brocades, and were spoken of in very glowing terms; Dacca muslins were said to be like 'webs of woven wind' – one writer maintaining that if they were laid on the grass and dew fell on them, the muslins were 'no longer discernible'.

As far as the Americas were concerned cotton was indigenous to Peru and cotton cloth has been found in Mayan cities dating from *c.* 632 BC. In Mexico, cotton cloth and fragments of fibre, often interwoven with feathers and fur, found in caves have been dated to 7,000 years ago. In the American colonies the first attempts to cultivate cotton were made in 1607 in the state of Virginia under Wyatt. But it was a simple invention by a young man named Eli Whitney which gave a great boost to the export of cotton: this was the 'cotton gin' (engine), a device which made the extraction of the seeds from the raw cotton easy and quick.

Only about 10 per cent of the weight of raw fibre is lost by the removal of the impurities such as wax, protein etc. The rest is nearly all pure cellulose and is a natural polymer. Cotton is a hair attached to the seed of several species of the genus *Gossypium*, a shrub 4–6 feet in height, indigenous to nearly all tropical regions, but growing best near the sea, lakes, or large rivers where there is a warm, humid climate and sandy soil. The principal cotton-growing areas are Egypt, the southern United States, India, Brazil, the west coast of Africa, the West Indies, the USSR and China (the last two do not export). In some countries the annual plant becomes perennial and tree-like, but the best crops are obtained by cultivating the plants annually.

Cotton has many qualities which make it an ideal fibre, and it is probably the most varied of any. The reason for its

absorbency, wet-strength, softness, durability and other characteristics lies in the fibre itself. Each fibre has 20 to 30 layers of cellulose built up in an orderly series of spring-like spirals. When the cotton boll (seed-case) opens, the fibres dry into flat, twisted, ribbon-like shapes and become kinked together and interlocked. This interlocked form is ideal for spinning into fine yarn. Cotton fibre characteristics can be improved through plant breeding and also by mercerizing and other means.

Harvesting

Some six to eight weeks after planting (from February to June in various areas of the USA) the flower buds are already forming, and in another three the flowers emerge. These quickly fall, to be replaced by the pod (or boll). The fibres growing inside expand the boll until, having reached maturity (about 1 in. in diameter and $1\frac{1}{2}$ in. long) it eventually opens. Forty-five to sixty days elapse between flowering and the opening of the boll, but this period can be shortened by causing the plant to shed its leaves prematurely (as it would in frost). This is now done by defoliants. The plant is thus exposed to full sunlight and air, which ensures that the bolls ripen more uniformly. This is essential if the crop is to be gathered mechanically: one of the causes of irregularity of colour in cotton yarn and cloth, making it difficult to bleach, dye and print, is the presence of unripe fibres.

At present, 99 per cent of the crop in the United States is gathered mechanically, but this mechanization has only been achieved to any degree since the Second World War, although it was as early as 1931 that John Rust of Memphis first developed the idea of the smooth, moistened spindle for mechanical picking. And strangely, between 1850 and 1935 over 800 patents were filed for different picking devices.

Although there are many varieties of cotton there are three main classifications of quality. Marketing value is determined by staple (the average length of the fibres); by

Stripper-type mechanical harvester collecting the ripe cotton after the plants have been defoliated.

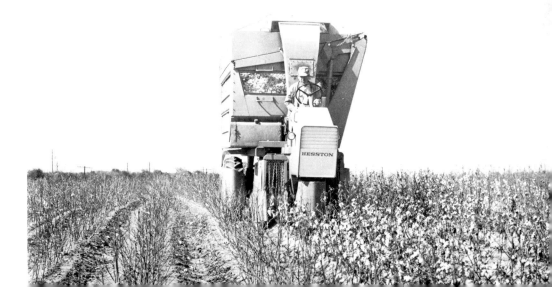

grade which covers colour and brightness; and by the amount of foreign matter present.

staple	characteristics	origin
1–$2\frac{1}{2}$ in.	long, fine, strong fibres of good lustre	Egyptian, Sea Island
$\frac{1}{2}$–$1\frac{5}{16}$ in.	intermediate	American Upland
$\frac{3}{4}$–1 in.	short, no lustre	Indian Asiatic generally

It must be stressed, however, that improvements in strain are being made all the time. The best fibre is from Sea Island cotton, which was formerly grown on the east coast of the USA, and Florida. It was introduced into the United States in 1786 and its growth extended to the Sea Islands off Charleston, South Carolina. However, it is no longer produced in commercial quantities, being very susceptible to attacks by the boll weevil because of the longer growing period it requires. Some extra-long-staple cotton (American Pima) is produced in West Texas, New Mexico and Arizona, and a revival of the production of Sea Island is now being attempted. It is extremely fine and soft, having a 'count' of 120–300 (the count of cotton yarn is the number of 840-yard hanks produced from 1 lb. of cotton during spinning).

Production

Because burrs, sticks, crushed leaves and other dirt are mixed up with the fibre they have to be separated out prior to 'ginning'. Then the raw cotton moves to the 'gin' stand where the lint is separated from the seed. The 'saw gin' has circular saws whose teeth pull the fibres through a series of slits and they are then either brushed off the saw teeth or blown off by blasts of air. As the seeds cannot pass through the slits they fall into a seed pan. The 'linters' (the waste down adhering to the seed) is used in the production of cellulose acetate or for other cellulosic products.

The bale of cotton, on arrival at the mill, goes through the following series of processes: opening-up and picking;

Engraving of a cotton 'gin' from Barnes's *History of the Cotton Industry in Lancashire*. This rather crude hand mill, turned by women, consisted of two teak rollers, fluted longitudinally and revolving in contact.

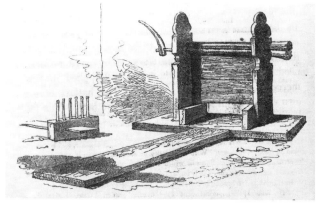

The modern method of ginning cotton.

forming into a sheet about 45 in. wide (a 'lap'); the roll of 'lap' is fed into a carding machine, which consists of a revolving spiked cylinder (high-quality cotton is also combed); it is progressively drawn into smaller and smaller strands; it is finally slightly twisted together (or 'roved') prior to spinning.

After spinning by the ring spinning or other methods, cotton can be woven or knitted into an immense variety of cloths for printing: voile, organdie, lawn, satin (both dress and furnishing), poplin, pique, corduroys and velvets, repp, cotton/linen union, denim, gaberdine, figured cloths and many more.

The cellulose of the cotton fibre can be changed chemically to give the yarn or cloth different characteristics although the fibres themselves still retain their fibrous structure. This capacity for change is used in many different ways to give the cloth easier acceptance of dyestuff, better electrical insulation and more heat and rot resistance.

Sliver ready for spinning.

As far as the natural characteristics of cotton cloth are concerned, because the fibre is actually a hollow tube (although the central canal is almost completely collapsed), it has the ability to absorb a great deal of moisture, which makes the fabric very good for wearing in hot weather. The fibres are actually stronger when saturated, and this liking for humidity accounts for the once supreme position of Lancashire as an area of cotton spinning and weaving; factory humidity is now controlled by artificial humidifiers. Cotton fibres have varying degrees of natural lustre because the outer layer of cellulose contains a wax which gives surface smoothness and allows even untreated cotton cloth to regain a great deal of 'newness' and smartness when ironed smooth. And because of its resistance to heat, cotton can be laundered and ironed at quite high temperatures; it does not start to 'yellow' until around 120°C (250°F). Exposure to strong sunlight for prolonged periods does also cause yellowing but when it is stored in reasonable conditions cotton does not degrade much, if at all.

As far as the use of dyes is concerned, cotton can be printed with very fast dyes, such as vats and reactives, which can be boiled without loss of colour, while most of the chemicals normally used in dyeing and printing, and the dyes themselves, cause no damage to the fibres. The exception is strong oxidizing agents but, even so, hydrogen peroxide bleaching can be carried out in controlled conditions.

The textile printing industry of the eighteenth and nineteenth centuries was founded entirely on calico (although silk and wool were also printed). In the twentieth century cotton has enjoyed varying degrees of popularity, being overshadowed by 'art' silk in the 1930s, but it came back into favour in the early postwar years when the Cotton Board's Colour, Design and Style Centre in Manchester, the first Design Centre anywhere in the world, 'sold' British cotton fashion and furnishing fabric throughout the world by exhibitions and promotion generally.

Now, after bad harvests and an upsurge of synthetics, cotton is again coming back into far greater popularity, as its excellent qualities are becoming more widely recognised.

LINEN

It is believed by some authorities that linen was used as a textile fibre even before cotton. In the Near East and Egypt it was well established by 3000 B C. Although the earliest examples of printed linen extant are from about the fifth century A D, records show it to have existed from at least 2500 B C and almost certainly before printed calico. It was in fact linen, or a mixture of linen and cotton, that was printed in the early days of textile printing in Europe, partly because of the bans imposed on the printing of calicoes but also because until the invention of mechanical spinning, cotton could not be spun fine enough or strong enough to be suitable for the warps of dress fabrics. This brought into use a fabric called 'fustian', consisting of a linen warp and cotton weft.

Linen is woven from yarn made from the fibres of the flax plant, a member of the family Linaceae: *Linum usitatissimum* is the only member of the family which is important. The flax plant has blue or white flowers and grey-green stems and it grows to a height of 3–4 feet; the types which are grown for fibre (some are grown only for linseed-oil production) branch only at the top of the stem. To grow well the flax plant needs a temperate and fairly equable climate, free from very heavy rains although moist winds during the growing season are good.

Some of the best-quality flax used to come from Ireland, where the warm July temperature helped to produce longer, silkier fibres, but flax ceased to be cultivated in Northern Ireland about 1954, and even before that, by 1950, it was no

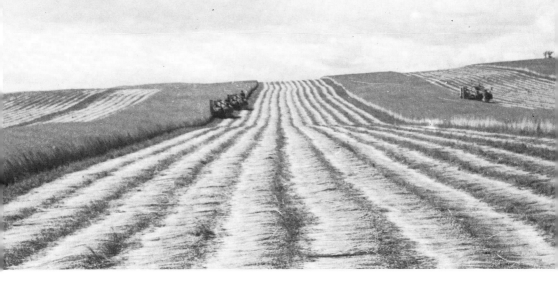

longer a commercial crop. But a few years ago Kirkpatrick of Ballyclare Ltd were responsible for bringing back the growing of flax in Southern Ireland (at Bunclody) and it is now grown commercially on a small scale. But most of the fibre used in the linen industry in Ireland comes from France and Russia. The USSR is a big grower but the fibres are not of a high quality, being shorter but very strong.

One double and two single machines harvesting flax.

Production

Flax is harvested – pulled from the ground, not cut – when the green stems are just beginning to turn yellow. It is now entirely harvested by machine.

Possibly the most important process is 'retting', the purpose of which is to get rid of the woody part of the stems. This is accomplished by the action of water and bacteria, and it has to be done carefully or the fibres will be damaged or broken. The older method of water retting is now virtually extinct and has been replaced by 'dew retting', which is carried out on the ground under the influence of light, moisture, and bacteria. It is difficult to get an even result, and so fibre separation is achieved by the use of chemicals at the spinning stage. Dew-retted flax is very difficult and often costly to bleach and is much darkened and discoloured by the bacterial action, so attempts have

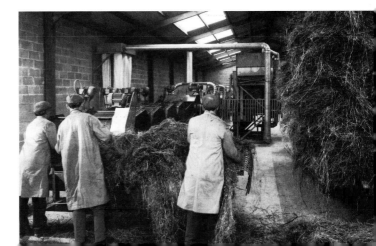

The first flax being scutched in the new £50,000 plant at Bunclody, Ireland.

been made recently to leave out the retting process and to 'scutch' the flax (see below) in what is known as the 'green state'. Obviously this means that there is a lot of waste matter and dirt left in with the fibres and although flax spinners do not like the method because they have to de-gum the flax, it makes for a strong fibre which can be spun into very fine yarns.

After retting, the flax is dried and then beaten or 'scutched' to break the pith and to free the fibres with as little damage as possible. (In 1936 turbine scutching machines were developed which were less costly from a labour point of view.) The scutched flax is sold to the mills but some improve the quality still further by combing it and putting it through hackle pins, which results in a still higher grade of fibre.

The best fibre is pale yellow in colour, softly lustrous and quite flexible, although not so much so as cotton and wool. By comparison with cotton yarn, also, linen is much more irregular.

Linron

A very interesting development – the precise details of the method have not yet been published – is the production by Kirkpatrick of Ballyclare Ltd of a bleached and chemically pure linen fibre called 'Linron'.

Linen as a fibre had very nearly lost its place as a dress fabric by about the 1950s but since it began to be used in blends, such as 50/50 Terylene/linen, it has come back into favour again. Because of its uniformity and controlled quality, Linron lends itself very well indeed to blends with wool (making wool more suitable for warmer-weather wear), acrylic fibres (for use in knits) and many others.

The difficulties of bleaching, dyeing and printing linen will be dealt with later. Retting can affect the evenness of bleaching and the presence of 'sprit' (the woody parts of the flax stem) can mean either heavier or lighter dyeing, depending on the class of dyestuff used. Mercerizing is definitely recommended for all the usual reasons (see p. 53) but also because it makes the linen cloth less susceptible to abrasion.

It should be obvious that the production of a fibre like Linron is a great step forward, the only possible disadvantage being that some of the rather delightful textural irregularities are lost. It is possible, however, to re-dye the 'natural' colour at the fibre stage.

The UK is a very important buyer of flax because linen is still used in its traditional way for high-quality, high-priced table linen, tea towels, sheets and pillowcases, furnishing and, in particular, upholstery fabrics – either alone or as 'union' cloth with cotton. Because of its high price and durability it is usually printed with vat dyestuffs whose qualities of fastness to light and washing make them equally durable.

As a dress fabric, linen's great attribute of coolness is slightly overshadowed by its tendency to crease. Crease-resistance is a problem and it is for this reason that the 50/50 Terylene mixtures are so good, the resulting fabric having the best qualities of each fibre.

SILK

The Chinese had a monopoly of silk production for about 3,000 years before the secrets of sericulture were passed on to Turkestan and other places. But India probably had her own methods as early as 1000 BC, using the thread of other types of silk-producing caterpillars. But in China sericulture was a closely guarded secret; everyone has heard the story of the two Persian monks who penetrated into China disguised as Christian missionaries and who smuggled out a small quantity of silkworm eggs hidden in a hollow cane. They took the eggs, and the secrets they had learnt about silk production, to the Emperor Justinian; in AD 552 he proclaimed a monopoly and from then on charged more for the silk than did the Chinese themselves.

In about the tenth century the Arabs spread the knowledge to Sicily and Italy, and Lucca in northern Italy became for centuries the centre of the silk-weaving industry. By the thirteenth century Lyons and Tours were also well-established silk-weaving areas and northern Italy and Lyons have remained so ever since. From the seventeenth century onwards many attempts were made in Britain to start sericulture, but the only one in England, with a small success in the 1940s and 1950s, is run at Lullington Castle in Kent, by Lady Hart-Dyke.

Silk can be obtained from the cocoons of several types of caterpillar or 'silkworm' but it is the Chinese silk moth *Bombyx mori* that is now mainly cultivated. *Bombyx mori* is an unprepossessing ash-white moth whose horned caterpillar feeds on mulberry leaves and converts most of the albumen content of these leaves into liquid silk which it stores in its body. When mature and ready to spin its thread it exudes a little of the silk solution through two glands on either side of the head (spinnerets), and fixes it on to some form of support – specially provided when cultured – and then stretches this thread out strongly by drawing back its head. The cocoon is in three sections and about the size of a pigeon's egg, about 35 mm (1.4 in.) across. The two filaments of albumen (or 'fibroin' as it is called), are covered in a protective sheath of silk gum (or sericin) which comes from other glands and acts as a coating to stick the filaments together in the cocoon.

If allowed to behave naturally, the moth would emerge from the cocoon damaging and cutting the threads in many places, so in cultivation the cocoons are hot-air dried to kill the chrysalis within. The outer part of the cocoon consists

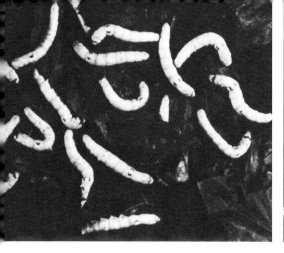

Half-grown silkworms on mulberry leaves in the trays.

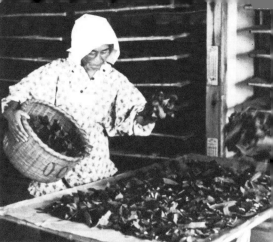

Silkworms being hatched out evenly over the trays of mulberry leaves.

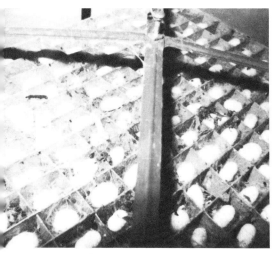

Celled trays with formed cocoons.

After a period in the heated chamber which kills off the pupae, the cocoons are examined visually for any irregularities.

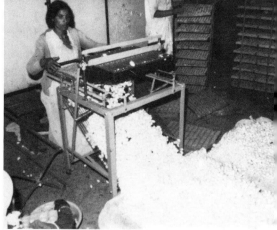

Cocoons being separated from the surrounding straw after detachment from the trays.

The start of a Japanese reeling installation, where cocoons are being fed out of a pre-softening bath into a main abrasive bath. The banks of revolving abrasive brushes can be seen to the right of the photograph.

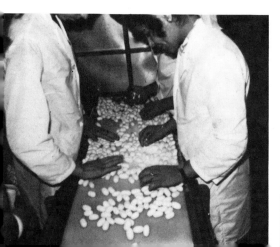

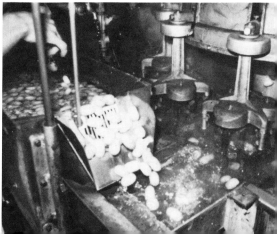

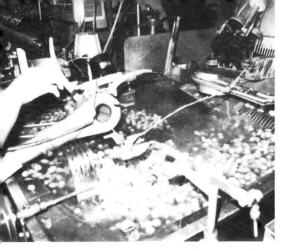

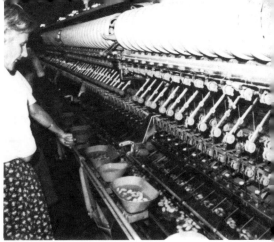

The brushes raised out of the water, at a different stage of the cycle. The ends of the yarn which they have caught up from the cocoons are being drawn over a system of racks and serrations to keep each fibre separate, while the cocoons float on down the streaming channel towards the point at which they enter the main reeling array (*top left*).

An array of reeling heads, several hundred of which extend along the length of the machine. In front of the heads is a streaming channel in which are just seven cocoons to each head. Behind this is a reserve channel for replacement cocoons. The whole operation is entirely automatic and the reeled silk is drawn off over little wheel-guides at the top of the photograph.

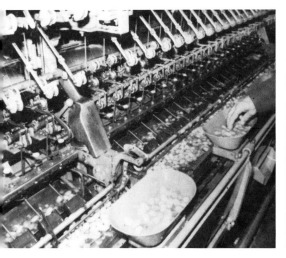

Another view of the reeling heads, to show the wheel-guides.

After twisting two or more threads of raw silk in a variety of ways to achieve different effects, the yarn is ready for weaving into undyed fabric. The picture shows a typical silk-weaving shed. Alternatively, it can be dyed in yarn form.

The silk is now wound on to hanks, and these made into bundles, ready for testing and grading.

Close-up of the shuttle carrying the 'pirn' (on which the weft thread is wound) being fired across the width of the loom through the opened warp threads.

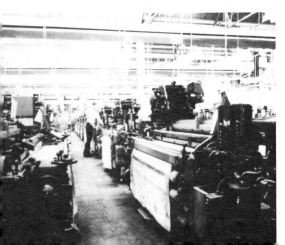

of fluffy fibres, or 'floss', which is discarded, and then the middle section is boiled in water to soften the gum which seals it. The end of the thread is found, and is wound on to a frame until all this section is unreeled. The inner part is very papery and this too is 'waste silk', so although the silkworm spins on average about 2,000 yards of thread only about 500 yards is used as continuous filament, the rest being spun, together with filaments from damaged cocoons, to make a less good quality of yarn. About twenty years ago the Japanese developed a machine for getting the thread unwound from the cocoon. By 1970, in spite of initial difficulties, almost all silk produced in Japan was being unreeled mechanically; with this method it is also possible to regulate the thickness of the thread.

As previously mentioned, there are many other silk-producing species which are not domesticated, mostly found in Asia, and living on oak and other leaves. These produce 'tussah', 'shantung' or 'honan' (i.e. wild silk). Tussah silk fabric, which used to be worn a great deal in the 1920s and 1930s, is quite irregular and 'slubby', has a harder handle, and is much less lustrous. Instead of being naturally creamy white it varies, according to origin, from grey to yellowish or brown – an attractive feature of wild silk fabric.

Natural silk is one of the strongest textile fibres, which is accounted for by the stretched-out molecular form. When de-gummed it has a tensile strength of 4–5 grams per denier, whereas softened steel has a rate of only 3 grams; nylon is a little stronger, at 5 grams per denier. Silk fibres can be extended by between 20 and 25 per cent of their length before breaking and they also have a very good recovery rate (i.e. resilience). Other very important characteristics are the warm feel which silk has on the skin, its fine draping quality and its natural crease-resistance.

Up to the early 1920s all silk was hand block printed and then gradually hand screen printing began to take over. Northern Italy and the area around Lyons are the world's most important producers of high-fashion silk prints for couture clothes and scarves, with Switzerland as the next in importance. In the city of Como and in the hills around there are scores of often quite small hand screen printers who produce unbelievably clever and beautiful effects, often using 40–50 screens to gain subtle tones and close colour schemes. Northern Italy has always been the centre of the silk industry in Italy but it is only since the Second World War that printing has joined weaving and many printworks have now established themselves there.

WOOL

It is not known with any degree of certainty when wool was first spun and woven but certainly woollen fabric was made and worn in the seventh century BC.

Wool and hair are fibres of protein (in the form of keratin) with a very complicated structure consisting of dead cells which emerge from the hair follicles and are much overlaid with grease. (The fleeces, sheared during the warm season, contain only about 43–50 per cent of wool by weight – the rest is oils, fats, moisture and dirt.) The wool fibre is enclosed in irregular overlapping scales with the cell tissue inside them. Although the outer cuticle is resistant to wetting, paradoxically moisture in vapour form can be absorbed by the fibres – in fact wool can absorb up to one-third of its own weight in moisture without detriment and it is for this reason that wool is good next to the skin for absorbing perspiration. Also, because so many fibre-ends project from a wool fabric, a layer of air between fabric and skin provides extremely good insulation. Of all the natural fibres, wool is the most resistant to creasing, and it has elasticity, but it is only about one-third as strong as cotton.

The main disadvantage of woollen fabric, in the past, has been that very careful washing has been needed to avoid felting and, as a result, shrinkage; however, this has now been largely overcome (see below).

The wool fibres are classified by the average diameter or 'fineness', and there are various systems of grading; in one of these the grading is done by 'count', which is the number of 560-yard hanks per pound of the finest yarn that can be spun from the wool (as distinct from the 840-yard hanks on which the 'count' of cotton is based). The finest quality is merino (produced in Australia and South Africa), with fibres on average 38–100 mm ($1\frac{1}{2}$–4 in.) long; breeds such as Cotswold and Leicester yield longer, lustrous fibres (125–355 mm., 5–14 in.), but the highest world production is of crossbred wool.

The fleece is separated into the various parts having different qualities – fineness, length, colour etc. After this 'stapling' process the wool is thoroughly cleansed of its greasy impurities and general dirt by being washed in a series of tanks containing soda, soaps and detergents. After-wards it is dried and then oiled to make the subsequent carding and combing process easier. After combing, the sliver is spun into woollen or worsted yarn: the woollen is thicker, usually of shorter staple, and is used for tweeds and blankets, whereas worsted is much finer, smoother and firmer, the fibres being aligned and twisted together to make a fine, strong yarn.

Recent research by the various wool organizations in Australia and by the International Wool Secretariat has succeeded in solving the important problem of uncontrolled shrinkage, so that at last it is possible to have completely machine-washable wool fabrics which will not felt or shrink. To produce this, the slivers of wool are treated with a water-soluble reactive polyamide (e.g. one trade-named Hercosett 57), which forms a fine film, coating the surface of every fibre, and so preventing shrinkage through felting,

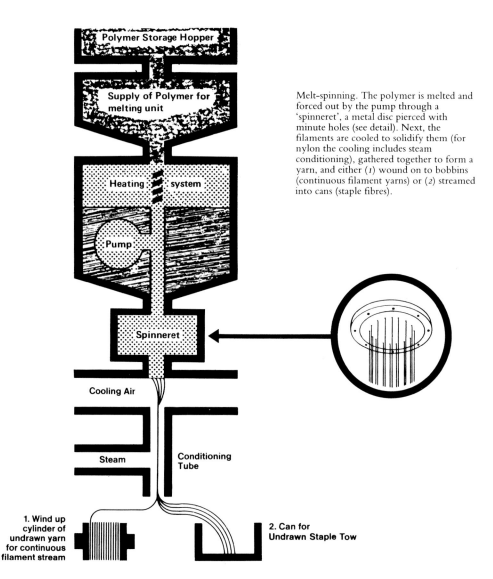

Melt-spinning. The polymer is melted and forced out by the pump through a 'spinneret', a metal disc pierced with minute holes (see detail). Next, the filaments are cooled to solidify them (for nylon the cooling includes steam conditioning), gathered together to form a yarn, and either (*1*) wound on to bobbins (continuous filament yarns) or (*2*) streamed into cans (staple fibres).

yet leaving the other properties of the wool unaffected.

Many hundreds of different types of cloth are woven and knitted from wool but those which are used for printing are mainly dress cloths such as crepes, jersey cloths, lightweight plain weaves (such as Liberty 'Varuna') and also mixtures – e.g. 'Viyella', Lantana and expensive wool and silk blends.

Like silk, wool can be printed in rich and brilliant colours.

MAN-MADE FIBRES

The term 'man-made' is of fairly recent origin, as previously one tended to identify fibres other than the natural ones by the qualification 'artificial' – as in artificial or 'art' silk, which was the first man-made textile fibre to be developed. The

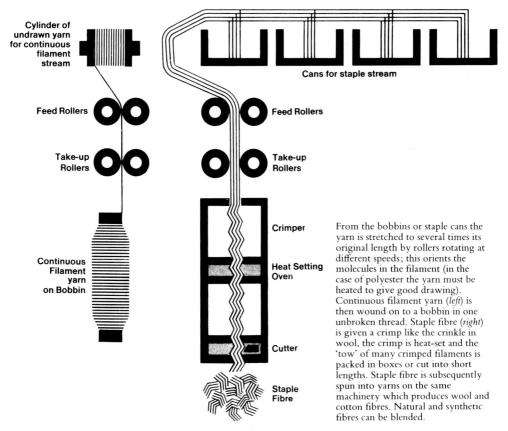

Cylinder of undrawn yarn for continuous filament stream

Cans for staple stream

Feed Rollers

Feed Rollers

Take-up Rollers

Take-up Rollers

Continuous Filament yarn on Bobbin

Crimper

Heat Setting Oven

Cutter

Staple Fibre

From the bobbins or staple cans the yarn is stretched to several times its original length by rollers rotating at different speeds; this orients the molecules in the filament (in the case of polyester the yarn must be heated to give good drawing). Continuous filament yarn (*left*) is then wound on to a bobbin in one unbroken thread. Staple fibre (*right*) is given a crimp like the crinkle in wool, the crimp is heat-set and the 'tow' of many crimped filaments is packed in boxes or cut into short lengths. Staple fibre is subsequently spun into yarns on the same machinery which produces wool and cotton fibres. Natural and synthetic fibres can be blended.

fibre industry and its various organizations, such as the British Man-made Fibres Federation, naturally frown on the term because it tends to convey the impression that the newer fibres may be rather poor copies of the original natural ones – which is certainly not so at the present time.

There are so many variations on the different man-made fibres and their names that it would be impossible to consider more than a few of the important ones; but it is worth remembering that owing to competition between fibre-producing firms all over the world there are many different names for virtually the same product.

At first, of course, man-made fibres were developed, as were so many other products, in an effort to copy and then improve on nature. The rise of the fibre industries over the years since the Second World War and the proliferation of new fibre variations has been so great, however, because the tremendous increase in world demand for textiles has meant that the natural crops have been quite insufficient to supply the market.

The idea of extruding a viscous fluid through very fine holes was developed from the silkworm's method of forcing out the liquid silk through the gland or 'spinneret' in its head, after which the thread solidifies and is wound into a cocoon. In the production of man-made fibres three spinn-

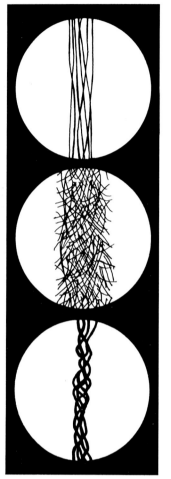

ing methods are used: *wet spinning*, in which the filaments are coagulated in acid or other chemical; *dry spinning*, in which the chemical from which the fibre is made is dissolved in a volatile solvent which simply evaporates as the filaments reach the warm air on leaving the spinneret; and *melt spinning*, in which a hard plastic is melted and extruded as filaments which solidify on cooling.

Production can also be 'continuous filament', either used singly ('monofilament'), or with up to as many as several hundred fine filaments together ('multifilament'), or 'staple production', in which thousands of these filaments are collected together in a thick rope or 'tow' which is then cut up into precise lengths. Bales of cut 'tow' are sent out to the various mills and it is then spun on conventional textile machinery. Although seemingly illogical, this enables a greater variety of textiles to be manufactured and blends of different fibre to be made, and in fact is less difficult to work.

Historical background

The first man-made fibre was manufactured by Count Hilaire de Chardonnet of France in 1885. It was highly inflammable, being made of nitro-cellulose or guncotton. It was known as 'Chardonnet' or 'art silk'. In 1893 C. F. Cross and E. J. Bevan in Great Britain obtained patents for their method of making cellulose acetate after having been responsible, with a colleague named Beale, for the discovery of viscose rayon in 1892.

But it was not till 1918–20, after cellulose acetate had been used for coating (or 'doping') the canvas wings of aeroplanes in the Great War, that the brothers Henri and Camille Dreyfus set up a factory at Spondon in Derbyshire (later to become British Celanese Limited).

Both viscose and acetate rayon are 'cellulosics', forms of regenerated cellulose using chemical wood pulp. In the production of acetate rayon the cellulose in the wood pulp is acted on by acetic and sulphuric acids to produce tri-acetate; out of this ordinary (secondary) acetate is formed, which is dissolved in acetone before extrusion. In the production of viscose rayon, however, caustic soda (a strong alkali) is used to break down the cellulose into alkali-cellulose, which is then further acted on and dissolved before being extruded.

In the 1920s and 1930s these two new fibres made a tremendous impact on people, particularly women, who were able to buy 'silky' lingerie and stockings comparatively cheaply. And as far as fabric printing was concerned when the big dyestuff problems were overcome, an era of gay and bright 'art silk' floral and geometrical prints was ushered in, executed by the newly perfected 'hand screen' process.

The term 'rayon', which 15–20 years ago was used for both acetate and viscose cloths, is now virtually synonymous with viscose. This form of cellulosic was developed com-

Under magnification, continuous filament yarns (*top*) are seen to consist of a number of separate, unbroken filaments drawn together and give a slight twist. They have a smooth surface and are used for a wide variety of knitted and woven fabrics. Staple yarns (*centre*), generally speaking, give fabrics which have more fullness of handle and are warmer to the touch; they are used for suitings, coatings and blankets. Bulked filament yarns (*bottom*) are 'straight' filament yarns which have been so manufactured as to give them much greater bulk, and thus some of the feel of staple yarns. The individual filaments which make up the yarn are fixed in a crimped configuration. Crimplene is an example of a bulked filament yarn.

mercially by Courtaulds from 1905 onwards but also by many other firms throughout the world. After approximately 77 years of development rayon is the most important man-made fibre by weight. Rayon staple fibre, first brought out in the 1930s, is spun on conventional spinning machines.

Of recent years many fabrics woven and knitted from 'modified viscose' (generally termed 'modal' fibres) are available and so gradually, because of these variations, brand names have started to be used, such as 'Sarille', a crimped type with a natural warmth, much used in fairly inexpensive crepe; 'Vincel', a recent development often blended with cotton, a modification characterized by good wet-strength (formerly rayon was very poor) and much used in dress goods, shirtings, sheets, pillowcases and furnishing fabrics; 'Darelle', which is flame-retardant; and 'Evlan', a tough rayon fibre developed for the carpet industry.

Since the introduction of nylon much less acetate has been used because the newer fibre has completely taken over the stocking and lingerie industries. It is still used, however, for knitted and woven dress fabrics, linings and curtainings. In the 1950s in Britain it was found possible to make filaments from tri-acetate without first converting into the secondary form (this was originally impossible) and so 'Tricel' was born. Fabrics made from Tricel can be shiny or matt; they are used for both knitted and woven dress goods and can be pleated. Tricel is used also for tufted bathroom furnishings and bedspreads.

Polyamide (nylon)

If the introduction of acetate and viscose rayons made a great impact in the 1920s and 1930s, it is equally true that the development of nylon, the first completely synthetic fibre, changed many aspects of life during and immediately after the Second World War. Unlike its predecessors in the 'man-made' field, nylon was produced, not more or less accidentally, but as a result of the work of a special team set up by E. I. du Pont de Nemours of the USA and led by a very brilliant young chemist, Wallace Hume Carothers. Their brief was to explore the possibilities of long-chain molecules, and in 1934 he and his team discovered that by a series of reactions they could form long polymeric chain compounds; they used this principle in the formation of the polymer which they named 'nylon'. These filaments showed the phenomenon of 'cold stretch' – hitherto unknown with artificial fibres – i.e. the filament extended without difficulty to 3–4 times its over-all length.

Nylon is obtained by the polymerization of a substance known as 'salt 66' which is prepared from phenol, a coal-tar derivative. Polymerization occurs at 280° C (536° F) in a purified nitrogen atmosphere. It is cooled, dried, crushed and then melted again and forced through a filter to spinnerets. As it solidifies on emergence it is passed over rollers

and drawn out when cold to thicknesses of 20 denier or more. It took five years from discovery in 1934 before Du Pont could market nylon just before the war.

From the dyeing and printing viewpoint, because these polyamide long-chain molecules contain chemical groups similar to those found in wool, acid dyestuffs can be used. Like wool and silk, too, it contains certain chemical groups which make it stable even in tropical heat.

The British rights to the invention of nylon were acquired by ICI just prior to the Second World War, and they and Courtaulds formed a joint company, British Nylon Spinners Limited. This existed till 1964 when ICI Fibres took it over, leaving Courtaulds to organize a separate company to market 'Celon', a slightly different form of nylon based on the German version, which is nylon–6 as opposed to Du Pont's nylon–6.6. Nowadays nylon is almost all based on petroleum products whereas previously phenol was used.

The fabric uses for nylon are too numerous to mention and in any case are very well known, but again because it ultimately has a bearing on printing it is worth noting that nylon (and other synthetics too) are much used in the production of laminated or bonded fabrics, that is to say two fabrics made to adhere together, sometimes with a layer of foam between. Bonding is particularly favoured for loose fancy-knits as it gives stability while retaining a fine open look. Pile fabrics and many others can be so treated. Loosely knitted fabrics present a great problem to the printer and so the fact that they can first be bonded and then transfer-printed has proved a great asset.

Perlon

As we have seen, five years elapsed between the first development of nylon in 1934 and its actual marketing. During that time an IG Farben chemist, Paul Schlack, director of the acetate silk factory 'Aceta', after carefully studying Carother's first patents decided to pursue his own experiments with ammonium caproic acid and, later, caprolactam (which had been rejected by Carothers as unsuitable for polyamide synthesis). In January 1938 he produced a continuous filament which also had great strength and which he called 'Perlon'. Just prior to the war stockings were produced in Germany of Perlon and in the USA of nylon, but afterwards all production was to go to the war effort on both sides of the Atlantic – particularly for parachutes and the reinforcement of aeroplane tyres. One of the remarkable things about Perlon is the comparatively small expenditure involved in the development of a product which was to be such a great commercial success.

Polyesters

An ester is formed when an alcohol reacts with an acid, and a polyester when many esters are polymerized together.

Terylene was the first polyester fibre to be discovered, in 1941 at the Calico Printers Association laboratories in Accrington, Lancashire by the team of John R. Whinfield and James T. Dickson. It was, in fact, Britain's major contribution to synthetic fibre discoveries, which have tended otherwise to emanate from the USA. ICI took over commercial production of Terylene and presented it to the world soon after the end of the war, and it has proved to be the fastest-growing man-made fibre of recent years.

Terylene is based on the petroleum products ethylene glycol (which is similar to glycerine) and terephthalic acid, and the fibres are linear, long-stretched filamentous molecules.

Production licences were issued while the patents were still in force and in 1953 Hoechst of Germany procured one of these and commenced industrial production of 'Trevira' in 1957. The Terylene patents ran out in 1967 and since then other British-based companies such as British Enkalon, Courtaulds and Hoechst (UK) Ltd (with Trevira) have been manufacturing polyester yarns.

Although basic production methods are the same, each manufacturer has his own particular secrets and 'know-how' and is naturally unwilling to share this with others. But all polyester has great dimensional stability and water repellency. ICI kept a suit in water for many months without it losing its creases, and strength can be demonstrated by the fact that polyester is used for car seat belts.

Terylene is much used in this country in staple fibre form and in blends with wool for men's suitings, to give strength and shape-retention, and in polyester/cotton blends for shirts and blouses and cool summer nightwear, where it adds an easy-care quality to a largely cotton appearance. Latterly polyester/cotton household textiles have been in great demand in the UK and USA; often, because of the expense of wide-width after-processing, and the fact that polyester presents difficulties in printing, pigments are used a great deal in the UK.

Terylene and its French counterpart 'Tergal' are also much used for sheer curtains which in the last few years in Britain, but for longer in the USA and on the Continent, have often been printed with similar designs to those of the heavier cotton or linen furnishing fabrics.

Acrylic fibres

Fibres of polyacrylonitrile, a by-product of petroleum chemicals or natural gas, were first manufactured commercially in the USA by Du Pont. To produce this type of fibre, ammonia, propylene and oxygen are brought together to obtain liquid acrylic nitrile. When this is polymerized it is converted into polyacrylonitrile, a synthetic resin powder. This is then dissolved in a spinning solution and pumped through spinnerets.

Printed 'Cambrelle' from ICI.

The first experimental plant went 'on stream' in 1946 and three years later the first 100,000 men's and women's suits and garments were on display in American stores. Du Pont set out to completely conquer world markets with their new fibre and because, of all man-mades, acrylics are most like wool in inherent warmth and softness of handle, 'Orlon' very quickly became very popular indeed. Du Pont now also manufacture Orlon in Northern Ireland. The British acrylics, 'Acrilan' and 'Courtelle', were developed separately and not by any licensing arrangements.

Much of the fibre goes in the production of knitted fabrics and garments (such as jumpers), carpet pile, long-pile fabrics and simulated furs. Because, like other synthetics, the fibre is thermoplastic, fabric made from it can be pleated and jumpers and other garments heat-set to a good shape. This will be looked at again in relation to transfer printing.

All British acrylics are made as staple fibre but in Germany, Farbenfabriken Bayer manufacture 'Dralon', another acrylic fibre, in both continuous filament and staple form. This is used a great deal in furnishing fabrics, both for 'sheers' and in heavier weights, and in particular for beautiful velvets.

Before leaving the subject of man-made fibres, mention should be made of non-woven fabrics. These have had much publicity in recent years because as well as being used as interlinings ('Vilene'), advances have been made in the development of 'paper cloths', disposable garments and sheets for hospitals, and attempts have been made to popularize disposable day and even wedding dresses. The expression 'non-woven' covers any fabric produced by methods other than weaving or knitting, and consisting of a web of loose fibres flattened and bonded by pressure and heat, or with the aid of chemicals. ICI have marketed 'Cambrelle' in this field and there are also 'needled' and 'stitch-bonded' ones, the latter having the web stitched and held firmly by nylon or polyester yarn, sometimes also made extra strong with the addition of a thin lining.

Opposite: Another type of non-woven structure.

Blends

There is no doubt, though, that many people, even those young enough to have been brought up almost entirely in the 'man-made' era, do still find pleasure in wearing fabrics of cotton and other natural yarns and often prefer them to the 'man-mades'; the advantages of 'easy-care', 'crease-resistant' and 'drip-dry' do not always live up to expectations. Nylon underwear still discolours; 'non-irons' often do need ironing to look really crisp; mixture fabrics still 'pill'; and whereas natural fabrics possibly need a little extra care, almost always they retain their newness and freshness longer. But in the last few years particularly, possibly because of certain criticisms and a great revival of interest in cotton and other natural fibres, the manufacturers have paid more attention to yarns and fabrics whose appearance, handle and colour have been rather less harsh and brash. Many of the resultant fabrics have really delightful qualities, such as 'Qiana' (Du Pont, USA); 'Trevira' (Hoechst UK); the newer types of 'Crimplene' (ICI); some very fine acrylic jerseys; and the so-called 'miracle velvets'. But even the industry will admit that often the best performance and appearance result from blends of man-made and natural, as witness the extra strength in Terylene/wool, and reduced creasing in polyester/cotton and Terylene/linen mixtures.

Many of the characteristics of man-made fibres are very different indeed from the natural ones and it is the job of the technologist to harness these qualities and use them to the best possible advantage in the resulting fabrics. For instance, one of the characteristics of nylon and other synthetics which was at first thought to be a disadvantage was the very small amount of moisture the fibres could absorb. But it was quickly realized that this allowed the fabrics made from them to dry very quickly after washing. On the other hand, this low absorption rate does make nylon and other synthetics a trial in hot weather and is one of the reasons for the development of knitted rather than woven nylon for shirts and underwear as it is more absorbent.

Fabric and garments made from synthetics can be permanently pleated or pressed and garments can be heat-set to retain a good shape provided they are not afterwards washed at too high a temperature. But one of the main general advantages of man-made fibres is that they can be altered almost endlessly to achieve greater variety of use. Yarns can be crimped and textured (or bulked), made finer or coarser, harder or softer, shiny or dull, almost at will, so in theory at least it should be possible for the public to have the sort of cloths it needs and which it likes the most. And continuing research will produce few actually new fibres but many variations in quality among the already established ones.

However, as this book is concerned with the printing of fabric, after this short survey of man-made fibre development we will concern ourselves solely with those aspects of textiles which directly influence their printing.

2 Preparation of cloth

Samples of unbleached and bleached calico.

Any cloth which is to be dyed or printed must be absolutely clean and free from all impurities. Surprisingly perhaps, even fabrics made entirely from synthetics need to be scoured to remove any contaminants acquired during spinning and weaving, such as size, wax, spinning oil and tints, but cotton and other natural fibres have natural impurities in addition which, if allowed to remain, would dull the colours subsequently used, making the dyeing and printing irregular and unsatisfactory.

Preparation, while varying from cloth to cloth, can be summed up very simply: scouring to remove any foreign matter, and bleaching to render the cloth as white as possible. Today this process can be very highly automated, using chemicals in modern adaptations of ancient techniques.

The Greeks and Romans cleaned wool with a plant, called *radicula* by Pliny, and later classified by Linnaeus as *Saponaria*, soapwort. As late as in the eighteenth century, shops sold it as an aid to stain removal. White spurge also, which grows abundantly in France, was used in whitening linen. Its milky juice has an alkaline content.

Although there are no records of ancient bleaching methods it is believed that an alkaline soak made from seaweed ashes and water was used. Then followed an acid soak, or 'sour' – immersion in sour milk, followed again by many days' bleaching in the sun.

These processes, described by one writer as a 'classical sequence', were definitely in use before the Christian era.

In the seventeenth century, however, when the East India Companies began to bring back fine muslins and beautiful hand-painted 'chints', interest in them was so great that travellers described, as best they could, some of the processes for treating the cotton which they had witnessed. According to Jean-Baptiste Tavernier, in an account of his travels in the East which was translated into English in 1684, 'The white calicuts [calicoes] are woven in several places in Bengal and Mogulistan, and are carried to Raioxsary and Baroche to be whitened because of the large meadows and plenty of lemons that grow thereabouts, for they are never so white as they should be till they are dipped in lemon-water'. The eighteenth-century Jesuit priest, Father Coeurdoux, in his very detailed account (1742) of the making of 'painted

Bleaching 'Indiennes' in the sunshine of the Haut Rhin area of France, near Mulhouse.

calicoes', tells us that the Indians used the dried and ground 'cadou' fruit (generally known as myrobalan) steeped in sour buffalo's milk to make a bath in which to immerse the cloth. Afterwards it was hung to dry in the sun for a time, washed out, and then left in the shade. So here the citric acid of the lemons was replaced by the lactic acid of sour milk.

By the mid-eighteenth century, when the various bans on the printing of cotton were finally lifted in England and France, a very complicated and lengthy series of similar processes had been established for the preparation of the cloth; in fact it occupied a period of 6–8 months! The *Encyclopaedia Britannica* of the period (1768–71) describes bleaching in the following manner:

> It consisted in steeping the cloth in alkaline leys [or lye, i.e. alkalised water made by soaking burnt seaweed or other vegetable ashes] for several days, washing it clean and spreading it upon the grass for some weeks. The steeping in alkaline leys, called 'bucking', and the bleaching on the grass, called 'crofting', were repeated alternatively for 5 or 6 times. The cloth was then steeped for

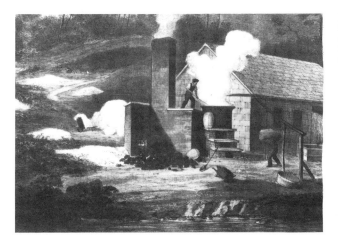

Early industrial bleaching in nineteenth-century Lancashire. A man is tending a kier, and behind him lengths of cloth are spread out on the grass.

some days in sour milk, washed clean and crofted. These processes were repeated, diminishing every time the strength of the alkaline ley, till the linen had acquired the requisite whiteness.

While the cloth was spread out on the grass it had to be watered continually so that the milk did not dry on it. It was washed with soap and trodden with 'clean feet' for half an hour or so. Often it was then 'blued' with azure, in preference to indigo, and possibly starched. When it was possible to lay out very large bleachfields, four to six men or women could look after as much as about sixty women just using the banks of a stream. According to Baines (*History of the Cotton Industry in Lancashire*), and others, a great deal of linen, particularly from Scotland, was sent to Haarlem in Holland for bleaching because of the excellence of the work, and there also it was kept for six months.

But so many of the basic ingredients in the cleansing and bleaching processes were used in a purely traditional manner, ways of working being passed on from generation to generation and country to country, often without any real understanding of the reasons for the use.

SCOURING

Soap, of great importance in textile preparation, was made in a rather haphazard way for many centuries; it was referred to by Pliny the Elder in A D 70 but may have been made many centuries earlier. Only after it had been produced industrially for as long as 150 years was it correctly analysed so that intelligent improvements in its manufacture could be made. Oils and fats were boiled together with alkali and some common salt, which threw out the soap into a curd that could be made into bars. Because many different materials could produce soap when acted on by alkaline substances, many experiments were made with alternative ingredients, in the mistaken hope that the results would be improved. When, however, investigations into the nature of the alkali of seaweed ashes (kelp) were carried out it was found to be always mixed with other salts, such as sea-salt or magnesium salts.

Because of the scarcity of ashes throughout Europe, the Académie des Sciences in 1775 offered a prize for a method of making alkali from non-vegetable sources. Nicholas Leblanc, a French chemist, did a great deal of work on methods of crystallizing salts and in 1790–1 he submitted and patented a method for making sodium carbonate (washing soda) from sodium chloride (common salt). The commercialization of this process meant that supplies of seaweed or any other biological material were no longer necessary in alkali production. This was the true start of the heavy chemical industry, and it meant that at the start of the nineteenth century the textile trade could be supplied

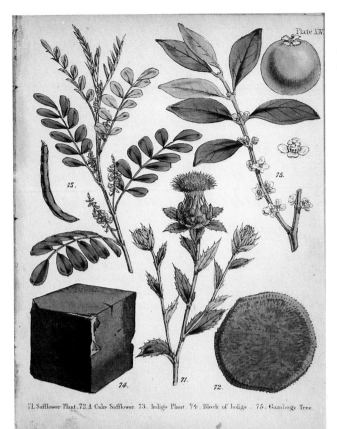

Plate XIV.

71. Safflower Plant. 72. A Cake Safflower. 73. Indigo Plant. 74. Block of Indigo. 75. Gamboge Tree.

Two pages from the nineteenth-century volume *Economic Botany*.

Plate XV.

76. Logwood Tree. 77. Fustic Tree. 78. Munjeet.
79. Sumach 80. Madder.

33

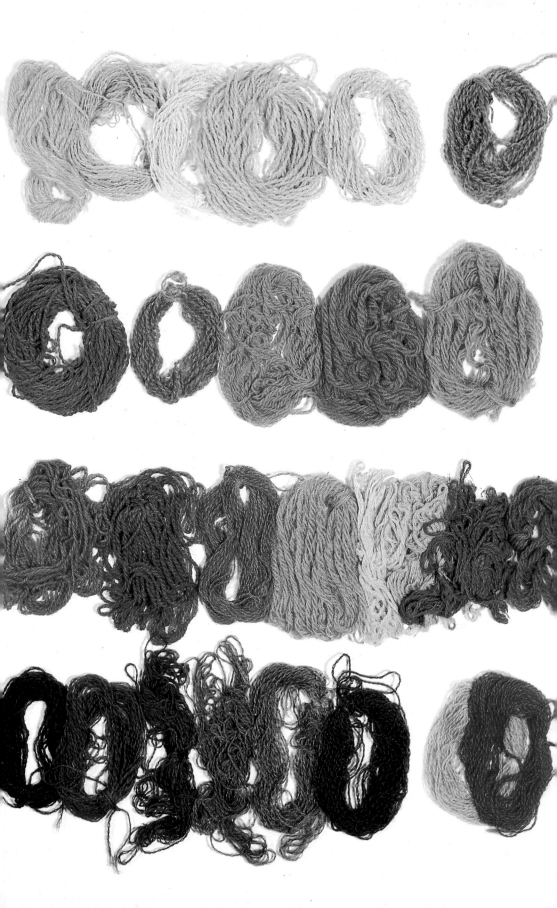

with soda – and therefore also soap – of a consistent quality and at a fast enough rate to cope with the ever-increasing production of the then largely mechanized industry. The salt tax was not repealed until 1823, in spite of repeated agitation, and until that time the alkali industry could not make its best contribution to textile finishing.

The first important improvement in bleaching consisted in substituting a far more powerful acid for that found in sour milk. In 1756 Dr Francis Home of Edinburgh started to use water acidulated with sulphuric acid; he was given a premium for his treatise on *The Art of Bleaching*. The transition from ashes and sour milk to sulphuric acid meant the speeding up of that part of the bleaching process from a possible eight months to four.

The greatest contribution to bleaching, however, was the discovery by the Swedish chemist Carl Wilhelm Scheele, in 1774, of chlorine (formerly known as oxymuriatic acid). He observed that it had the property of destroying vegetable colours, and this observation suggested to the French chemist Claude-Louis Berthollet the idea of applying the acid to the bleaching of cloths made of vegetable fibres. In 1785, after various experiments, he made known his discovery, which brought the time required for bleaching down from months to days, or even hours. James Watt, who was a chemist as well as a mechanical engineer, and Thomas Henry of Manchester, both independently following Berthollet's precepts, started the use of 'oxymuriatic acid' in Great Britain. Watt's father was already in the bleaching trade near Glasgow and Henry helped to instruct in the new process at Horwich, near Bolton.

The acid was very strong-smelling and Charles Tennant of Glasgow added lime to it because he found that this reduced the smell but did not impair the bleaching qualities. After various experiments and applications for patent rights he started to manufacture a bleaching powder made with slaked lime (calcium hypochlorite), in a dry state with chlorine. This was reckoned at the time to be twice as efficient and it cost half the price. This continued to be used well into the twentieth century.

INDUSTRIAL BLEACHING IN THE NINETEENTH CENTURY

The cotton cloth was first singed, by being drawn quickly over red-hot copper or iron cylinders, which burned off the down and loose fibres on the surface without injuring the fabric. The cloth was then thrown in loose folds into a cistern of cold water for a period, and washed in a dash-wheel – a large hollow wheel, divided into four compartments and having a slit at the side through which a jet of clear spring water was supplied and with which the cloth was further washed as it was thrown backwards and

Opposite: samples of natural-dyed wool, showing the wealth of colour that can be achieved from easily obtainable plants and different mordants. *Top row:* goldenrod, green and red seaweeds, orange lichen, heather. *Second row:* bark (*Myrtus luma*), grey lichen, goldenrod, onion skins, thread-like lichen. *Third row:* madder, orange lichen (bichromate), blackberry and elderberry. *Fourth row:* logwood chips and two cochineal.

forwards in the rapidly turning wheel. This process got rid of a considerable portion of the weaver's dressing.

Then the pieces of calico, with layers of cream of lime between them, were put in a wooden 'kier' or boiler, which had a false bottom perforated with holes. The boiling water spouted on to the cloth, filtering through it and the lime into the compartment below the false bottom, after which it was forced up a central pipe and the process was repeated again and again for about 8 hours. This lime boiling completely removed the dressing, dirt and grease and in turn the lime was washed away in the dash-wheel.

The cotton was soaked for about 6 hours in a cold solution of bleaching powder (chloride of lime) and water. This whitened it considerably, and it was then washed again. Next came the 'souring' process, in a weak solution of sulphuric acid, for about 4 hours, producing an even whiter effect because the acid removed the deposit of iron oxide which the foregoing operations had deposited on the cloth, giving it a rather yellowish look. The cloth was again washed in cold water and then boiled for a further 8 hours in an alkaline lye (sodium carbonate). A second steep in the bleaching liquid – reduced to two-thirds strength – for 5 or 6 hours, was followed by a final soak in sulphuric acid and water, after which a final wash completed the job.

The calico was then squeezed dry through rollers, often starched if it was to be sold in its white state, and 'calendered', i.e. passed over hot metal cylinders which smoothed the cloth out and gave it a sheen.

During the latter years of the nineteenth century sodium hypochlorite gradually replaced bleaching powder (calcium hypochlorite), although the latter was still much in use in the 1920s. Bleaching powder was always difficult to dissolve and there was a tendency for it to be sludgy and as a result to mark the cloth and to bleach it unevenly. Sodium hypochlorite was easy to make by bubbling chlorine into a cooled solution of soda ash and/or caustic soda, and much more reliable as a bleaching agent.

MODERN METHODS

So with the development of the chemical industry and the introduction of chemicals into textile processing – such as sodium carbonate (washing soda), sulphuric acid, chlorine and, later, sodium hypochlorite – the time taken to scour and bleach fabrics was drastically cut down. The slow bleaching action of sun, air and moisture was replaced by the swifter chemical action. With the gradual advancement of chemical knowledge came the understanding that there were in fact three important variables, and although as the twentieth century has progressed the machines and systems used have changed somewhat, the underlying principles are the same. The three important points to be considered are

still reaction time, temperature, and chemical concentration, and should any one of these be changed it is essential to vary the others if the same end result is required. In the last few years, seeking for speedy turnover, but without the extra cost involved in the necessarily higher chemical concentrations required for speed, the bleaching trade has turned its attention to developing the idea of using continuous processing under steam pressure. Reaction times have now been cut down to about two minutes, dealing continuously with cloth at speeds of up to 125 metres (140 yards) a minute.

It was not, however, until the decade immediately prior to the Second World War that in the United States, as a result of the drive and commercial initiative of the chemical companies, bleaching became the subject of much scientific research and the methods in use today were developed. From this combined research and the setting-up by various companies of technical service groups to help in the commercial application of their developments, came continuous processing with hydrogen peroxide (E.I. du Pont de Nemours and the Buffalo Electrical-Chemical Co.) and the use of sodium chlorite – trade-named 'Textone' – (Mathieson Alkali Corporation). Bleaching is, in fact, one of the areas of textile processing in which the contribution of the USA has been most considerable.

SCOURING AND BLEACHING TODAY

As we have seen, almost always two main operations are involved in preparation: scouring, to cleanse the material and remove impurities; and bleaching, to attain the whiteness necessary for satisfactory dyeing and printing. However, some synthetics are delivered white enough not to need bleaching, and clean enough to respond to very light scouring, so the trend is towards less harsh bleaching and the substitution of a gentler system and the use of optical brightening agents (OBAs). Scouring and bleaching processes have obviously to be adapted to the character of the material – its fibre and also its weight and type, e.g. whether knitted or woven. Cellulosic fibres are resistant to alkalis but very sensitive to acids, whereas in protein fibres the reverse is true. Synthetics, on the other hand are difficult to bleach (should they need it) because they are hydrophobic, that is to say they resist the intake of water.

Bleaching itself is not a very difficult process, and a number of different chemicals are used or have been tried; however, it is not so easy to devise methods which will whiten the cloth while not harming it unduly. Stringent controls are necessary to ensure that the impurities are attacked before the fibres become degraded.

In order to understand a complicated and difficult subject it will simplify matters if it is presented from three viewpoints:

1 The chemicals used in bleaching
2 The sequence of chemical processes used for various types of fibre and fabric
3 The machinery systems which can be involved and which have been developed for these chemicals and chemical sequences.

The chemicals

As we have seen, *sodium hypochlorite* gradually replaced bleaching powder and is still much used in Britain today for bleaching cotton and viscose fabrics. The cloth is impregnated, usually with cold solution (i.e. at room temperature) and stored for 3 to 4 hours; recently, warm solutions have been used, cutting the storage time to 30–40 minutes in a container of the J–Box type (see p. 47). Very careful control of concentration and temperature is needed to avoid 'tendering', or weakening of the fibre.

Sodium chlorite is used in continuous or semi-continuous systems in conjunction with a conveyer steamer. It was first manufactured by the Mathieson Alkali Corporation (now Olin Chemical Corporation) of the USA in 1938 under the name 'Textone'. In 1960 Laporte Chemicals erected a plant for its production in Britain. It was fairly expensive at first but is more economical now. As far as heavy cotton furnishing, cloths and linen or linen-union are concerned, it is considered by many furnishing fabric printers to be the only really effective yet economical method of bleaching to obtain the whiteness necessary to give clear colours on these cloths; they regard it as better than the older-established hypochlorite. Although there is the possibility of danger for workers in the process if it is not severely controlled (toxic chlorine gas is formed), and the liquor is very corrosive to the bleaching plant, it produces a very good white and its application affects the cotton far less adversely than sodium hypochlorite. It is also used for regenerated cellulose (viscose).

One of the earliest uses of *hydrogen peroxide* – as early as 1880 – was for the bleaching of straw. Wool and silk have been bleached with hydrogen peroxide ever since 1890, but it is in the period 1930–40 that it assumed major importance in the United States as the bleaching agent most used for cotton and cotton mixtures; it also completely took over the preparation of wool from the previously used sulphur dioxide. It is now one of the three most used agents in Britain also. It has gained ground because the emphasis now, as previously mentioned, is on less fierce bleaching coupled with the use of optical brightening agents. Hydrogen peroxide gives rapid bleaching, and often pre-scouring is not necessary. Because of its high alkalinity it scours and bleaches waxes and dissolves starch. It is necessary to use a stabilizer to control and slow down the oxidizing action and for this sodium silicate is used. However, because this is one

of the water-soluble impurities in 'grey' cotton it has been found that unscoured cotton bleaches to a superior white, with less chemical change to the cotton, than that which has been pre-scoured. However, slightly higher concentrations of hydrogen peroxide are then advised and this one-stage treatment will not suffice if the cloth is of a very poor colour to start with. Unfortunately quite a lot of cotton of recent years has tended to be of very mixed colour and quality, although there are definite signs of a great revival in cotton production and use, which is likely to result in more high-quality stocks.

Great difficulties can be caused by the mixing of cotton qualities, and therefore colours, as these differences do not always become apparent until after bleaching. They can be caused partly by mechanical methods of crop harvesting which, of necessity, causes some unripe seeds to be included. Again cotton which is hand-picked in India, or other countries where hand labour is used, is often also contaminated with scraps of colour and yarn from workers' clothing and the bales are also sometimes marked for identification purposes with crayons dyed with colour difficult to bleach out.

As well as its use in continuous systems peroxide has the advantage that it can be used by cold-pad methods, using small-scale equipment such as a pad-mangle and a small washing machine. It is easily handled, leaves no smell on the fabric – which remains white – and is safe in use. During the last 30–40 years it has become possible to render it stable, that is, to control the release of the oxygen which occurs when the temperature is raised, and by so doing to ensure that even bleaching results. If a stabilizer were not present some of the cloth would be rotted away while the rest would not be bleached at all. Sodium silicate is often used for this purpose but it does tend to leave a deposit on the cloth, which can cause harshness of handle and subsequent uneven dyeing and printing; it is therefore beginning to be replaced, at least partially, by organic stabilizers such as Prestogen P.C., which is made by Badische Anilin- und Sodafabrik (BASF).

When peroxide is used in a single-stage kier boiling and bleaching process, the order of introduction of chemicals is very important, as is their precise concentration and quantity. As five or six different additions are needed – for instance magnesium sulphate, sodium silicate, sodium carbonate, sodium hydroxide, wetting agents, and finally the hydrogen peroxide – it was considered sensible to market a product such as Lapotex, which contained all the necessary ingredients in solid form.

There are a few other chemicals employed for bleaching, one of which is peracetic acid (a reaction of concentrated hydrogen peroxide on acetic acid, developed originally for removing the heat-setting discoloration of nylon), but none as important as the three already mentioned.

39

The sequence of chemical processes

WOVEN COTTONS I. The 'grey cloth' (the unbleached fabric) is run off into wagons and the ends of each bale are sewn together to make a continuous wagon load. It is then singed, the hairy surface being removed by passing the cloth, in open width and at speed, between rollers and over a row or rows of gas or petrol burners. Some machines, such as the 'Parex', singe both sides of the fabric and have devices which ensure that results are not uneven, also full cut-out systems to stop the cloth from being burnt by a sudden hold-up in cloth delivery to the machine. From the singer, the cloth passes quickly into a 'quench-box' to reduce the heat in the fabric.

Cotton cloth contains size (usually a mixture of starch and PVA) and spinning oils, as well as the natural impurities of the fibre, and this sizing is now broken down by an enzyme treatment instead of the older hydrochloric acid. The enzymes feed on the starch, converting it into soluble sugar, and it is important that the temperature of this solution be kept fairly constant at about 77° C (170° F) because a higher heat would kill the enzyme and stop the process. The cloth is then 'batched' (wound on a 'beam' or drum) and allowed to stand for about 3–4 hours, rotating meanwhile. (If singeing does take place prior to the enzyming the enzyme can be dissolved in the quench-box, making a continuous process of this part of the job.)

After about 4 hours the cloth is unwound and is 'roped' (or open-width washed) to remove the by-products of the enzyme treatment. An alkaline scouring treatment follows – kier boiling in dilute sodium hydroxide (caustic soda) for 8 hours at a maximum pressure of 25 lb. per sq. in. ($1\frac{3}{4}$ kg per square centimetre), followed by another wash. This is the end of the actual scouring process: the cloth is now clean but not yet white and the fibres are opened up to make them more receptive to the dyestuffs.

The cloth is impregnated with dilute sodium hypochlorite solution (adjusted to pH 10 or above, i.e. moderately alkaline) at room temperature and then stored in pits for 3 hours before washing off. As we have seen, a recent development is to use warm hypochlorite solutions, which cuts the storage time down to about 30–40 minutes in a J–Box or similar device. Then there is a further rinsing and impregnation in a warm dilute acid (necessary to neutralize the alkalinity of the bleach) for about 20 minutes, followed by a final rope washing. All that then remains is to 'scutch' the cloth into width, mangle and cylinder dry, stenter to correct width, and wind on to beam for printing.

Briefly the sequences are:

1 Sew ends.
2 Singe, pad enzyme and wind on to beam.
3 Mercerize (if necessary) and wash.

Top: Sodium chlorite bleaching range.

Centre: Cloth passing through a 'Parex' singeing machine.

Below: Sewing the ends of each bale of cloth together.

Below right: Cloth wound on to a beam and left to rotate after enzyming.

4 Kier boil in sodium hydroxide.

5 Rope wash.

6 Hypochlorite bleach.

7 Rinse.

8 Acid impregnation for 20 minutes.

9 Rope wash.

10 Scutch; mangle; dry.

11 Stenter and wind up for printing.

WOVEN COTTONS 2. Heavy furnishing cottons or cotton/linen unions can be bleached with sodium chlorite in a conveyer steamer. This is usually part of continuous processing (as practised in the United States), or at least semi-continuous, and the bleaching in a steam chamber takes only about an hour.

The cloth is scoured in a sequence of processes much the same as that previously described, and put into a cold solution of sodium chlorite, acid and a stabilizer, which controls the rate of evolution of the chlorine dioxide. The cloth then passes into the steam chamber; the steam raises the temperature of the cloth and then the highly toxic chlorine gas is formed. Passage through the conveyer steamer takes about one hour. This process is obviously a dangerous one needing very careful handling; the gas is a respiratory irritant, but the cloth is very well bleached by the chlorite and is not in so much danger of degradation, considering the speed of the process. Next it has a passage through boiling water and then cold, followed by one through an alkali (soda ash, i.e. sodium carbonate) to neutralize the acidity of the bleaching. Finally it is washed in soap and other detergents and rinsed.

The sequences are:

1 Sew ends.

2 Singe, enzyme and wind on beam (batch).

3 Wash by-products out.

4 Scour in alkali in presence of steam for 1 hour.

5 Wash in boiling water and then neutralize in acetic or hydrochloric acid.

6 Rinse.

7 Enter cold into chlorite bleach, pass into conveyer steamer – passage, one hour.

8 Passage through boiling water and then cold.

9 Neutralize in solution of soda ash.

10 Finally soap, rinse and dry.

From beginning to end, this scouring/bleaching process takes about 4 hours.

SPUN VISCOSE DRESS GOODS. These fabrics do not need a severe preparation and should not be given one. They are sewn, singed (if necessary), padded in enzyme and stood in wagons or on a beam for about 4 hours, rotating as previously described. Then follows a scouring in rope form or in open kiers. Sometimes bleaching is not necessary but, if it is, a dilute solution of sodium hypochlorite at room

temperature is used and impregnation is for a period of about 1–2 hours. After rinsing, it can be neutralized in a dilute acid or sodium bisulphite.

The sequences are:
1 Sew ends.
2 Singe (if needed); enzyme and store or wind on beams.
3 Rope wash or wash in open kier.
4 Impregnate in dilute sodium hypochlorite for 1–2 hours.
5 Rinse and pass through weak acid or sodium bisulphite.
6 Final washing.

COTTON/'VINCEL'* cloths of the heavier type, such as are used for sheetings and furnishing fabrics, may be bleached if necessary in sodium chlorite.

WOVEN POLYESTER/COTTON FABRICS. There is a tremendous variety of blends of these fibres in the dress field, ranging from 40/60 polyester/cotton to 85/15 polyester/cotton, as well as the stronger cloths used for sheets and pillowcases. When there is more than 67 per cent polyester, mercerizing is usually omitted, though otherwise it is an essential part of good-quality processing for dress goods. It is extremely important, however, when polyester fibres are present, to control the percentage of caustic soda strictly, because strong concentrations will dissolve the yarn. Normal concentrations are 4 to 7 per cent, but suggested levels for polyester/cotton blends are 4 per cent or less.

These and other similar fine-mixture cloths are often pre-set before scouring, as this prevents lightweight cloths from becoming strained or torn subsequently. However, if the cloth is badly contaminated and stained with spinning oil, pre-setting has to be done after scouring, to avoid setting-in the stains. So this type of cloth, if fairly clean, is usually padded in optical white, pre-set on a stenter (such as the Artos, which is heated) to the correct width, then singed as previously described. (Care has to be taken in the singeing of polyester/cotton blends if the cloth is to be deep-dyed, because the singeing causes the polyester to melt into tiny globules which show up after the dyeing process. Fabrics of this type are often singed after dyeing to ensure an even result.) Then follows the enzyming, a passage through boiling water and a sequestering agent such as 'Calgon', followed by cooling in cold water before the stabilized hydrogen peroxide bleach. The cloth is passed through the hydrogen peroxide and into a steam chamber for about 2 hours; it is then washed off and dried, and is ready for printing or dyeing. Sometimes an optical white is added to the hydrogen peroxide solution.

The sequences are:
1 Sew up.
2 Singe – if not to be dyed with deep shades.
3 De-size in enzyme.

* Trade name for modified viscose.

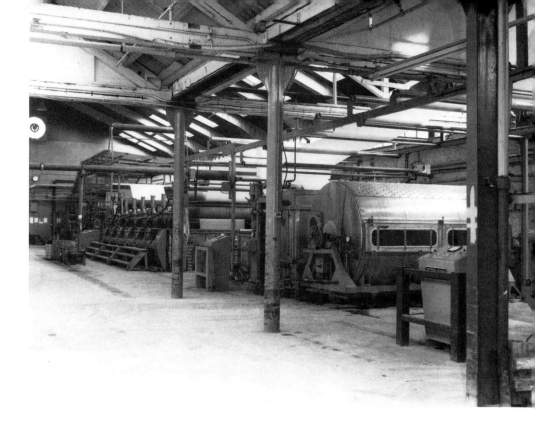

4 Pass through boiling water and sequestering agent such as Calgon.

5 Pad with stabilized hydrogen peroxide and into steam chamber for 2 hours.

6 Wash off in water.

7 Dry and make ready for printing.

Scouring and bleaching processes for these mixtures vary considerably in different works according to plant and systems available. Many are difficult to scour because they contain quite large amounts of sizing materials and spinning lubricants. If only tallow is used removal is quite difficult but if, instead, a hard wax is present it has been found helpful to scour with a solvent/detergent mixture added to a desizing bath, followed by an alkaline scour and a peroxide bleach. The result is very good, and is achieved in much less time than had been previously possible. But at the present time, any system which uses solvents is frowned on because of the growing demand by ecologists for the reduction of harmful industrial effluents.

The sequence would be:

1 Sew ends.

2 Singe; pad enzyme and rotate on beam for 4 hours.

3 Mercerize and wash.

4 Rope or open wash and cylinder-dry.

5 Pad fluorescent white, dry and heat-set on a pin-stenter. (This will also fix the OBA.)

6 Solvent-peroxide pad-roll bleach.

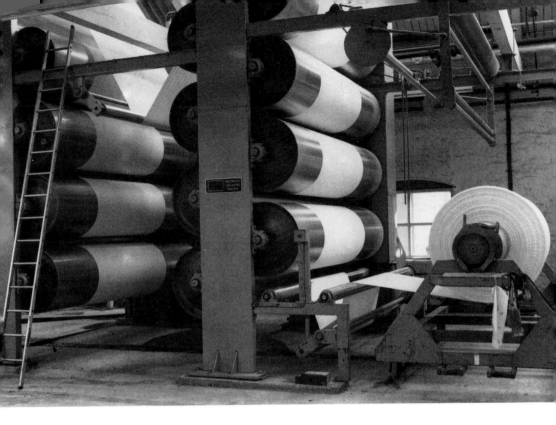

7 Open–width wash off.
8 Pin–stenter or cylinder–dry.

Cloths containing 85 per cent polyester or spun polyester lawns are not mercerized and enzyming is not necessary, so the sequence is:

1 Sew up.
2 Pad fluorescent white; pin–stenter and heat–set.
3 Singe.
4 Scour.
5 Open–width wash and pin–stenter dry.

OTHER SYNTHETICS. As we have already stated, synthetics often do not need much in the way of scouring or bleaching because the fibre is usually delivered clean and free from contamination, but the cloth will in all probability need some washing because it may have picked up dirt and stains during weaving and transportation.

Nylon. After being split open, if it is tubular, a straightforward treatment at or near the boil in an alkaline detergent solution containing a sequestering agent is usually sufficient, but if the cloth is knitted the problem lies in ensuring that the right equipment is used. This must allow of a completely tensionless passage in a relaxed state – in winches, say, or, particularly with lighter-weight dress wear, using specially created machinery like the 'Mezzera'. If bleaching is needed it should not be done with hypochlorite or any liquor containing active chlorine, but sometimes hot acidified sodium chlorite can give a good degree of whiteness.

45

Stretch nylon is usually scoured and dyed in fluorescent white in a machine of the Mezzera type and then rinsed through a perforated drum washer, pin-stentered and dried in wagons; with *warp-knitted nylon* it is best to heat-set before scouring and then follow a similar procedure.

Acrylics again usually respond to a light scouring such as treatment for 20–30 minutes at 50–60° C (120–140° F) with a solution (0.5–1.0 g per litre) of non-ionic detergent and the same of trisodium phosphate. If, however, it is known that the cloth is ultimately to be dyed with disperse dyestuffs instead of the modified basics, a better treatment to avoid spotting due to the aggregation of these dyes is a treatment with a similar proportion of an anionic detergent applied at pH 6–7 for 20 minutes at 50–60° C (120–140° F). Strongly alkaline conditions should always be avoided as they can damage the fibre and spoil subsequent dyeing and printing.

If it is considered necessary to obtain a whiter cloth, an OBA may be used either alone or in conjunction with a non-ionic dispersing agent, sodium chlorite, phosphoric acid, and sodium nitrate (to inhibit corrosion).

PROTEIN FIBRES. Wool and silk both require very thorough scouring to get them into a state and colour suitable for dyeing and printing. *Wool* contains much grease and other impurities and is usually given a warm soaping in a bath to which ammonia or sodium carbonate has been added. For bleaching it is common to use hydrogen peroxide, which must be slightly alkaline (pH 9–10). As well as being scoured and bleached, wool fabric (if it is to be printed) is also chlorinated by being passed for about one minute, in open width, through a concentrated sodium hypochlorite solution diluted with cold water and sulphuric acid. Afterwards the cloth is washed in cold water and given an anti-chlor treatment with sodium bisulphite.

Silk must be 'de-gummed' or 'boiled-off' by passing for about $1\frac{1}{2}$ hours through a series of tanks containing a 1 per cent boiling solution of a special textile soap, based on olive oil. If this is allowed to fall below boiling, the gum and other impurities which had been released would begin to attach themselves to the fibres again. One hot and one cooler rinsing-off follow.

The machinery systems

The ultimate mechanical development in the fields of scouring and bleaching is the production of completely continuous scouring/bleaching ranges in which yarn or fabric, in its progress from one end of the plant to the other, can pass through a caustic alkali boil, be rinsed, bleached in hydrogen peroxide, washed off, dried and wound up. This has, in fact, been the system adopted very widely in the USA and some large European concerns since the Second World War. In Britain, however, partly no doubt through lack of money for completely new installations, but mainly

because of the shorter orders of the same quality cloth requiring processing at any one time, changeover to completely continuous systems has not taken place to any great degree. New equipment in Britain, therefore, is more often of a semi-continuous type, although a new Courtaulds factory in Northern Ireland is equipped with a completely continuous Mather and Platt 'Vaporloc'.

Kiers – the steel cylinders used for the boiling of fabric in an alkali – and traditional vessels will take different weights of fabric together whereas the J–Box and Vaporloc demand, for smooth operation, completely uniform cloth in very big yardages.

The steel cylinder has a false perforated base, and a tubular heater outside, and the fabric is fed into it in rope form through a funnel. The alkaline scouring liquor is pumped through the funnel as the cloth is being systematically layered in the kier. The kier is then closed and the liquor continually circulated downwards through the fabric, into the false base and back up through the heater for about 7 to 8 hours. Obviously it is very important that the cloth be layered very evenly and that the liquor circulate in a uniform and consistent manner.

The J–Box. Patents for continuous bleaching using hydrogen peroxide were taken out in the USA as early as 1936, as a result of observing the strong and speedy bleaching effect of steam on a piece of cotton cloth saturated with a cold bleach solution and realizing that bleaching could be performed continuously and quickly by this means.

The basis of a continuous system was developed jointly by the Buffalo Electro-Chemical Corporation and E.I. du Pont. But a great deal of experimental work was necessary, not only with varying concentrations of bleaching liquor, reaction temperatures and timings, but also on the development of a piece of equipment which, while the cloth passed through it at speed, would still give sufficient holding time to allow a complete reaction. The result was the J–Box, developed from an earlier J-shaped structure which had been used for some time as a bleaching vessel in the United States. The two systems promoted – the Becco J–Box and the du Pont J–Box – used steam heating in different ways to heat up the cloth piled in the upright part of the 'J'. Both gave retention times of $1\frac{1}{2}$ hours, and from these was developed a completely continuous bleaching system with speeds of up to 300 yards per minute and a total elapsed time of 2–3 hours. The war stopped further work and it was not till about 1945, with the release of stainless steel from wartime controls, that the great drive towards the mass introduction of continuous equipment began. By the end of 1960, 67 per cent of bleaching in the United States used continuous systems of one type or another, and percentages have increased appreciably since then.

The other continuous system (again from America) was the *conveyer steamer* of the Mathieson Alkali Corporation,

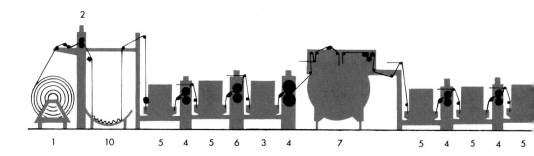

2

1 10 5 4 5 6 3 4 7 5 4 5 4 5

Diagram of a single-stage Vaporloc with desize washing and final drying. The cloth can be run through the range once or twice, depending on requirements. *1* Big batch entry. *2* Draw nip for big batches. *3* Chemical saturator. *4* Squeezing nip. *5* 11-metre washing unit. *6* High-expression nip. *7* Vaporloc chamber. *8* Batch wind-up. *9* Cylinder drier. *10* Scray for continuous operation. *11* Plaiter.

developed for use with 'Textone', their trade name for 80 per cent sodium chlorite powder. In this system the saturated cloth entered a steam-heated chamber at about 96° C (205° F) and was plaited on to a series of conveyer belts, the speed of which ensured that the cloth was in the chamber for 45–60 minutes.

Both the J–Box and the 'Textone' treatments processed the cloth in rope form, i.e. it was gathered together and funnelled into the J or the conveyer steamer, as it had been in kiers. Between 1960 and 1970, however, about 30 open-width ranges were established in the United States. Open-width processing, as its name implies, is the treatment of the cloth in all stages over a series of rollers which enable it to be spread out to full width, in an effort to avoid all possibility of crease-marks which might tend to become permanent, and to get as even a bleaching as possible. Obviously open-width machinery is rather greedy with space and for this reason is sometimes avoided.

The first development in open-width J–Boxes was the use of much smaller J's because, even though width-ways creasing could be avoided, heavy weights of cloth could

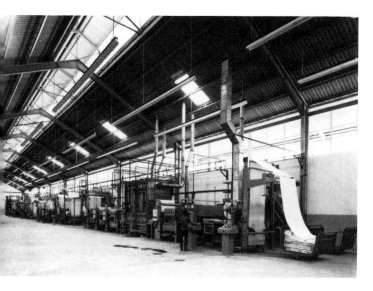

View of complete preparation range as installed by Mather & Platt in Malaysia. It is a two-stage installation and the two Vaporloc chambers can be seen at the far left of the picture.

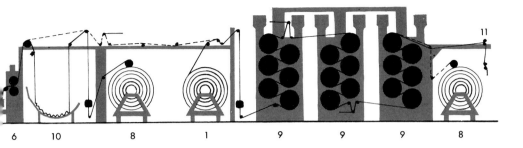

6 10 8 1 9 9 9 8

cause 'dwell' marks in the other direction. In an effort to compensate for the shorter 'dwell' time – now only 8–10 minutes – a 'rapid bleach' was used of higher chemical concentration.

We have seen that, if speed is required, the alternative to more concentrated, and therefore more expensive, chemicals is the use of steam pressure to raise the temperature of the reaction. Atmospheric steamers have been used since the early years of this century (e.g. the Mather & Platt atmospheric steamer of 1913); these are still used a great deal and are ideal for the fixation of dyestuffs and for steaming during de-sizing, but the use of continuous-pressure processing was something new. Laboratory successes came in 1960–61 with only 2 minutes taken to obtain a good white. Although systems were developed in the United States and Europe and were operational from 1964, it was not till the late 1960s and early 1970s that the worth of Kleinewefer's and Mather & Platt's methods were proven and that the various teething troubles were over.

The 'Vaporloc'. Although the idea of pressure processing was slow to become popular because, like so many inventions, it was before its time and the textile industry was not ready for it, now there are Vaporloc ranges in countries all over the world, although not as much in the UK (for the reasons already stated). Using hydrogen peroxide to process cloths ranging from lightweight 100 per cent cotton voiles to heavy polyester blend ducks, at widths from 1.2 metres to 3.0 metres (4–12 ft), the Vaporloc operates at pressures of up to 4 atmospheres and a temperature of 150° C (300° F), which gives a reaction time of up to 3 minutes with cloth speed at 125 metres per minute (although 2 atmospheres for 2 minutes is the most practical). In the chamber the cloth is 'rippled' down on to a roller conveyer bed in a completely relaxed condition. This allows of a better chemical reaction and no marking of cloth. The Vaporloc is a steel chamber through which the cloth can pass continuously without loss of pressure and is large enough to allow 375 metres' holding capacity. Access to the inside of the chamber is through a quick-opening door operated by two hydraulic cylinders and a hand pump. It is fitted with floodlights, two armour-glass inspection windows and even a television camera. The

Interior of the Vaporloc chamber.

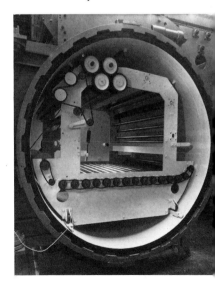

most important aspect of the Vaporloc is its specially patented seal assembly which is situated at the top of the vessel. Although simple in design, it nevertheless took Mather & Platt seven years to perfect; it has, it is claimed, a longer life and is cheaper to replace than any type of seal known. Its life is approximately one month and it can be replaced in thirty minutes or so. The quality of bleaching and scouring – should a two-stage treatment be needed – is consistently excellent and possibly the only difficulties are in the greater widths. Trouble may also arise if joins in the fabric are not well stitched, so causing problems when passing through the seal.

The range can be a single one used for a single-stage process, i.e. either a scour of 4–7 per cent caustic soda plus a wetting agent, with a two-minute steam at 2 atmospheres; or a bleach with a slightly higher concentration of hydrogen peroxide. Alternatively, if two-stage treatment is needed or preferred, the single unit can be used twice or, in larger organizations, a double range can be installed (see diagram). Chain mercerizing units can be incorporated into the range either before or after the scouring section or after bleaching. It is obviously very important that the cloth is efficiently saturated with the chemicals and that after passing through the nip a controlled percentage of liquor is retained (about 80 per cent in fact). This is particularly important where wet-on-wet saturations are used, e.g. for mercerizing.

MERCERIZING

This process, which can be done either before or after bleaching, derives its name from that of its discoverer, the distinguished self-taught chemist John Mercer, who patented it in 1850. While he was working at the Oakenshaw Print-works in 1844 he noticed that spots of caustic soda effected a remarkable change on a cotton cambric filter he was using; later he continued experimenting with the alkali until his application for a patent.

The patent states:

My invention consists in subjecting vegetable fabrics and fibrous materials, cotton, flax, etc. to the action of caustic soda or caustic potash, dilute sulphuric acid or chloride of zinc, of a strength and temperature sufficient to produce the new effects and to give the new properties which I have hereinafter described. . . . I pass the cloth through a padding machine charged with caustic soda or caustic potash of sp. gr. say, 60°/70° Tw, at the common temperature say 60° F or under, and without drying the cloth wash it in water, then pass it through dilute sulphuric acid and wash again; . . . the more remarkable [properties] . . . I here describe. It will have shrunk in its length and breadth, . . . effects somewhat analogous to that produced on wool by fulling and milling. It will have acquired

Modern Persian block-printed cotton. These prints, using old wood blocks and natural dyes, are of good quality and are becoming increasingly difficult to date.

Indonesian slendang, 1913.

Mouchoirs à Châle Uni - Türkisch rot mit Aetz weiss u Aetz blau
Schondru in der Chlorkalkküpe, Aluminium mit Tafelgelb u Tafelschwarz,
alles wie auf vorhergehenden Blatt.

Erstellt in den 1830er/40er Jahren in der
nachmals Felix Weber in Netstal S. 349 P.

Two nineteenth-century prints. *Above:* Turkey red handkerchief, 1830–40. *Below:* very good example of early aniline colours, showing methyl green, fuchsine, water blue, steam black and a natural orange.

Platte - Dampf Schwarz
- Fuchsin u Wasserblau mit Aethenige. The
nach dem Dampfen Theerober Teplorange gedruckt

Uno Hamburg Figuren
1870er Jahre L 1603/4 u 577/9

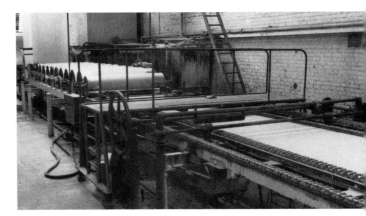

Chain mercerizing.

greater strength and firmness. . . . It will have acquired greatly augmented and improved powers of receiving colours in printing and dyeing.

Strangely, though, the quality we associate with mercerizing today – that of a permanent, silky lustre – was not discovered until some 50 years after Mercer's work, when his process had been more or less forgotten, unused because of the excessive shrinkage of cloth involved. Cloth and yarn are now mercerized under tension. In 1899 a man named H. A. Lowe was mercerizing hanks of cotton under tension to prevent shrinkage, and noticed that they gained a silky lustre. It was realized that the action of the alkali was to cause the fibre to swell up, shrink and become translucent and elastic, in fact to change completely, and this knowledge led to the subsequent treatment of cloth by caustic impregnation, followed by 'chain-stretching' to prevent shrinkage in width and length.

Today the term 'mercerizing' is usually limited to this process of producing permanent lustre by the action of caustic soda. Cloth so treated dyes to darker shades and also more rapidly, and therefore more economically. In taking on the smooth cylindrical form which results from the alkali-swelling treatment, the fibre is in a state to be still more lustrous by calendering with a Schreiner calender, which flattens the surface. There are many variations, but a fairly usual treatment is to use around 20 to 25 per cent of caustic soda solutions at room temperature for half a minute to 2 minutes, with the cloth restrained to control the shrinkage.

Vats and reactive dyes particularly are much enhanced and brightened by this pre-treatment and indeed reactives were developed for cotton so treated, and lose yield and brightness very much without it.

DYEING

From the point of view of the printer, cloth is either pre-dyed in order to be printed on later in some deeper shades –

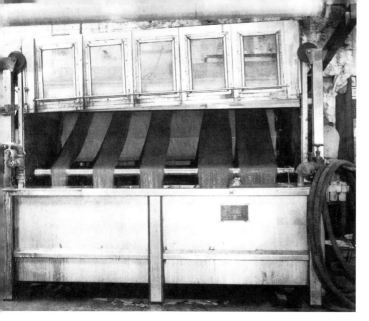

A winch dyeing machine.

as for sheets or other domestic furnishings or dress goods – or dyed in preparation for subsequent discharging (fine cotton direct-dyed, discharged with vats, or silk or wool using acids, for example).

Very briefly, piece goods are mainly dyed either (a) by being moved through the dye liquor in some way or other, or (b) by systems in which the cloth is kept stationary while the liquor circulates. The former includes 'jig' dyeing and 'winch' dyeing, the oldest methods; recently the winch has begun to be superseded by 'overflow' systems (see below). The latter, which is called 'beam' dyeing, can be carried out at high temperatures or at atmospheric pressures.

Winch dyeing

Diagram of a winch dyeing machine. The endless cloth drops into the trough of dye liquor, is relaxed, and is then drawn out again at the front.

The winch, the oldest form of dyeing machine, was originally turned by hand; modern versions are now often enclosed and can be made for dyeing in 'rope' form or 'open-width'.

The winch consists of a fluted roller or one composed of slats – circular or elliptical in form – and a guide roller, situated over a vessel containing dye. The fabric, machined into a long, continuous piece, is pulled out of the dyebath at the front and folded down at the back. Because some of the cloth is always loosely piled in the liquor, unlevel dyeing can result, and for this reason 'levelling' agents are often needed. Another difficulty is that irremovable crease marks can also be made. The newer enclosed models with glass doors help to maintain a more even temperature and therefore produce more even dyeings.

Jig dyeing

These machines consist of two batching rollers with guide rollers, over a V-shaped trough of dye. The cloth is wound round one of the rollers and then is drawn downwards

through the dye liquor and so wound on to the second batching roller. The cloth can be drawn backwards and forwards in as many passages as are necessary to achieve the depth of colour required, and about 500 yards can be processed at a time.

Continuous processing of synthetics in open width is often achieved by 'thermosoling', i.e. the cloth is 'padded' with dye liquor, dried by infra-red heat and passed for about three minutes through a HT chamber at 160–180°C (320–360°F) in order to diffuse the dye into the fibre. Alternatively the cloth can be put through a specially designed stenter and heat-set. A great deal of polyester fabric is so treated. Mixed cloths of polyester/cotton (such as sheets) are often dyed in two stages – with the disperse dyestuff first, as above, and reduction-cleared in caustic soda and sodium hydrosulphite to remove loose surface dyestuff, then winch-dyed with reactives. Latterly dye companies have been developing more and more 'mixed' dyes to cope with the increasing number of blended fabrics; the Cottestrens produced by BASF, for instance, are a vat/disperse blend for cotton/polytester.

A small winch for college use, with fabric in place ready for dyeing.

Beam dyeing

Since the Second World War there has been a great increase in the manufacture of knitted fabrics, often fine and delicate in structure, which are delivered to the dyer wound on to a roll. It was soon realized that the experience gained in the dyeing of packaged yarns would prove helpful in developing beam-dyeing machines in which the cloth remained stationary and the liquor circulated.

Filament yarns of man-made fibres vary in their capacity to take up dye, and as a result 'bars' of irregular dyeing often show up at a later stage. This variation is much reduced at temperatures of over 100°C (212°F), so much beam dyeing is at high temperatures.

The beam on which the cloth is wound before being placed in the dyeing chamber is perforated all over with a

A Samuel Pegg pressure dyeing unit. Note the small device which allows a sample to be withdrawn for inspection.

series of small holes, and is closed at one end while having a means of connection with the circulating pump at the other. There has to be a means of running the horizontal beam into the chamber through the end door and usually some form of carrier runs on rails to deliver it. When the machine is closed the dye liquor can be transferred to it or it can simply be filled with water which is then heated up and a concentrated solution of dye pumped in. Obviously in a completely closed system, and one which is so fully automated, it is essential to have close control of time and temperature, and to know the penetrability of the cloth and the rate of liquor flow. It is also important to be able to withdraw samples of cloth from the pressure chamber to test for depth of colour in full confidence that these samples are true indicators of the main batch colour. Pattern-holders are provided for this purpose which, placed inside the chamber, can be isolated by means of a pressure lock and withdrawn for inspection. Thus the bulk fabric is not taken from the beam-dyeing machine until it is not only dyed to the correct shade but also rinsed and completely dried.

As mentioned earlier, although winch-dyeing machinery is still in demand in various places, it is being superseded by the 'overflow' system. Because it is easy to damage delicate fabrics during the dyeing process, tension-less systems are being developed, such as Samuel Pegg's Supersoft machines, for both atmospheric and pressure dyeing.

Advertisement for bleaching and dyeing equipment, from *The Printing of Cotton Fabrics* by Antonio Sansone, published in Manchester in 1887.

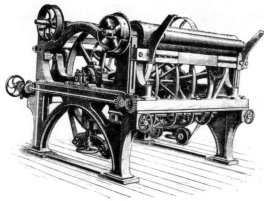

3 Dyestuffs, natural and synthetic

Textile printing is really a 'localized' or restricted form of dyeing and in order to confine the colour to a particular area of cloth (in the form of a design), a 'printpaste' has to be formulated. This paste is the vehicle which conveys to the cloth the colouring matter (in the direct style), the mordant (in the dyed style), the resisting or discharging agent in those particular styles, or any other agent required to bring about a colour-fast design on the cloth.

In direct printing the dye is printed on to the fabric with all the necessary chemicals and auxiliaries, and on fixation directly produces the whole printed pattern without further treatment. In the direct style then the printpaste consists, in simple terms, of all or most of the following ingredients:

1 Colouring matter
2 Solvent (and aids to solution)
3 Some agent or agents to aid or bring about fixation
4 Thickening

The colouring matter has usually to be dissolved in water or acid; provided with the chemicals needed for fixation of the particular dye type (alkalis, reducing agents etc.); and thickened to ensure that the particular shape to be printed can be reproduced exactly by the mechanical process decided on (screen, roller etc.) time after time, without either being distorted by bleeding-out due to capillary attraction of the fibres, or being broken up and textured by incorrect use of the thickening agent.

So before getting on to the actual printing processes this and the next chapter will deal with these constituents in more detail.

NATURAL DYESTUFFS

To many people the most exciting thing about any piece of fabric is its colour, and certainly in studying printed textiles the development and application of dyestuffs is one of the most interesting aspects. Until the latter half of the nineteenth century, with the exception of a few mineral colours, all dyes were vegetable or animal in origin. Colouring matter was extracted from the roots and stems, leaves,

berries and flowers of various dye-plants, and from certain insects and shellfish by an elaborate series of processes used, with little basic change, from hundreds of years before the Christian era, through the Middle Ages, until the rationalization of chemistry in the eighteenth century. These natural dyes, with very few exceptions, are not substantive (that is to say they have little or no colouring power in themselves), but must be used in conjunction with mordants* – or 'drugs', as they were often called. A mordant, usually a metallic salt, has an affinity for both the colouring matter and the fibre and in combining with the dye in the fibre forms an insoluble precipitate, or lake.

Nearly every book written about the dyeing and printing of fabrics quotes Pliny the Elder who, in AD 70, wrote of 'mordant dyeing' as practised by the Egyptians, but because it so well and simply describes both the process and the magic felt in seeing it, it is worth quoting yet again:

> . . . the white cloth being first stained in various places, not with dyestuffs, but with drugs, which have the property of absorbing colours. These applications do not appear on the cloth, but when the cloths are afterwards plunged into a cauldron containing the dye liquor they are withdrawn fully dyed of several colours, according to the different properties of the drugs which have been applied to different parts; nor can the colours be afterwards removed.

This first-century description of mordant dyeing in Egypt, while being much less detailed, is in essence the Indian process described by Father Coeurdoux, the Jesuit missionary in Pondicherry, in 1742, from which the French dyeing industry received invaluable help. After a complex series of preparatory processes, he then goes on to describe the use of the alum mordant:

> Put two ounces of powdered alum into two pints of [hard] water; add four ounces of . . . Sapan wood also reduced to powder. The whole is then put in the sun for two days, taking care that nothing sour or dirty should fall into it, which would deprive the colour of its strength. If the red is required darker, more alum is added. If, on the other hand, it is wanted lighter, more water must be poured in; and so the various gradations of this colour are effected. To make a shade of dregs of wine inclined to violet, take one part of red, i.e. mordant (just described) and an equal part of black.

The mordant for the black, in simple terms, consisted of pieces of iron fermented in rice water and so becoming acid.

The flowers and leaves were then painted in on the cotton cloth with the various mordants of different strengths and then the whole immersed in a dyebath of pounded chaia root. (Chaia, chaya or cheyroot is *Oldenlandia umbellata*, a plant growing on the Coromandel coast of India which

* The group of salts known as alum constituted the commonest class of mordants and for many years stocks were handled by Mediterranean traders.

actually contained some alum and which was at times used instead of madder.)

The direct style of textile printing was little used (with the exception of some early steam colours) until the advent of certain artificial dyestuffs in the latter half of the nineteenth century, so the skill of the dyer was as important as that of the printer in the production of a good painted or printed fabric; both the earliest styles, resist and the dyed style, needed the dyebath to bring out the pattern in one form or another.

But although the craft of dyeing was understood in Europe in pre-Roman times and afterwards, as with many other achievements its finer points were mainly lost during the years following the break-up of the Roman Empire. In the Middle East and the Orient, however, the knowledge was preserved and was gradually brought back into southern Europe and Spain by the Arabs during the early eighth century AD, and so dyestuffs and the methods of working them which had been known to the Greeks and Romans were revived.

In the Middle Ages, under the guild system, the dyers were at times badly treated and were often part of the weavers' guilds until the foundation of the Worshipful Company of Dyers in London in 1188. But from the beginning of the guild system the classification of types of work and the training and status of members were very much the same all over Europe. In the second half of the seventeenth century, when Louis XIV's finance minister Colbert was having the dyeing trade and the dyers' workshops investigated, he issued decrees naming the same groups of workers as those operating in medieval times:

1 Black or 'plain' dyers (i.e. dyers of black and simple colours)
2 Dyers of high colours (those who worked with the finest materials)
3 Silk dyers (mainly in northern Italy)

The Society of Dyers and Colourists' *Colour Index* (3rd edition) defines natural dyes and pigments as follows:

These dyes and pigments comprise all those that are obtained from animal and vegetable matter with no, or very little, chemical processing. They are mainly mordant dyes but include some vat dyes, a few solvent dyes, some pigments, some direct and acid dyes. Only one natural basic dye is known and there is no natural sulphur, disperse, azoic or ingrain dye or oxidation base.

The *Index* lists only those dyes which have at some time attained some importance as colouring matters for textiles and other substrates, but there are many others. Most are no longer used industrially – the exceptions being logwood, osage orange and bitumen – but many are still used by handicraft workers and home industries.

The most widely used and known dyes up to the invention of synthetic colours in the 1850s were purple, madder, woad, indigo, kermes, cochineal, saffron and orseille, but the *Colour Index* lists 32 natural reds, 3 natural blues, 5 natural greens, 12 natural browns and 6 natural blacks.

Purple

This expensive dye was obtained from several species of shellfish of the two genera *Murex* and *Purpura*, some species of which come from the Mediterranean area. Because of the enormous number of shellfish required the production of the dye was very costly – in fact about 8,000 shellfish were needed to obtain 1 gram of dye. In places like Tyre, where it was a speciality, great piles of shells, and the tools used for extracting the creatures from them, have been unearthed. The dye, a glandular secretion, is naturally a pale yellow, which gradually changes to purple, through shades of yellow-green, green, pale red to deeper red by the photochemical action of the sun's rays. It was diluted with water and stale urine (alkali) and boiled for about ten days to obtain a very concentrated solution. More urine was added, and also honey as a reducing agent.

Depending on such factors as the dyeing time and the type of shell or mixture of shells used, many shades up to deep violet or even reddish-black were possible. 'Purple', as a term used in antiquity, comprised a whole range of shades which could be produced from the purple shell. All were extremely fast even in the strong southern sun. Because of the rarity and costliness of purple cloth it became in certain periods a symbol of power and social status; Julius Caesar restricted the wearing of a purple toga to his own use, letting senators have only a purple stripe on the toga hem. Dyeings from the murex shell were used up to the fifteenth century, when reds were obtained from the kermes shield-louse, the cochineal insect and the madder root.

Scarlet

As well as the reds obtained from the 'purple' *Murex*, a brilliant scarlet dye had been known and used since ancient times, obtained from the dried bodies of pregnant females of the kermes shield-louse, *Kermes*, or *Coccus*, *ilicis*. The name 'kermes' comes from *qirmiz*, the Arabic name for the insect. The shield-louse lives on the leaves of an evergreen shrub growing around the Mediterranean and in south-west Europe, which is known as the kermes oak (*Quercus coccifera*). The kermes louse looks exactly like a scarlet berry on the evergreen bush, and for a long time there were arguments as to whether it was animal in origin or not: it was thought that it was an insect inside a berry. Wool, silk and leather were dyed with the dried and ground powder

and in fact the 'cardinal's purple' robe which was decreed by Pope Paul II in 1464 was not produced from the purple murex but from kermes. By the mid-fifteenth century 'purple' dyeing ceased altogether.

Later. in the sixteenth century when the Spaniards conquered Mexico they discovered the Aztecs wearing materials dyed bright red and they immediately had vast quantities of the dried cochineal insects, from which the dye was obtained, shipped to Spain and other countries. The so-called cochineal beetle is in fact another species of the shield-louse family which lives on cactus plants. Cochineal was used to dye wool, silk, morocco leather and, later, cotton, and quickly replaced kermes. Cochineal dye has a powerful affinity for alum.

Woad

The fleshy leaves of the plant *Isatis tinctoria* were fermented and after lengthy processing gave a rich blue dye. The depth of colour obtained was determined by the quality of the woad and the number of times the cloth was immersed. A fresh dyebath gave black, next it could be used to give blue, and finally when the bath was more exhausted it would yield a green. The guild rules concerning the cultivation and use of woad were very strict. Only a controlled amount could be grown and no one was allowed to try to corner the market by going to other villages for extra supplies. In Britain woad is chiefly remembered for the fact that the ancient Britons painted their bodies with the dye instead of clothing themselves, but throughout the Middle Ages it was by far the most important dyestuff in use in Europe, where the principal growing areas were Saxony and Thuringia. The quality was tested by the guilds and, after testing, the barrels were stamped to indicate the quality.

Indigo

Indigo (*Indigofera tinctoria*) entirely superseded woad once it started to be imported in quantity, although the woad dyers did everything in their power to stop its use. In Frankfurt on the Main in 1577 a decree was issued

> that the recently invented, harmful and corrosive dye, which is named the Devil's dye, causes much injury to all persons, vitriol and other corrosive and cheap substances being used for such dye in place of woad; although the cloth so dyed is equally good in appearance as cloth dyed with woad, and can be sold more cheaply, such dyed cloth will be fretted and consumed in a matter of a few years even when it is not being worn and is laid away in chests and stores. For which reason we wish to prohibit entirely such harmful cloth dye.

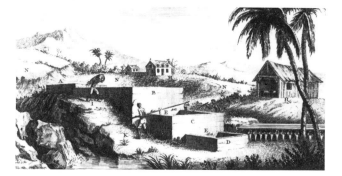

The preparation of indigo, showing the series of cement-lined brick fermentation tanks. From Diderot's *Encyclopédie*.

But in a very few years it was King Indigo that was used for all blue dyeing, and woad that was forgotten.

The plant is a sub-tropical bush about five feet high. At the time of flowering, particularly if the buds were removed, the leaves, from which the colouring matter was obtained, yielded their highest percentage if they were cut down close to the ground and immediately collected into bundles and put to steep. The roots which were left very quickly started to sprout again, giving a second and sometimes a third and fourth crop, but yielding progressively weaker concentrations of colouring matter.

The area of lower Bengal by the Ganges was celebrated in the nineteenth century for the excellence of its indigo and the organization of its factories. About a hundred bundles of the plant were packed tightly into tanks with water. As fermentation proceeded a straw-coloured liquid formed, and was gradually allowed to drain into two rows of cement-lined brick tanks about 6 metres square and about 1 metre deep, one row on a slightly lower level than the other. When all this was drained off the fermentation tanks were emptied of the used leaves and cleaned, and another batch was brought in. The yellowish liquid was then stirred and beaten for several hours by men and women standing waist-high in it, to oxygenate it and convert the indigo-white into the insoluble dyestuff. As this agitation proceeded the colour became pale green and the indigo flakes started to become visible. The workers then left the tanks and as the fluid content was gradually reduced more flakes collected at the base of the tank; after various alkaline additions in the form of plant and bark juices, these flakes were strained, then the rather pasty mass was washed and boiled in an attempt to remove all impurities. The best grades were well filtered to remove foreign matter but the worst ones deliberately adulterated with sand to make them more profitable. Even in the 1920s, when natural indigo was still used a little in Europe, it was supplied in hard, gritty cakes which needed to be ground, often for as long as a week, before they could be used. This grittiness is particularly awkward for use in engraved roller printing. When synthetic indigo was introduced commercially in

1897 it very quickly supplanted its natural counterpart, as that had supplanted woad.

The Indians knew that indigo would not give a colour which was fast to washing if it was painted (or printed) on to the cloth directly and so they, like the Javanese and many others, used an elaborate process of resist dyeing. All those parts of the cloth that were not to be blue (or green) were painted with wax on one side and then carefully exposed to a limited amount of sun to allow just sufficient melting to penetrate to the other side of the cloth, with pressure to help it through. After the lengthy preparation of the dye the cloth was folded in two so that the right side was outside and the wrong side inside and steeped in the indigo bath for about $1\frac{1}{2}$ hours. Father Coeurdoux enquired most particularly about the reason for the use of the dyeing method and was told that otherwise the blue would disappear after two or three washings. The Indians considered that adding an infusion of *taverei* seeds (which have not been identified) was essential in ensuring a fast colour.

Madder

True madder (*Rubia tinctorum*, also popularly known as dyer's madder) is a member of the family Rubiaceae (madderworts). Of this family – which includes quinine (*Cinchona*) and the wild madders or bedstraws (*Galium*) – dyer's madder is the foremost dye-producing member. It was the principal red dye of the Middle Ages in Europe but it was not until the sixteenth century that it began to be cultivated in large quantities. It is a native of, and grew prolifically in any tropical and temperate zones in, Asia Minor, the Caucasus, Greece, and Mexico, China, Japan, Siberia, India and Persia, and was very successfully cultivated in Holland, Silesia, Hungary, Provence and Alsace. *Rubia tinctorum* is not indigenous to England although some 18 species of wild madders or bedstraws do grow here.

In Asia Minor dyer's madder was known as *lizari* or *alizari*, from which the modern name of the dye extracted from its roots, alizarin, is derived. *Rubia tinctorum* grows to about four feet and bears yellow flowers in early summer. The bulk of the pigment is found between the outer skin and the woody core of the roots. The roots were dried and ground to a fine brown powder. The characteristic red colour of madder is not present directly but as a yellowish compound, which yields the clear red only in the presence of alumina. Yarn or cloth had to be treated with alum, in the process known as 'mordanting', and so alizarin is a mordant dyestuff.

While *Rubia tinctorum* is indigenous to Asia Minor and southern Europe, its cultivation reached the highest standard in Holland, where it was grown extremely well as early as the fifteenth century, and in France, Holland's only real rival. Whereas in the east the plants were often trained on to sticks

to increase the length of the stem and thus of the root as well, in Holland too much root per plant was not considered necessarily good for the quality of the dye. The bushes were grown for only three years and then the roots were taken up and ten years allowed to elapse before the same fields were again planted with madder. Before being milled it was treated with a mixture of potash, and cow-dung which had been kept for a year. The yellow powder which resulted from the refining was stored, very tightly sealed against moisture and sunlight, for up to five years. The fermentation which went on in the sealed containers increased the ultimate colour yield.

In 1869 alizarin was produced synthetically by Graebe and Liebermann (see p. 75), and the growing of madder was almost completely abandoned in a few years, causing great hardship and even starvation among the peasants who had relied on the madder market for their sole income. In 1869 Britain imported from Holland stocks valued at £1,000,000, but only ten years later madder growing ceased everywhere.

There were three main qualities: poor, an ordinary medium quality, and then the very superior 'crop' madder or *garance robée*. Because the dye extracted from the root in water solution does not give a fast dye, prior preparation is needed and traditionally this was done with 'red liquor' – alum with a certain amount of clay. For several hundred years the sale of alum was the prerogative of the Mediterranean traders who obtained supplies from Turkey and, later, Greece. There are records as early as 1229 of the sale of different qualities of the salt. In the first half of the sixteenth century the Italians discovered a source, but it was more costly than the Turkish.

Madder used in conjunction with 'red liquor' was remarkably fast and a cheap dye for wool, cotton, linen and even silk, but unfortunately it yielded only a rather dull terracotta, in no way as brilliant as the scarlet obtainable from the kermes shield-louse. The production of a brilliant, clear red from the madder was only possible by the elaborate Middle Eastern method of dyeing which became known as 'Turkey red'. For many years this process was a closely guarded secret and dyers in western Europe tried without much success to find out how the rich colour was achieved. The fact that climatic conditions were very different in Europe from those of the Middle East did nothing to help the experiments continually being tried by dyers, although it was known that the cloth had to be prepared with an oil as well as the traditional alum and that many different processes and stages were needed, occupying about a month. Not until the eighteenth century was a simplified process developed in France, as we shall see (p. 72). But even now it is uncertain how the Turks did achieve such marvellous effects.

Yellows were obtained from many sources and were not very fast in shade; saffron, safflor (also rose-red, giving the

fashionable 'ponceau' or poppy colour), and weld were used, among many others.

In the sixteenth century many new dyes were introduced from the Americas – cochineal and also many dye-woods (the colour being extracted from the woody trunk and branches), such as brazilwood and logwood or Campeachy wood, so named from the port of Campeche in Yucatan from which it was exported. Logwood is still used to a certain extent, chrome logwood black being a very rich, deep and fast shade, while up to a few years ago 'school red ink' was made from a decoction of acetic acid and logwood chips. The action of alkali produces purple or violet.

There are two other important sources of colour from the vegetable kingdom – lichens and astringents.

Lichens and astringents

There is a group of lichens (according to Crookes and others), particularly *Roccella tinctoria*, which yield a vivid violet (sea or marine orchil) under the influence of ammonia and atmospheric oxygen. This property was said to have been discovered by a Florentine nobleman in 1300, and for a hundred years or so Florence supplied all the 'orchil' to the rest of Europe; later some came from Corsica, the Greek islands, the Canaries and Madeira. At the end of the nineteenth century industrial forms were produced – orchil pase, orchil liquor, cudbear, and French purple – industrially treated to make concentrated products easier to handle.

There are a series of natural substances which are really *astringents* – that is, substances capable of contracting the organic tissues of the body and thereby checking excessive discharges – rather than dyes; these include nut galls, myrobalan, sumac and catechu. All astringents, particularly sumac, act as if they contained yellow colouring matter and yield tannic acid (or tannin) which is a mordant and also used in the tanning of hides. The galls are grown on a variety of oak (*Quercus infectoria*) found in India, Persia, Syria and the Levant, parts of Greece and southern Europe, and are in reality a vegetable excrescence produced by the deposit of the egg of an insect on the bark or leaves of the plant. The best (blue, black or true nuts) are gathered before the larva has fully developed and escaped; the others are called 'white' of 'false' nuts. In the Middle Ages gall-nuts, with iron filings in vinegar as a mordant, were used for a black dye by Rhenish monks. Catechu, another astringent, was not used in Europe until about 1806; obtained as an extract from a tree of the acacia family, it was used to print browns, fawn, drab, and wood colours generally.

Natural dyestuffs today

Natural dyes are used very little today for even in Indonesia, India and other countries less industrialized than Europe the

easier and quicker chemical dyestuffs have gradually super-seded or are superseding the laborious older methods.

In African villages mixtures of specially grown plants pro-vide dyestuff but often also powdered dyes (both natural and synthetic) are imported into the area and used in a combina-tion of old and new techniques. Even in Indonesia, although synthetic dyes are being used today for most work, natural dyes are often used – for instance, in conjunction with fer-mentation techniques many hundreds of years old. During the last few years, however, in an effort to preserve old traditions, interest in block printing is being revived in Isfahan and cotton is again being printed with blocks, often 200 or more years old, and with madder, indigo and other natural dyes. These are so well and carefully executed that they will become increasingly difficult to date.

Natural dyes are still used, in a very limited way, in the dyeing of yarn for Harris tweed. But owing to the very high labour costs involved in collecting and preparing dyes of natural origin they are only used for very special orders, where the demand is for a completely natural product and consequently the customer does not object to the necessarily high cost. Apart from the high labour costs, using natural dyes makes impossible the accurate repetition of colour and shade – indeed this is, to the people who use them, their great charm and interest. The traditional colours used in Harris Tweed are orange, originally from ragweed (*buagha-lan*), green from heather (*fruoch*) or iris (*seilister*), red from lichen scraped off the rocks (*corein*), yellow from bracken roots (*rainnech mor*) or peat soot (*crotal*). *Crotal* is the only one which does not need mordanting. Alum (aluminium sulphate), salt, bichromate of potash, iron and copper sulphates (with cream of tartar) are used as mordants.

MORDANTS FOR NATURAL DYES

The scoured wool or silk is usually mordanted before dye-ing, but it can be treated during dyeing, or sometimes even afterwards.

Dissolve the mordant in the bath of water (holding 4–5 gallons of water to a pound of wool) before entering the wool and then, after entering, bring the water very slowly to the boil. Boil gently for about 30 minutes. For each kilogram of wool the approximate amount of mordant is

alum	250 g
bichromate of potash	16 g
iron sulphate	16 g
tin crystals	
(stannous chloride)	16 g
cream of tartar	62.5 g

If chrome mordant is used (bichromate of potash), the wool is immediately ready for dyeing, but aluming is more

A crofter weaving Harris tweed on a Hattersley domestic loom in his own home in the Outer Hebrides.

difficult and it is better to leave the wool to cool in the mordant and then to keep it damp in a bag for a few days until it is to be dyed. If this is impracticable, then it is better to mordant for at least 45 minutes. In any case, the longer the time taken over this part of the process the more permanent and even will be the final dyeing.

Because natural dyes are in the form of roots, stems, bark and berries, they are liable to be caught up in the hanks of wool and are difficult to remove. Therefore it is a good idea to put them into a fine cotton or muslin bag and immerse this in the dyebath. Boil or keep just under the boil (depending on the particular dye) for half an hour to 3 hours. For the classic foreign dyes still obtainable – madder, cochineal and logwood chips – the following methods are suggested, but many variations can be found in various reference books (see bibliography, p. 185).

Madder

For this, hard water is needed; if the water is soft, add a little powdered chalk. After mordanting with alum and cream of tartar for at least 45 minutes, the wool is best left damp in a bag for 4–5 days. The crushed madder or madder powder (about 500 g per kg of wool) can be soaked overnight, but this is not entirely necessary. Instead, bring it to the boil and keep it just below boiling point for about 20 minutes. Then enter the wool (still damp) and keep it simmering for about 1 hour. Allow it to cool in the dye liquor and then rinse it several times before boiling it in a soap bath; this brightens the colour. It is essential to keep the dyebath below boiling point as the yellow content of the dye root is released at a higher temperature and the colour will become dull and browner. If a small quantity (about $\frac{1}{4}$ oz.) of tin crystals is diluted in water and added to the dyebath the colour will be more scarlet.

Alternatively, the wool can simply be mordanted with tin and cream of tartar.

An iron mordant will produce near-black, and chrome gives purple.

Cochineal

Mordant with 70 g alum and 43 g cream of tartar. 60 to 90 g of cochineal is needed per kilogram of wool, and this should be added to the mordant bath. Boil for 30 minutes. Again, tin crystals can be added to brighten the colour, or used alone, when the colour will be still brighter.

Logwood chips

Mordant with alum for violets to dark, blackish greys; with chrome for bluer greys and with tin for purples. Put the chips (43–56 g for greys and purples, up to 140 g for black) into cold water and heat gradually. After adding the wool, bring it up to near boiling point. If duller colours are wanted, the dyeing should be done very slowly, with up to 3 hours' simmering. Logwood has always been used for very good blacks, while good warm greys can be got by adding a little acetic acid or vinegar to chrome-mordanted wool.

Almost all vegetable matter will yield dye to some degree, but easily available sources are onion skins (with or without alum), blackberries and elderberries, ragwort, goldenrod, and lichens (which need no mordant).

NINETEENTH-CENTURY DEVELOPMENTS

Although the first synthetic dyestuffs were not discovered until the latter half of the nineteenth century a keen interest in the chemistry of coloration was evident in the late eighteenth and early nineteenth centuries. At the end of the eighteenth century, particularly in France, a dye chemistry based on scientific principles began to grow up. Prizes were offered by both the Royal Society in London and the Académie in Paris for new colours and new ideas generally in the field of textile science. Books and encyclopaedias dealing with chemistry – the *Dictionnaire de Chimie* (translated into English in 1778), Chaptal's *Elements of Chemistry*, or simpler works such as *The Chemical Pocket-book, or Memoranda Chemica* by James Parkinson of Hoxton (1803) – were in demand and read and used by the self-taught chemists like John Mercer and others interested in improving calico printing.

In the 1790s inorganic colorants or 'mineral colours' such as iron buff, antimony orange, Prussian blue and manganese brown were introduced. Prussian blue, used only as an artist's pigment until it was developed by the French chemist P. J. Macquer as a dye, was improved on at the end of the eighteenth century by Charles Mackintosh and others and sold in great quantities in Europe and even in the Far East.

Three stages of madder work (from Sir William Crookes, *Practical Handbook of Dyeing and Calico-printing*, 1874). In the first stage (*left*) the mordants (then technically known as 'colours') had been printed on. In combination with the dye they provided black, purple, red and light brown on a white ground. The fabric was then cleared and dunged to remove the thickenings and saturate any mordant attached to the fibre and not yet perfectly decomposed. Stage 2 shows the condition after dyeing in the madder-beck and a subsequent washing but before the final clearing. The shades are developed but not yet very bright, and the ground is still a dull light red. The final stage (*right*) is reached after a hot rinse and a hot soap wash at 160° F. The cloth is rinsed to clear away the soap, cleared in a very dilute solution of chloride of lime, washed in clean water and finished. This clears the ground and reduces the colours and depth (for which allowance was made) and brightens them.

Examples of Perkin's purple (1862) from an early dyèr's notebook.

Journal

of

Recipes and Memoranda

from 4ᵗʰ September 1859 to 27ᵗʰ March 1863. —

Test for Madder Purples. m.c. 4/9/59
.301.

If Purples or Lilacs are dyed
in Madder touching them with
Murt Tin gives the Yellowish
tint as in this bit. —
Logwood gives a purple Tint

Plain Blue on Flannel Cylr. J.R. 4/9/59.
.140.

Pale. — Mordanted as usual
for blues — viz — 2 ps only at a 1.4.
time in sour chemic (1/35) and
dress'd as for block. — Pad with
Full pad in the Blue 1.3 or 1.4 1.3.
from Blue o. Blo. (1/30) + Red 9 Lij Cylr
(7/31)

Opening page of a working dyer's
notebook. Keeping accurate notes is
still essential today.

70

Many experiments with sulphide of antimony led John Mercer to produce antimony orange (although it had previously also been produced on the Continent) and later, in 1817, to develop antimony yellow. He also analysed a sample of French calico having a madder purple ground and a bright yellow discharge and found that it was chromate of lead. Soon he found that by applying acetate or nitrate of lead to the calico first, then sulphate of soda and finally passing the cloth through a solution of chromate of potash, he obtained chrome yellow, which previously had only been used for carriage painting and similar decoration. By adding an alkali he could also print chrome orange.

Among the many applications of chemistry to calico printing in the early nineteenth century that of manganese bronze, introduced by Mercer in 1823, was very important. He was interested in the manganese glaze used by a local pottery and decided to try to produce in a 'wet' state a colour similar to that produced by fire in a 'dry' way. Manganese bronze, which became an immensely fashionable colour, was the result. (Around the same time this was also discovered by Hertman's of Munster.) Simpler ways of working indigo and a method of extracting a far higher yield from cochineal were some of the many other contributions he made to the colour chemistry side of calico printing even before he discovered the famous process to which he gave his name.

Perhaps the most noteworthy discovery of the period from a colour viewpoint was the discovery in 1809 of a good 'solid green'. A prize of £2,000 had been offered for a recipe for a solid green dye, which up to that time was not known anywhere in the world (except for Chinese Lokao which is colourless on silk but oxidizes green). Green had always been produced by printing or 'pencilling' a dull yellow over blue, which gave a rather dull, weak green, the yellow part at least being very fugitive. The prize was thought at first to have been won in Britain, but the results were so unconvincing that the credit was later (1809) given to Samuel Widmer, relative and colleague of Oberkamphe; he revealed his discovery, it is said, in return for being shown an English three-colour engraved cylinder machine.

Turkey red

The colour Turkey red, known in France as *rouge Turc, rouge des Indes* or *rouge d'Adrianople* was an especially bright red cotton colour produced from madder, and one which was extremely fast. For many years, as we have seen, the way it was produced was a closely guarded secret which European dyers tried desperately to find out from those countries of the Middle East which practised it so successfully. Although many attempts were made in the eighteenth century to copy what was known of the technique the results were not nearly so bright and certainly not fast. In 1747 a workshop was set up near Rouen, with the help of Greek dyers, for this pur-

pose, and about the same time the Dutch were making attempts at Leyden. In 1756, 1761 and 1779 the Society of Arts made awards to various people but the results were quite poor. Many reasons were put forward for the failures: among these was the difference in the climate and in the ingredients used, but insufficient knowledge and understanding of the complicated series of processes was no doubt the main reason. Although it was known that while in ordinary madder dyeing only alum was used as a mordant, the brilliance of Turkey red needed an oil also – this came to be known eventually as Turkey red oil.

By the mid-eighteenth century a simplified but still long drawn out version had been devised in France, while in 1786 the full details of the process were presented to the Manchester Literary and Philosophical Society by one John Wilson of Ainsworth near Manchester. He was a dyer and manufacturer who went to the trouble of finding out all he could from Greek dyers in Smyrna. It was a very tedious process and could only be carried out on cotton cloth of which the yarn was mechanically spun and therefore strong enough to withstand the sequence of processes involved.

The method in operation in Europe became the following (but some of the processes were repeated several times):

1 Oiling: steeping in sour olive oil (Gallipoli oil) emulsified by the fermentation of the fruit.
2 Dunging and galling (or sumaching): the action of the tannic acid fixed the oil in the fibre. This 'animalizing' was very important to printers and dyers of the eighteenth and early nineteenth centuries. They thought that because animal fibres had been found to dye much more easily the use of animal products would somehow aid the dyeing of vegetable ones. (Many printworks kept their own herds of up to 20 cows to supply their needs.)
3 Aluming.
4 Dyeing: the madder dyebath contained a variety of ingredients, including ox-blood. Often the cloth was re-dyed after being treated in between with gall-nuts, chalk and other ingredients.
5 Clearing: the oldest method was a series of soap baths containing potash. After boiling and rinsing, the cloth was spread on the grass in strong sunlight.

French chemists discovered that a brighter colour was obtained if stannous oxide (tin salts) was added to the soap bath.

By the latter half of the nineteenth century many changes had been made in the Turkey red dyeing process, cutting down the time needed and the quantity of oil and madder used. The greatest improvement was made by Steiner of Accrington, who managed to impregnate the cloth with sufficient oil in a single operation, thus shortening the preparation time from weeks to days. This was achieved by the use of hot olive oil kept at $110°$ C ($230°$ F). About 1860, castor oil began to be used instead of the older Gallipoli oil,

and the weight of oil needed was greatly reduced. In 1864 Walter Crum, a Scottish industrialist, developed an aqueous emulsified castor oil for this purpose, which came to be known as Turkey red oil (TRO). As for the quantity of madder, for a long time it was thought that as much as 150 to 160 per cent of cloth weight was essential to attain a stronger colour. (In modern dye work this proportion is rarely as much as 15 per cent.)

The introduction of artificial alizarin brought about a further revolution in methods, as also did the soluble Turkey red oils made by treating olive or castor oil with sulphuric acid and the resulting sulphonated compounds with neutralizing caustic soda or ammonia.

Because of the difficulty and complication of Turkey red dyeing, specialist works were set up for it, situated mainly in hard-water areas because the lime content was necessary. Today the process is virtually extinct, and in fact even with all modern chemical analytical expertise it is not known beyond all doubt how the original methods were carried out.

Before leaving the subject of natural madder dye it is important to mention the production of garancin (the name comes from the French *garance*, madder). During the normal production of madder dye from the plant, a great deal of the colouring element was lost, but it was discovered that by steeping the roots of the madder plant in water acidulated with sulphuric acid a far higher yield of colour was obtained because the acid acted on the woody fibres, setting more colour free. The garancin style was characterized by strong, saturated crimsons, browns and burnt oranges.

THE SYNTHETIC DYESTUFFS

The high point of nineteenth-century dye research was the development of aniline dyestuffs. The German chemist Carl Runge had pointed out that treating aniline with chromic acid produced a violet colour, but it was William Henry Perkin, a pupil of Professor August Wilhelm Hofmann at the Royal College of Chemistry in London, who, when only 18 years old, discovered that the dark precipitate formed when his attempt to synthesize quinine went wrong stained a piece of silk a bright purple. It was in fact a mixture of potassium bichromate and impure aniline. He was quick to recognize the importance of what he had found out and decided to give up his studies at the College and produce the 'purple aniline' commercially, having obtained English Patent No. 36,140 for the process in 1856. Lyons silk dyers suggested the name 'mauve' for the colour (and 'mauveine' for the dye), and for a decade and more it became a very fashionable colour. (In England the colour was nicknamed 'Perkin's Purple'.) But commercial production was not without its problems, not least of which was the shortage of aniline, obtained at that time in very small quantities from

Advertisement for the Clayton Aniline Company, which celebrated its centenary in May 1976.

The manufacture of aniline blue. From W. J. Crookes's *Practical Handbook of Dyeing and Calico-printing*, 1874.

Retorts for the distillation of aniline in the nineteenth century.

benzene, an equally rare chemical. Mauve at first, therefore, cost £90 per kilo. However, soon afterwards it was discovered that aniline could be obtained from coal-tar. From coal-tar (a by-product of the manufacture of gas), which the distiller separates into, among other things, benzols or benzenes, naphthalene, and anthracene, was to gush an almost illimitable stream of new and exciting colours. They were the basic dyestuffs.

In 1858–59 Hofmann himself discovered aniline red which, because of its similarity to the bright blue-red of fuchsia, was to become known as 'fuchsine' or 'magenta' (from the battle fought in 1859 in northern Italy). Aniline blue, violet and green followed quickly. At the International Exhibition held in London in 1862, fabrics dyed in the new colours were given a great welcome and were considered a 'victory parade for the English dyestuffs industry'. Professor Hofmann described the beautiful silks, cashmeres and feathers so brilliantly dyed and shown next to samples of 'the black, sticky, evil-smelling, semi-liquid substance . . . a very troublesome by-product of gas manufacture . . . gas tar', and he expressed confidence that all shades formerly obtained from vegetable and animal sources would in future be obtainable from tar.

DYESTUFFS TODAY

This is a suitable point at which to describe, in a general way first of all, the main groups or classes of dyestuffs, all of which are in use today. Some, like the basics for instance, are far less used now than about twenty years ago, but the disperse dyes have a greatly increased use owing to the development of synthetics and their application in transfer printing, developed in the last ten years.

Basic dyes

These dyestuffs, the first coal-tar colours developed by Perkin and Hofmann, are very pure and brilliant on animal fibres, particularly on silk which absorbs them freely in a simple solution of water and acid. Unfortunately they have very poor all-round fastness properties and are used now only to a fairly limited extent for textile dyeing (sometimes for brightening shades), though they are still important for dyeing paper and leather. Basics were produced simply as a result of observing phenomena.

Mordant dyes

The great step forward in understanding came with the successful synthesis of alizarin, the colouring principle of the madder plant and therefore, as we have seen, a mordant dye. In 1868 Carl Graebe and Carl Liebermann, assistant and laboratory technician respectively to the famous chemist Adolf von Baeyer, were responsible for this synthesis. Alizarin orange followed in 1874, alizarin brown and alizarin blue in 1877.

In contrast, equipment used by Ciba-Geigy in the production of modern dyestuffs.

Mordant dyes have little or no colouring power of their own but in combining with metallic oxides form insoluble coloured precipitates (or colour lakes) on the cloth. The mordant (commonly acetate of aluminium, chrome or iron) has an affinity both for the cloth and for the dyestuff.

With the development of these dyes the centre of importance in the research field shifted to Germany and Switzerland and away from France and Britain. Mordant dyestuffs are not used much now except in highly specialized fields such as that of African printing. However, some years ago Durand & Huguenin (now Sandoz) brought out their *chrome dyes* – mordant colours based entirely on the use of a chrome mordant. These are simple in application, having very good wet- and light-fastness, but are duller in shade than acids. They are widely used for wool dyeing and also for printing on cellulose.

Acid dyes

From the understanding of the underlying principles of colour in natural substances it became possible to synthesize,

also to change and finally to create substances having no natural prototype.

The first was 'Bismarck brown' (1862), and in the 1870s and 1880s there followed many others, of which 'Biebrich scarlet' was a very successful rival for the natural scarlet dye traditionally produced from cochineal with tin mordant on silk and wool. Acid dyestuffs were obtained by the action of nitrous acid on a coal-tar derivative, and give very bright, pure colours on animal fibres. They are simple in application, and water-soluble, but must be applied from an acid medium. They vary considerably in their fastness ratings. Selected dyes are suitable also for use on nylon.

All the dyestuffs developed up to the 1880s were good for animal fibres and either, like acids, without affinity for cotton or, like basics, needing the mordanting of the cotton with tannin and tartar emetic. And of natural dyestuffs, only three were direct (or substantive) colouring agents for cotton: red (saffron), orange (annato), and yellow (Chinese turmeric). So, obviously, the discovery of the first coal-tar dye capable of colouring cotton directly, without the use of a mordant, would be of tremendous importance.

Direct dyes

In 1883 a Geigy chemist discovered 'sun yellow' by boiling a sulphonic acid with soda lye, but of greater importance was 'Congo red', discovered by a German scientist, Boettiger. Directs are water-soluble and suitable for a large field of cellulosic dyeing where high wet-fastness is not so essential. Latterly, greater fastness to washing has been achieved by various after-treatments. Directs are used for dyeing ground shades to be colour-discharged with vats.

Vat dyes

Probably the greatest triumph in dye chemistry was the production of synthetic indigo, because natural indigo was the most widely used natural dyestuff. It has been estimated that if synthetic indigo had not been developed, and if indigo had been produced by the original means, half of India would have to consist of indigo plantations to meet the present vast demand. About 300 brands of Bengal indigo alone were known in 1856.

But in 1880 Professor Adolf von Baeyer, professor of chemistry at Munich University, after many attempts succeeded in synthesizing indigo, and was awarded the Nobel prize in 1905 for his achievements. Unfortunately, however, when the patents were acquired by industry – by the Badische Anilin- und Sodafabrik (BASF) and Hoechst – it was found that although a perfect indigo dyestuff was possible the cost of the basic raw materials was prohibitive. Later developments at Zurich Polytechnic produced a more economic version and the days of 'King Indigo' were numbered. This dye was an indigoid vat dye.

In 1901 a German chemist, Bohn, discovered how to make the first fast vat dye, from anthracene. Named 'Indanthrene blue', it was the first of many anthraquinone vat dyes in a variety of colours. These vat colours are still the fastest dyestuffs made and are used wherever good light-fastness is required, as in high-quality furnishing fabrics in cotton or linen; or wash-fastness where high-temperature washing is needed to meet hygiene requirements – e.g. expensive sheets and pillowcases in top-quality cotton, or fabrics for hospital use.

As we have seen, a 'vat' dyestuff is one which will only be accepted into the fibre in a 'reduced' or 'vatted' form; when it is re-oxidized it is then fixed to the fibre firmly. Formerly, with the natural indigo, the reduction was achieved by fermentation using sugar-containing fruit, bran or bread or, as in an old Indian method, arsenic sulphide. But in 1869 P. Schutzenberger developed a cheap method of producing hydrosulphite, so that with the development of the anthraquinone vats the whole process became a much simpler operation – although only comparatively because printing with vat dyes still needs a great deal of skill and experience: they are not for anyone wanting an easy, quick, cheap job.

The basic principles of vat dye application can be summarized as:

1 Conversion of the insoluble vat dye into the soluble sodium-leuco form by reduction or 'vatting'
2 Absorption of the soluble reduced dye by the fibres
3 Conversion of the absorbed dye back to the insoluble state by oxidation
4 After-treatment of the dyed or printed material in a hot detergent bath to produce the true and stable shade with maximum fastness

The cloth is printed with a thickened mixture of the dye, a reducing agent (i.e. a substance which readily withdraws oxygen) and an alkali carbonate (usually potassium carbonate) or a caustic alkali. The commonest reducing agent is sodium sulphoxylate-formaldehyde (known by such trade names as Formosul and Rongalite). This is a compound produced when hydrosulphite of soda is treated with formaldehyde, stable in the air but decomposing rapidly on steaming; at that stage it is an extremely powerful reducing agent. Starch/tragacanth or British gum is used as a thickening, or Manutex of special grades, either alone or mixed with wheat starch.

Prior to steaming it is essential for the fabric to be stored dry and at low temperatures; this makes vat dyestuffs rather difficult to use in hand screen printing, where it is often impossible to avoid the cloth lying on the print table in the warmth of the print room for considerable periods between the printing of different colours of the design.

Reduction is induced by the passage of the cloth through a steamer or 'ager' but this passage must be air-free. To

develop the full colour, the cloth must then be passed through a bath containing dilute sodium dichromate solution (or more usually now hydrogen peroxide, which is more expensive but less dangerous) and then a boiling soap solution.

Because the Formosul also discharges, or takes out, dyed grounds (e.g. direct-dyed) as well as acting as a reducing agent for the vat colour, vats are much used as 'illuminating colours' (those added to a discharge paste which colours the cloth at the same time that the dyed ground is being discharged).

In 1931 Ciba (now Ciba-Geigy) made the first vat dyes in micro-powder form, with a view to making their application more economical. The expertise required to produce fine divided dyestuffs has also been applied to other classes of dyestuffs.

Although the consumption of vat colours has gone down somewhat in recent years in relation to other dyestuffs – partly because of the development of reactives and also because of the far higher percentage of man-made fibres being produced and therefore being printed – the level of consumption has now probably stabilized. Vats are still extremely important for the markets already mentioned.

Solubilized vat dyes

In 1922 Durand & Huguenin of Basle were successful in producing indigo directly in the fibre – Indigosol O. This was a new and stable sulphonated derivative of indigo and was very easy to apply to both vegetable and animal fibres in a neutral or alkaline state – it was in fact a water-soluble vat. Shortly afterwards Scottish Dyes introduced Soledons, which were solubilized derivatives of their anthraquinone vats trade-named Caledons. These can be applied in a similar way but have a strong affinity for cotton, and this can make difficulties. They are applied mainly by the nitrite process in which sodium nitrite is added to the printpaste and then the printed cloth is developed by passing it through a bath of dilute (2 per cent) sulphuric acid at 70° C (158° F). These dyes are very useful in places – such as schools – where there is no steaming equipment, as long as a strict control is kept over the use of acids.

Metal-complex dyes

In the early years of the twentieth century Professor Werner of Zurich, investigating the properties of metal atoms, discovered that during the mordant dyeing process the synthetic and natural colours join with the metal which is the central atom to form complexes in the textile fibre. From this discovery came the idea of building the metal into the mordant colour, so shortening the dyeing and printing processes considerably. Many types of metal-containing (metal-complex) dyes resulted. There are two types – those applied

from a strongly acid medium, and those from a weaker acid or neutral. These are now much used for silk and wool printing and dyeing.

Azoic dyes

These were pioneered in the 1880s by Robert Holliday of Huddersfield when he managed to dye cotton red by first padding it in beta-naphthol and then treating it with a diazotized beta-naphthylamine, but it has taken many years of development to reach today's standard. Unlike other colouring matters the azoics (or ice colours) are not prepared as dyestuffs but have to be produced directly in the fibre by the combination of their constituent parts. Peter Greiss, in 1858, discovered not only that certain organic compounds are characterized by the presence in their molecules of two atoms of nitrogen bonded together, but also the diazo-reaction by which this pair is introduced into compounds. These discoveries led to the industrial synthesis of azoic colours. The oldest are beta-naphthols such as 'Para red' and 'Naphthylamine Bordeaux'. The red was as bright as Turkey red and the others brighter than the alizarin colours. There are several methods of application, but the simplest is the treating of the cloth with a naphthol solution and then printing with a diazo solution.

Beta-naphthol had only a little affinity for cellulose fibres and so it had to be dissolved in caustic soda. In 1912 the Greisheim Elektron Company in Germany discovered that it could be replaced by Naphthol AS and now it is possible also to print with specially stabilized products containing both the Naphthol AS compound and the diazotized base so that on steaming the two components couple as previously described. These dyes are much used in African printing.

A very important characteristic of any dye is its solubility in water – although there are organic solvents also. It is possible to increase or give water-solubility by treating the dye components with concentrated sulphuric acid, producing sulphonic acid groups.

Disperse dyes

With the development in the early 1920s of acetate rayon, a great deal of difficulty arose when it was found that the new fibre had very little affinity for organic compounds soluble in water. Coloured substances were known which had substantivity for cellulose acetate but they were not soluble in water, and to use basic or acid dyes made soluble in methylated spirits or acetic acid was not practicable. The solution of this difficulty led to a new principle of dyestuff application. It was found that, contrary to all beliefs held up to that time, it was not in fact necessary to make a dye water-soluble for it to be absorbed by the fibre, but that a very fine suspension or 'dispersion' of the colouring matter could be applied, and

afterwards the particles would dissolve in the fibre to dye it satisfactorily. This principle was discovered, and dyestuffs developed, by four British firms more or less simultaneously, producing the 'Duranols' of the British Dyestuffs Corporation (later part of ICI) and the SRA range (now no longer made) of British Celanese. This discovery by British chemists is one of the highlights of the development of dye chemistry and did a great deal to restore to Britain some of the initiative lost to Germany and Switzerland after the initial success by Perkin and others. The dyes (known until 1953 as 'acetate dyes') were in the form of pastes, the dye particles of which were uniformly dispersed in water with the help of Turkey red oil or other dispersing agents. Sometimes prints on acetate fibres exhibited a speckled appearance, due to the particles being too large. In 1954 Ciba introduced the first micro-disperse powders and pastes, using the expertise acquired with their micro-powder vat dyes. Although these dyestuffs were a tremendous breakthrough, without which the acetate rayon producers would have had little hope of increased sales, the fibre did not itself reach such great heights of popularity, and therefore production, as was hoped, and so it was with great delight that it was realised in the early stages of commercial nylon production (in the late 1930s) that disperse dyestuffs could be used to colour it. Polyesters, acrylics and other synthetics can also be dyed and printed with these dyes; sales improved enormously, making the sale of dispersing dyestuffs from various manufacturers in Britain in the 1970s 25 per cent of the total of all classes.

In the early days of disperse dyestuffs some of the colours faded badly but this has been completely cured over the years. Another problem was the tendency of some colours to 'sublime' – that is, to vaporize and transfer – when heated; but this defect has recently been used to advantage in transfer printing.

Modified basic dyes

In 1938 IG Farben (now Bayer) introduced a new range of dyestuffs known as Astrazones, capable of dyeing and printing acetate rayon – only this time they were water-soluble. These dyes were modified basics made soluble by the introduction of sulphonic acid groups. Since the end of the Second World War they have been widely used for the dyeing and printing of acrylic fibres, on which they give exceptionally bright shades of colours. They can also be used on modified polyamide and polyester fibres. They are cationic dyestuffs and for this reason the thickening must not be alkaline but rather neutral or slightly acid. They are freely dissolved but at the same time care must be taken to see that they are completely so. They can only be fixed by steaming and best results are obtained by a steamer of the 'star' type. Astrazones were followed by 'Solacets' (ICI), and 'Maxilons' (Ciba-Geigy).

Reactives

Since the discovery by Perkin of the first synthetic colour, many different principles have been used to create dyestuffs, but in none of these was the idea of chemically combining the dye and the textile fibre ever developed. However, for a long time chemists believed it to be possible, although as far as cellulose fibres were concerned they considered that the chemical change would cause irreparable damage to the yarn or cloth. A great deal of experimentation, therefore, went into reactions with wool fibre, but from 1933 onwards several patents were filed describing methods of producing coloured cellulose derivatives by 'esterification'.

In 1955 ICI were the first company to put cellulose-reactive dyestuffs on the market; these were named 'Procions'. They were soon to be followed by 'Cibacrons' (Ciba, 1957) and others. Research, being a complicated business, is usually carried out by teams of chemists working together, but the development of Procion dyestuffs was essentially the work of only two men, Professor Rattee and Dr Stephens.

The application of cellulose-reactive dyes is very simple: the dye, diluted in water, is mixed with thickening and printed in conjunction with an alkali. The dyes themselves have, in fact, very little affinity for the cellulose fibre. At first dilute caustic soda was used as an alkali, but later it was found that sodium bicarbonate was better for the purpose. The early fear that the reaction process would damage the cellulose fibre was completely unfounded, nor do they speed up the effect of light on the fibre. In fact it is claimed for them that they help to protect the cellulose fibres from deleterious photochemical action. By far the best results from these dyes are obtained on mercerized cottons, but any treatment must leave the fabric in a neutral or slightly alkaline condition or subsequent prints will be poorer.

One difficulty when they were first used was the fact that the dyestuff reacted not only with the cellulose of the fibre but also with the carbohydrate of the starch thickenings. This was the reason for the changeover to thickenings of the sodium alginate type or the use of emulsions or half-emulsions.

Another difficulty has been the fact that most reactive dyes are hydrolysed to some extent during application – to put it more simply, water reacts chemically on the compound to produce derivatives which can then no longer react with the cellulose. This means, in effect, that a portion of the colouring matter is unfixed and so after fixing by steaming or baking the cloth has to be very thoroughly washed in baths containing soap or detergent. Thus there is only about 70 per cent colour yield and, although the newest dyes show a marked improvement in fixation efficiency, washing off is somewhat of a problem. It needs to be carried out very vigorously and thoroughly and the cloth must pass through a number of baths and rinses; cottons are often rope-washed.

Reactives display a strong tendency to appear perfectly washed but, if the cloth is hung up, surplus unfixed colour will creep down the cloth and will stain quite strongly if allowed to dry on. However, because the dyes do have a very low affinity for cellulose this should wash out easily. All the later research therefore has been towards the production of dyes which have less and less affinity for the fibre and higher rates of solubility.

The chemical reaction with the fibre only occurs at temperatures of 70–100° C (160–212° F) and, as we have seen, in the presence of alkalis this can be achieved by dry heat (baking) or by steaming.

In 1957 the original Procion colours were added to in number and a range known as 'Procion H brands' was developed, which were more stable. In 1959 ICI produced a range of reactives for nylon, called 'Procinyls', and in the 1960s they and Ciba introduced 'Procilans' and 'Cibalans' respectively for wool fibres.

For a student, reactive dyes are very simple to use; they can be fixed, in the absence of baking or steaming equipment, by careful dry-ironing or by hanging in a warm room for a period. However, they are expensive – about halfway in price between vats and directs; they also have a limited shelf life.

Theoretically, the use of reactive dyestuffs makes possible the very highest degree of fastness to washing and friction and they have become a most important class of dyes, at present unsurpassed for women's dress cottons.

Pigments

To quote the *Review of Textile Progress 1971*:

Pigments are molecular aggregates, insoluble in the media to which they are subjected during application and use. They have no substantivity for the fibre and in pigment dyeing and printing their fixation is achieved by the use of a binder which encloses them and provides a bond between them and the fibre.

The most important textile pigments in the nineteenth century were chrome yellow and orange, Guignet's green (oxide of chromium), ultramarine blue (with the pink, green and violet derived from it), vermilion, sienna, umber and ochre. The earth colours were used in the block-printed linens executed in the Rhenish monasteries in the tenth to fourteenth centuries (the metallic prints being gold or silver leaf pressed on to adhesive) while some of the others, like the chrome yellows, were treated to make them soluble and used as dyes in the first half of the nineteenth century. Formerly, pigments were steamed for about an hour. In 1927, Henri de Diesbach, a professor at Fribourg, prepared an organic compound containing copper and produced an intense blue colour which was highly resistant to chemical

reagents. Six years later, further research was carried out at Imperial College, London, and in 1934 ICI brought out 'Monastral Blue' and IG Farben 'Heliogen Blue B'. This colour was applied either to man-made fibres by addition to the spinning solution in finely dispersed form, or to any textile material with thermosetting resins as binders; it is fast to washing.

There has been a considerable increase in the use of pigments, in Britain at least, over the last 8–10 years, partly because of the very high production of polyester and polyester/cotton cloths. Polyester has been difficult to dye and print, and needs high-temperature steaming; also, in Britain, polyester/cotton is used a great deal for wide-width printing of household textiles. This entails a heavy outlay of capital on new, large, flat and rotary screen printing machines, and the use of pigment systems obviates the necessity for wide-width steaming and finishing equipment, thereby cutting down on another large item of expenditure. Much experimentation has therefore been carried out to develop better binders, and auxiliaries such as softeners. Pigments are very light-fast, but owing to the establishment of more realistic standards related to end-use, they are now able to meet most relevant wash and rub-fastness demands adequately. The thermosetting resin binders are polymerized by heat and the colour is trapped inside a thin film, so the ultimate fastness of the pigment print is entirely controlled by the ability of the resin to resist abrasion: formerly these resins tended to break up very quickly indeed, and mark off on to other parts of the cloth in any sort of rubbing test.

In Great Britain and in Europe, pigments are used in conjunction with oil-in-water emulsions, because a thickening is needed, as it is with dyestuffs, but in the USA water-in-oil types are favoured (e.g. in Aridyes), which means that screens and rollers have to be cleaned in solvents of the white spirit type, not with a water wash. Before the development of emulsion thickenings for use in dyestuff printpastes, cellulose or alginate thickeners were used as pigment thickeners too, and greatly added to the stiffness of handle because they were partly retained in the fibre. So the adoption of emulsions in the 1950s was another reason for the further gradual increase in the use of pigment systems.

A few years ago concern for the pollution of the environment by industrial effluents brought about the banning of the use of hydrocarbon solvents in West Germany, and this concern is likely to result in similar laws in other countries. This is one of the reasons for the development in the last year of aqueous pigment printing systems. As well as colour, thickener and binder, many other ingredients are included – dispersing agents, softeners, catalysts and retarders – and the latest products are designed to do several jobs and thus to make application simpler.

As well as direct printing – which is by far their most important application – pigments are being promoted for

use in resist printing under reactives and aniline black. Using a pigment printing system is the only way to print matt (paste) white and colours, and metallic effects.

Because more and more cloths are now being made from mixed fibres – polyester/cotton, acrylic/linen, polyester/ wool and so on – the most recent development in dyestuffs has been the production of mixed dyes. Thus BASF have brought out their 'Cottestren' vats and disperses for use on polyester/cotton, and Hoechst their 'Remaron' line for dyeing and printing polyester/cellulose and polyester/wool blends.

As well as blended dyes, the dye manufacturers produce selections from classes of dyestuffs for particular uses. Among the acids, for instance, ICI have 'Nylomine Acids' for nylon, and Hoechst their 'Lanaperl' for polyamide fibres in general.

The latest and most important of these is the new ICI reactive/disperse product which is highly successful for the printing of difficult polyester/cotton. The dyes require the usual steaming under pressure but in addition are subjected to a caustic treatment which ensures a completely clean white.

Dyeing cloth at the Gobelins factory. From Diderot's *Encyclopédie*.

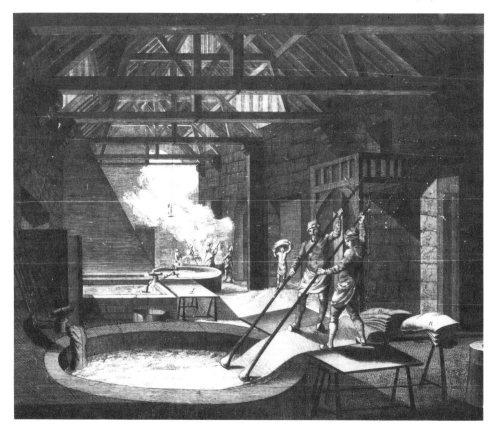

CLASSES OF DYESTUFFS

CLASSIFI-CATION	FIBRE	CIBA/GEIGY	ICI	BAYER	HOECHST	SANDOZ	L.B. HOLLIDAY
Reactive	Cell Wo	Cibacron Lanasol	Procion	Levafix Verofix	Remazol Hostalan	Drimarene	
Vat	Cell	Ciba/Cibanone	Caledon	Indanthren	Indanthren		
Solubilised vat	Cell		Soledon (discontinued late 1976)	Anthrasol			
Disperse	CA CT PA PAC	Cibacet Terasil	Dispersol (not PES)	Resolin	Samaron	Foron Artisil	Supracet Polycron
Modified basic	PAC	Maxilon	Synacril	Astrazone	Remacryl	Sandocryl	
Chrome	Wo Cell	Eriochrome	Solochrome	Diamond Chrome	Salicine Chrome		Chrome Diadem Chrome
Azoic	Cell			Many names	Fast colour bases and salts also Variamin Azanil Intramin		
Direct	Cell	Caprophenyl Diphenyl Solophenyl	Chlorazol Durazol	Sirius Benzo	Diamin	Solar Chloramine	Suprexcel Paramine
Acid	Wo NS	Cibacrolan Erio Eriosin Irgamol Neopolar Polar	Lissamine Coomassie	Supranol	Anthralan		Cyanine Elite Merantine Superlan Alizarin
	PA	Erionyl Tectilon	Nylomine Acid		Lanaperl	Nylosan	Elbenyl
Pigments	all			Acramin	Imperon	Printofix	

Key CA – secondary acetate; Cell – cellulosic; CT – triacetate; NS – natural silk; PA – polyamide; PAC – acrylic; Wo – wool.

Since this volume was first published in 1978, many dyes are now no longer obtainable due to environmental concerns as well as production difficulties.

4 Solvents, assistants and fixing auxiliaries

These are known collectively as textile auxiliaries – products which help the printing process. Traditionally, as we have seen, a great variety of natural and synthetic products were used as assistants in dyeing and printing. Today, however, not only are basic ingredients used such as acetic acid, sodium bicarbonate, caustic soda, urea, Glauber's salts and glycerine, but textile chemistry research and development have produced such a multiplicity of trade-named manufactured products for use in printing recipes that it is impossible for anyone who is not a qualified dye chemist, working in the laboratory every day, to be familiar with even most of them – and I suspect that works chemists themselves sometimes get rather confused! For those seeking clarification the *Index to Textile Auxiliaries*, produced every two years since 1967 by the Textile Business Press Ltd, is a valuable source of information. While industry needs every product which will in some manner assist in the making of a more perfect printed or dyed cloth, from a college standpoint it is often possible to dispense with some of the more sophisticated ingredients. A simple, short list of those appearing in the recipes, with their functions, will be found on pp. 89–91.

SOLVENTS

As well as dissolving the dyestuff in water, usually hot or even boiling (as in the case of direct and acid colours), or an acid, it is often necessary, or at least helpful, to assist the dyestuff into solution by pasting it with glycerine or by adding such ingredients as urea, or a trade preparation such as Solution Salt SV (ICI), Dissolving Salts A or B (L. B. Holliday) or Glyezin A (BASF).

Glycerine and urea are both hygroscopic and so they are also used to attract moisture in steaming when this is needed.

WETTING-OUT AND LEVELLING AGENTS

It is also often necessary to include auxiliaries which act as wetting-out agents. These ensure that in the printing of man-made fibres, for instance, which resist the intake of

Opposite, above: Technical literature from Ciba-Geigy. *Opposite, below:* two pages of dye records.

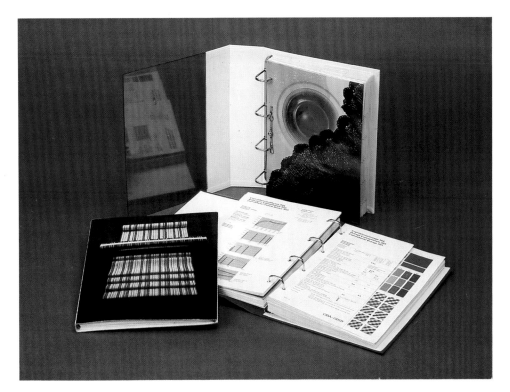

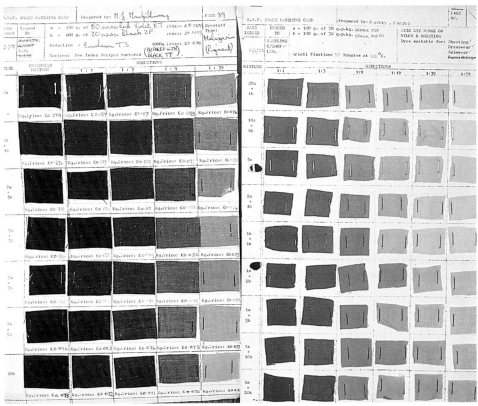

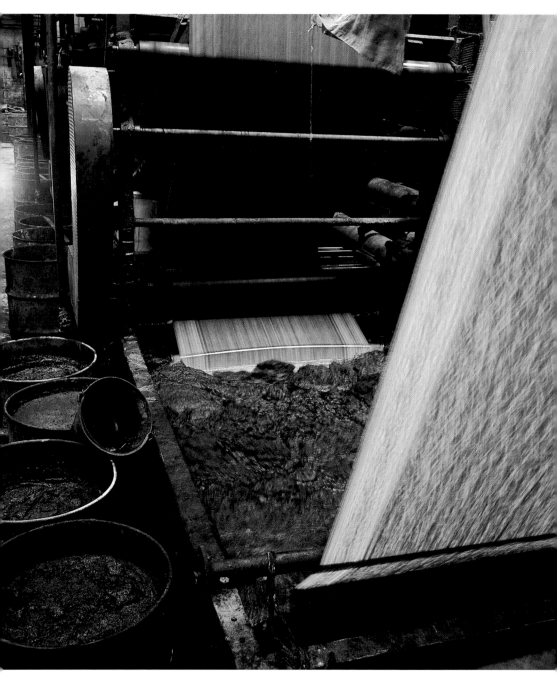

The indigo vats: the fabric moving
through the dye.

moisture, and of other cloths which may perhaps be tightly woven or difficult to penetrate for other reasons, a good penetration of dyestuff is achieved. Such products as Perminal KB (ICI), Silvatol (Ciba-Geigy), and Glyezin A are used for this. Some products (Glyezin A is an example) achieve penetration by means of fibre-swelling; this product, like many others, has several different functions and therefore can be used in a variety of ways.

The great developments achieved in the field of wetting-out and levelling agents before and after the Second World War stem from Turkey red oil, an aqueous emulsified castor oil which, as we have seen, was used as an oil mordant in the process which gave it its name. It was a wetting agent and has survived even though Turkey red work is no longer produced. For example, disperse dyes for many years were sold in paste form, the particles of colour being held in suspension in TRO.

If further discoveries were to be made in the field of assistants, it was necessary to understand washing and cleaning processes. It was realized that the dirt particles become enveloped by the soap molecules and then separate off the textile to be held in suspension in the washing water, but the molecules of the washing agent also act on the surface tension of the water, so making the solution penetrate the textile more easily – so the soap is a wetting agent. In the period 1923–27 cationic detergents were introduced, and cationic products with textile applications – e.g. softeners. The detergent effect of these new products is many times greater than that of soap and from them detergents with dyestuff affinity were also developed, such as the Albatex brands of Ciba-Geigy, which help to give more even dyeing and printing results.

FIXATION AUXILIARIES

As well as the necessary acids such as acetic and tartaric, and alkalis like sodium bicarbonate, there are now many special products – e.g. Luprintan PFD (BASF), and Invalon P (Ciba-Geigy) – whose functions aid speedy fixation without pressure, or assist in HT steaming while other auxiliaries make it possible to cut down fixation times to 40–60 minutes in thermosoling. There are special products which prevent loss by reduction (e.g. Ludigol), and in pigment printing such ingredients as retarders, softeners, catalysts etc. Reference to specific functions will be made later, in the recipe pages. The principal textile auxiliaries, their functions and their producers are shown in the table below.

LIST OF AUXILIARIES

The suppliers shown (in abbreviated form) in the third column are, for the most part, world-wide organizations,

and their local addresses or representatives should not be hard to find. Where no supplier is shown, the material can be obtained from a general chemical supplier.

chemical or trade name	main function	producer
Albatex (grades)	levelling and penetrating agents	CG
alum (aluminium sulphate)	mordant	
acetic acid	solvent and dyeing assistant	
ammonium oxalate	acid donor in printing	
Anthraquinone powder (paste)	discharge accelerator	BASF
Calgon	sequestering agent	A&W
Diphasol EV	emulsifier in producing emulsion thickening	CG
Dissolving Salt A (or B)	dispersing agent for printing	LBH
ferrous sulphate	mordant	
Formosul	reducing agent	A&W, ACC
Glauber's salt	dyeing assistant	
glycerine (glycerol)	solvent and hygroscopic agent	
Glydote B	solvent	BASF
Glyezin A	solvent for printing	BASF
hydrogen peroxide	bleaching and oxidising agent (vat dyes)	
Invalon P	carrier for dyeing polyester and polyamides; also fluorescent whitener	CG
Irgalon	sequestering agent	CG
Leonil PAT	develops efficiency of OBAs and controls bleeding in special print styles	H
Levapon (grades)	wetting, scouring and dispersing agents	B
Lissapol (grades)	detergent and wetting agents	ICI
Luprintan ATP	combination of products: fixation assistant, and improves colour yield of disperse dyes in printing	BASF
Ludigol	prevents reduction	BASF
Monopol Brilliant Oil	stabiliser for naphthol dyebaths and softener	S
Naphthol	modified β-naphthol, coupling component for azoic colours	H
potassium bichromate	oxidizing agent (vats)	
Perminal wetting	wetting and penetrating agent	ICI
Remol (grades)	dyeing accelerator	H
Resorcinol	solvent or swelling agent, to give increased colour yield	LBH
Redusol Z	reducing agent for discharge printing	A&W, ACC

ACC	Alliance Dye and Chemical Co. Ltd
A&W	Albright & Wilson Ltd
B	Bayer
BASF	B.A.S.F. (Badische Anilin- und Sodafabrik)
CG	Ciba-Geigy Ltd
H	Hoechst
ICI	Imperial Chemical Industries
LBH	L. B. Holliday Ltd
S	Stockhausen

chemical or trade name	main function	producer
Resist Salt C	prevents unwanted reduction	CG
Rongalit C and FD	reducing agents for direct and discharge printing	BASF
sodium bicarbonate	alkali used in reactive dye printing	
sodium carbonate	alkali used with vat dyes	
sodium chloride	dyeing assistant	
sodium chlorite	bleaching agent	
sodium hydroxide (caustic soda)	mercerizing, and as alkali with azoics. Wet fixation of reactives	
sodium hypochlorite	bleaching agent	
sodium phosphate	used with direct dyes to aid fixation	
Silvatol	wetting agent and detergent	CG
Solution Salt Special H	solubilizing agent and detergent	
Solution Salt SV	solubilizing agent	ICI
stannous chloride	discharging agent	
tannic acid	mordant	
tartaric acid	acid resist and used in print-paste where non-volatile acid required	
Ultravon (grades)	washing-off disperse dyes, also emulsifying and dispersing agent	CG
urea	solubilizing agent	

THICKENINGS

When calico printing began in western Europe in the latter half of the seventeenth century and the early years of the eighteenth, one of the many problems faced by the printers was the vagueness of their knowledge of the thickening agents obviously required if they were to block-print the mordant satisfactorily on to the cotton cloth before 'maddering' (immersing in the madder dyebath). The earliest prints were, of course, resists (in paste form) under indigo dyeings and so the problem did not arise, but once they started to experiment with the Indian 'mordant dyeing' technique difficulties arose not only because of insufficient knowledge and understanding of the use of the dyes and mordants involved but also because of a complete lack of experience of thickening agents.

Because the intricate floral and animal forms of the Indian palampores were painted by hand (tiny internal details being reserved in wax) on to cotton so perfectly prepared they did not need to thicken the mordant, only to tint it slightly with a little fugitive colour to enable the worker to see the shapes he was painting. So European printers had no real precedents to follow. However, along with all the other richly varied products brought back from the Orient and South

America were many natural gums to add to the starch pastes made from wheat and potato, already known for culinary and other purposes, and the natural starches. And so in the eighteenth century printing was a trial-and-error process, with experiments in the use of various thickeners (still in use today) as well as research into dyestuffs and the nature of the mordants or 'drugs'.

By experiment it was found that by their action on the mordant certain thickeners affected the final colour because of their acidity or alkalinity; others were difficult to wash out of the cloth afterwards, stiffening it and giving it a harsh 'handle'. Then again starches (or pastes) and gums served different purposes in use, for the printing of fine lines or bolder areas. Charles O'Brien, in *The British Manufacturers Companion and Calico Printers Assistant* (1792), put it precisely:

> For conveying these mixtures to the cloth various articles are necessary to be used according to certain circumstances; these vehicles are gums and pastes; paste, being of a more compact consistency than gum diluted, is used when lines or fine bodies or shades are required to be accurately expressed; diluted gum is more used in conveying solid bodies, in which no great accuracy of shape is required.
>
> Of gums, tragacanth has several advantages, and if properly managed, would distribute as well as the arabic.

In the nineteenth century there were recipes for gum Marone and paste Marone because the results were often different from each other. Although starch pastes were used much more for engraved roller printing, sometimes the same recipe used first gum and then starch for prints of different parts of the pattern, because gum gave paler tints than starch with acetate mordants.

The traditional thickenings – starches and gums – were used for about 200 years (till the 1930s) without any further developments except British gum (see below) being made. Most are still in use but often (e.g. powdered gum tragacanth) in a modified form which allows them to be prepared much more quickly and easily. They have been added to in recent years by starch ethers, locust bean flours, alginates, cellulose derivatives and emulsion thickenings.

Starch is a carbohydrate produced in plants from the sugar provided by photosynthesis. It is obtained in large quantities from wheat, rice and other cereals, potatoes, manioc roots, the pith of the sago palm, and other plants. Starch is insoluble in cold water, but when a suspension of it in water is heated the granules swell up to 100 times their original volume: this is a colloidal solution in which only part of the starch is in solution.

Wheat starch was of great importance in the textile trade for the stiffening of the fabric as well as being traditionally considered the best thickening agent for use in printpastes for engraved roller work, boiled up with a little vegetable oil. It is now little used.

Potato starch was often used to adulterate the more expensive wheat starch.

Cassava (also known as 'mandioca' or 'farine de manioc') is the pulp-dried and roughly powdered root of the tapioca plant, much used in places such as Indonesia in the production of resist pastes. Starches, often of the tapioca or maize type, are used a great deal in African printing.

The *natural gums* are products obtained as exudations from shrubs or trees – principally varieties of acacia – the most important of which is *gum arabic* (or gum Senegal). The purer qualities readily dissolve in their own weight of water to give a clear, light solution which keeps well and does not coagulate with the action of metallic mordants or tannic acid. Less pure varieties, of which there are now many, owing to the high price of gum, are often dirty and adulterated. To prepare for a thickening it is dissolved in cold water, the bits of chip etc. removed, and it is boiled in a double cooker for several hours. It is cooled, allowed to stand so that the sandy deposit settles, and then is strained and ready for use. (It is also supplied as a powder which needs no boiling.) Colours printed with a gum arabic base are very even and transparent but not so deep in shade as those printed with gum tragacanth or starch. Gum arabic was much used in the printing of natural silk because as well as the extreme purity of shade obtainable, the gum prevents the moisture content in the dye paste from spreading out by capillary attraction. (British gum is even better because as well as giving a clean printing edge this gum does not dry to such hardness; its ability to absorb moisture from the air prevents any danger of the fragile cloth cracking and tearing.) Gum arabic has a high solids content – made up at about 50 per cent.

Gum tragacanth (or Gum dragon) is obtained from slits in the bark of a leguminous plant, *Astragalus gummifer*, and in its old form was sold in white to yellow horny scales known as 'Devil's toenails'. These were dissolved in about 20 times their weight of water for about 24 hours and then boiled in a double cooker for several hours more, during which time the mucilage became smoother. Nowadays it can also be obtained in powdered form, which can be dissolved in water and used without 'cooking'. A very much used thickener was a starch/tragacanth combination aimed at getting the best qualities of each.

Dextrins and British gums: although all starches are similar some of them, such as that obtained from maize or rice, gel much quicker than, for instance, potato starch. This coagulation can be accelerated by acids and retarded by alkalis (a fact very important in the choice of thickenings). Although starches give high colour yields they are not as stable as natural gums and they are not so easy to wash out of the cloth. So about 150 years ago, dextrin, or 'British gum' as it was called, was developed. This was made by pre-treating the starch made from wheat or maize with acid, followed by

roasting at varying temperatures. A variety of qualities thus resulted, which were suitable for different uses: the product was more 'gummy' and had better levelling properties and was easier to wash out, but because of its reducing properties it was not possible to use it with certain dyestuffs. It is an important product still: Amisol is a maize British gum which is converted by an extended dry roasting, influenced by a trace of hydrochloric acid (virtually eliminated during roasting).

Until the 1930s very little thought was given to improving the means of carrying all the new dyestuffs on to the cloth. It does not seem to have been fully realized previously how much of the quality of the finished print depended for its success on the qualities inherent in the thickening. The depth of shade and its cleanness and brightness, the sharpness of outlines, the fineness of line detail, the level quality of bigger areas of colour or of the 'blotch', the lack of any trace of 'bleeding' – all are almost entirely dependent on the type of thickening agent used. In view of this, it is surprising that so many years elapsed without research into ways of making better thickeners. But in the early 1930s two new thickeners appeared: 'Solvitex', a cold-water soluble starch, and 'Nafka crystal gum', a refined gum product soluble in cold water.

Solvitex (or Solvitone) is a modified starch which dissolves perfectly when sprinkled into cold water while stirring. If left standing for about half an hour it is ready for use; if, however, it is to be used with starch it must be boiled. Thickening made from Solvitex is smooth and gum-like, may be kept without detriment for long periods, and is suitable for all dyestuffs.

Nafka crystal gum is a very good substitute for gum arabic. It has three or four times the thickening power of gum arabic, dissolves easily in cold or warm water and is quickly ready for use. It has no impurities and makes a very smooth, even thickening, suitable for all dyestuff ranges except azoics and chromes. Because Nafka is so easily soluble it is good for fine and delicate silks and artificial fabrics as final washing out is easy; it went far in replacing gum arabic for use with silk.

Postwar developments

During the 1950s and 1960s great changes came about in mechanical printing methods with the introduction of flat and rotary screen printing. Also there were great developments in the field of man-made fibres and the changes in dyestuffs necessitated by these, followed by new developments for cellulosics (the reactive ranges). Each of these changes, and the research carried out immediately before and during the war, have occasioned changes in the type of thickening agents in common use in recent years.

At present (although actual figures are not available), the shift has been away from the use of natural starches – traga-

canth, and other natural gums, dextrin or British gum – though these are still quite widely used, to the now more popular semi-synthetic derivatives of starch such as carob (locust bean), gum ethers and the increasingly popular alginates. These were joined by emulsion or half-emulsion thickeners which in some countries are already on the wane (or banned) for environmental reasons. At the time of writing these have been banned within the Tootal organization because of the explosive risk of white spirit.

With more research into the nature of thickenings and the jobs they do, a great deal of extra information is available. Aside from the traditionally recognized and obvious necessity of having a thickener in order to ensure that the dyestuff does not spread beyond the confines of the desired shape or line, and recognizing also that the thickening must not interfere with or change the constituents of the printpaste while carrying these constituents on to the cloth, qualities such as 'flow', coagulation and viscosity, percentage of solid content and suitability for wet-on-wet printing at speed have been found to be very important. Different thickeners release the dye to the fibre in different ways. The consistency, too, is important: whether it is 'tacky' or 'long', as gum, locust bean and alginates, or 'short', like starch/tragacanth and emulsions.

Alginate thickenings

Throughout history, seaweeds have been harvested for food and as animal fodder, and from the seventeenth century until the patenting of the Le Blanc process seaweeds were the main source of alkali in Europe, produced by burning the seaweed to make 'ashes'.

Except for the huge *Macrocystis pyrifera*, giant kelp, which grows to over 60 metres in length, the collection of the crop is all done by hand (for the industry in Britain the main areas are the Outer Hebrides and the west coast of Ireland). Many different elements are present in sea water and the tissues of the seaweed hold concentrations of these, some of which, such as alginic acid, do not occur in land plants. Although these discoveries were made as early as 1880 (by a Scotsman, E. C. C. Stanford), they were not commercially exploitable until about the 1930s, in the USA, and it was not until after the Second World War that they began to be fully used as textile thickeners.

The main reason for the sudden increase in the popularity of alginates in the late 1950s was the development of reactive dyestuffs; first in 1956 came the Procions of ICI; then in 1957 Cibacrons (Ciba), followed by Remazols (Hoechst) and Levafix (Bayer). These reactive dyes are fixed on cellulose fibres, in the presence of an alkali, by the formation of a chemical bond between the fibre and the dye. Reactive dyes, specially created to react to the cellulose of the cotton or other cellulosic fibre, will also react with many of the

carbohydrates traditionally used as thickening agents, thus forming very undesirable and insoluble deposits, difficult to remove, which leave the cloth harsh and with dullness in the colours of the printed pattern. Alginates such as Manutex (Alginate Industries) react little or not at all with the dyestuff and so are the most favoured thickening agent for the range. Although a controlled alkaline medium (usually sodium bicarbonate) is necessary to bring about the correct dyestuff reaction, the thickening itself should not be alkaline.

Among the main general advantages claimed for alginate thickenings are the following:

1 Solutions can be easily made with water, either by hand or with a high-speed mixer, and there is no necessity to sieve the paste.
2 There are a number of standardized grades which have different viscosities, making them suitable for a variety of different uses.
3 They allow the dye to penetrate deeply into the cloth and give smooth, level shades even when used to print large blotches.
4 These thickenings are easily removed from the cloth and even on delicate fabrics such as fine natural silk and wool do not affect the finished handle. Because the dried film is comparatively soft and pliable, it does not crack before the fixation treatment.
5 Alginates can be used with many dye ranges but are specially recommended for reactives, disperse, vats, acids, directs and pigments.

Locust-bean flours

Into prominence in the last few years have also come the locust bean (or carob gum) thickeners. The carob tree (*Ceratonia siliqua*) grows around the Mediterranean area and produces long sweet pods (the locust bean). The gum is extracted from the seeds and is chemically treated to make it soluble in cold water and resistant to fermentation. The correct grades of such products (Indalca, Meypro etc.) are very good indeed for silk and wool printing.

Cellulose derivatives

These thickeners are cellulose ethers made from purified cellulose of wood or cotton origin. Natural cellulose is partly amorphous, and partly a crystalline solid insoluble in water. If subjected to etherification the resulting products are soluble in water or other solvents. They are used, among other things, as thickeners for pigments; Celacol and Tylose are examples of cellulose derivatives.

Carragheen

This is a seaweed, also known as Irish moss. Its extract, marketed under the trade name Blandola, is pure, and soluble without the aid of chemicals. It gives good colour yields and is economical in dye consumption, especially for blotch grounds. It is not adversely affected by acids or alkalis.

CLASSES OF THICKENINGS

CLASSIFICATION	TRADE NAME	MANU-FACTURER	METHOD OF PREPARATION AND %	MAIN USES
crystal gum	Nafka	Scholten	cold or warm 33%	Natural silk and synthetics; disperse dyes. Good for rotary screen
	Karagum	Diamalt	cold or warm 33%	
burnt starch (British gum)	Amisol	CPC (UK) Ltd	warm 30%	Vat dyes, discharge printing; specially synthetics
	Diatex	Diamalt	cold or hot 30%	
modified starch	Solvitose	Scholten	cold or warm variable %	Vats and disperse dyes
	Solvitex			
locust-bean flours (carob seeds)	Meyprogum	Meyhall	cold or at the boil variable %	Reactive dyes, vats, acids, naphthols, modified basics; also for discharge work
	Indalca	Cesalpina		
	Printel	Ellis Jones		
alginates	Manutex	Alginate Industries Ltd	cold 4–10%	Reactive dyes (very important group); two-phase vat process; naphthols
	Lamitex	A/S Protan	3·5–10%	
Cellulose derivatives	Tylose	Hoechst	cold 2·5–6%	Used in wet-fixation treatment of reactives; component in pigment printpastes. Acid-resistant
	Celacol	British Celanese Ltd	cold 2·5%	Acid-resistant
	Natrosol	Hercules	cold 1·5–4%	Pigment printpaste component. Acid-resistant

5 From strike-off to finished fabric

In the normal course of events, when the colour chemist at a printworks has a new design to put into production, there will be no need to make decisions on the class of dyestuff or pigment to be used, or indeed on particular recipes, because most work tends to fall into regular categories. A printworks may be known for experience in the field of, say, pigment-printed polyester/cotton sheets or discharge-printed fine cottons, and therefore the particular cloth will have been test-printed many times and the problems of the cloth and the machinery will be well understood (although work and research are always going on with a view to improvements).

So the first job to be done is to produce a set of 'strike-offs' – cloth samples about $\frac{1}{2}$ m to 1 m square, printed in the colour schemes the converter has chosen or out of which he wishes to make a selection. These will be executed on a sampling machine (either engraved roller or automatic screen) or by hand screen and the job will thus be a fairly routine one with – probably – not many problems. If, however, the cloth is a new one, or one not conforming closely to those already used, or if the print is of a different style or is to be printed with a new machine, then obviously a great deal of preliminary testing work is involved.

A good printworks has a comprehensive sampling system, well catalogued, which is continually being expanded to provide as much helpful information as possible. Information from dyestuff manufacturers, in the form of pattern cards, data sheets and other technical publications, is put out in order to familiarize the customer with the information required for using the product concerned, whether dyestuff or textile auxiliary. These sheets contain descriptions of products, fastness data and recipes for general application, and also illustrate, by printed fabric samples, the shades available in the various classes of dye or pigment. Pattern cards, as well as showing the shade as printed on a particular fibre, give fastness ratings (see p. 181) and other details. Those for dyeing give yarn and piece dyeing information, while printed samples show the colours executed by screen and engraved roller. Dyes are illustrated in the sequence of the colour circle.

Usually, all the dyes in one class from a particular dye company have the same registered trade name, as 'Procion' for the reactives from ICI, 'Cibacron' (reactives from Ciba-Geigy) and 'Remazol' (reactives from Hoechst). But as well as the description – 'red', 'yellow' and so on – and the trade name, each dye also has code letters and numbers. Common codings (derived from the German words) are:

B – bluish	L – fast to light
G – yellowish or greenish	LL – readily soluble
R – reddish	T – dull

Numerals give an indication of colour intensity. If a dye is designated 5G or 6G, for instance, this means that it is greener than one with just 'G'.

Recently the codings have been getting a little simpler: where there were, a short while ago, several names within a range (possibly owing to amalgamation of companies) there have been strenuous efforts to tidy up the list and reduce the number of names within a class.

Finally, dyestuffs can be described as 'powder', 'paste', 'conc' (concentrated), 'extra conc' and so on. So we could end up with, for example, 'Remazol Turquoise Blue G conc', or 'Maxilon Yellow 6GL liquid 50%', or 'Caledon Violet 4R – FA Paste' (flash ageing).

The following code letters are used to denote the fibre for which the particular dyestuff is suitable:

C or Cell – cellulosic	PA – polyamide
W or Wo – wool	PAC – acrylic
NS – natural silk	PES – polyester
CA – secondary acetate	CT – triacetate

But detailed as all this information may seem to be, it is still insufficient for the works chemist. For instance, shade cards are usually issued showing each colour at full and half strength, often with little or no information on mixed colours. In order to have truly reliable information at his disposal, a good works chemist builds up his own reference files as he goes on, forming a very large collection of printed samples on the fabrics he normally uses, executed by the various machines at his disposal, and – very importantly – in his own printshop conditions. Although through training, force of habit or inclination, or through happy and successful contact with a particular dye company, he may take most of his dyestuffs from one source, he does usually make his own selection of colours of, say, the acid range from several manufacturers' lists; and so in the end, instead of a set of base colours at two strengths, he has on file many hundreds of shades and admixtures from numerous different sources.

Base colours are chosen for their usefulness and their economy in bulk, their easy availability and their keeping

Bulk mixing of printpastes. The standard mixtures are measured out from bulk containers to obtain the required final colours.

qualities. Works shade cards are prepared, for reference, giving the following information:

1 The base colours in five shades from 3 per cent downwards, e.g. 1:1, 1:3, 1:9, 1:19, 1:39*
2 Mixtures of these, very accurately executed, so that a gradual and subtle change can be seen throughout the sequence. (A sudden change would make for serious error in bulk mixing and show either incorrect proportioning or alternatively lack of compatibility between the dyes.)

Not much information is available from manufacturers, as we have seen, on mixed colours and so this is particularly necessary, not only from the colour viewpoint but because some colours within a class do not mix satisfactorily.

Local printshop conditions are the most important consideration of all: temperature, humidity, likely speed of processing, steaming conditions, washing and finishing treatments, all add up to a unique set of circumstances.

Also it is at this cataloguing stage that fastness testing is carried out, although these tests are also carried out on samples out of every wagon load of 1,000 metres of completed fabric leaving the works.

Preparing for bulk printing

A bulk mixing of all (or nearly all) the colours in the range the printworks uses is made – say 200 kg of each standard at 3 per cent. From these bulk standards, mixtures and reductions are made. The reason for the use of a stock thickening is to avoid the danger of ingredients being left out and to make processing as mechanical and rule-of-thumb as possible. If, however, there are any particular colours which are known to be awkward to keep (as some yellows, for example), these would be mixed when needed.

With particularly difficult styles, such as *devoré*, it would be absolutely essential to do full bulk production trials. It would be wrong to assume that, because it was possible to be successful with fairly small yardages, one could succeed in the production of several thousand metres. Styles like *devoré* require very critical timings, and obviously this needs to be planned for true production conditions.

As far as dress goods are concerned, with something like silk chiffon a good producer – and a fashion house too – would probably feel it was necessary to see more than the usual small strike-off, in order to be able to assess the correctness of colour and tone in more favourable circumstances.

Technical service departments

There is one other important source of technical assistance, and that is the technical service departments run by all the major dye companies. These departments are staffed by people, usually with wide industrial experience, whose job

* In other laboratories these steps might be 1:1, 1:3, 1:7, 1:17, 1:32. Alternatively, since metrication many authorities prefer to express all printpaste ingredients in grams per litre (g/l).

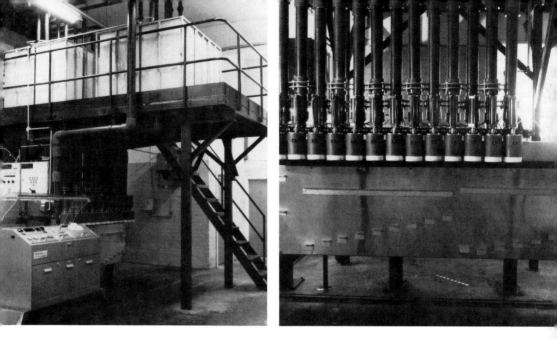

Left: General view of the Texicon Autoweigh T 200, developed by Tootal Ltd for the accurate, automatic mixing of printpastes in bulk; it has been in operation since 1976. A trolley mounted on rails stops at up to six valves for thickener and colour. A punched card with identification and colour recipe (by proportion) is inserted in the central panel and the total weight needed is indicated by pressing the appropriate button. The trolley automatically returns to the start position after completion. *Right:* close-up of the flow-control valves.

Automatic paste dispensing systems of which this Texicon was the first are in general use at this time – C.I.R. (Italy), Stork, and VanWyk (Holland) being the most used.

it is to endeavour to solve specific problems, either in their own laboratories or, more usually, at the works itself. There are a few, very small, new concerns who, in fact, rely on this service entirely for technical help, presumably being unwilling either to pay a chemist of their own or to accept the need for one.

STUDENTS' NOTEBOOKS

It is interesting to go back in time to the days when there were only natural dyes, and each printer had to work out his own recipes from the start, keeping them in his own invaluable notebooks. Possibly the earliest of these personal notebooks in existence is the *Livre de Fabrication de Jacques Stegman, coloriste*, who was born in Mulhouse on 24 November 1793, and worked for Risler & Koechlin in 1824 and also in Normandy. This extremely interesting document is preserved in the Musée de l'Impression at Mulhouse.

This seems a natural place at which to discuss the keeping of dye samples and technical notebooks by design students. Some colleges have highly qualified technical help, while others rely on assistance of only a semi-technical nature supported by the practical experience of the academic staff. Most students, given the opportunity to experiment, enjoy doing much of the practical side of the job themselves and

while all printed textile departments should have well-qualified technical teaching staff, interested in the design students' work and ideas, the staff should also be interested in helping students to develop as designers through the medium of practical work. There are, no doubt, a number of successful designers who have never interested themselves in practical printing work, but there are also many students whose work improves enormously once they learn to forget, for a time, the medium of paint on paper and to feel instead the qualities and textures of cloth, so that their later designs on paper become influenced by this. An interest, however elementary, in experimental printing techniques – sometimes new but often revived – and the qualities of fabric enhancement these can bestow, brings untold inspiration to the designer. And certainly one of the reasons for the interesting designs produced around Como and in Lyons is the close relationship between design studios and printworks, and the feedback of ideas this produces.

Testing procedures

The most essential feature of any testing is that one must first decide exactly what it is that one is testing – and then make strenuous and careful efforts to test exactly that. This obvious fact is often lost sight of.

A design student's main interest, naturally, is to obtain a correct colour match but then, often, many other considerations are forgotten which are of vital concern, neglect of which could radically affect the colour and the quality of the finished cloth: failure to wash and dry the sample correctly is one instance. So it is as well to bear in mind that simple testing concerns:

1 obtaining a correct recipe for the colour desired;
2 seeing that the printpaste is of the correct viscosity for the type of pattern to be printed and the weight of the cloth being used;★
3 finding the most suitable number of squeegee strokes needed;
4 printing any 'fall-on' colours (overprints) in the same sequence and under the same conditions as the final operation (used often in colleges but not much industrially);
5 seeing that the cloth is dried correctly and placed in the test steamer, suitably protected from condensation drops, and steamed (or baked or fixed in any other way) for the correct time;
6 seeing that the cloth is then washed as directed, is fast to this washing, and retains a clean white.

One of the major differences between testing in schools and colleges (I am not of course referring to industrial courses in textile technology) and in a printworks is the small amount of material usually available for testing – particularly of an expensive material such as fine silk, of which far more is

★ As a very general rule, only to be taken as a guide, in screen work fine lines require a slightly more viscous paste than a blotch, although one can bring about differences in line quality by alterations in viscosity. Fine cloths must not be printed with too 'runny' a paste or bleeding will occur. This aspect is, of course, very important in choosing the type of thickening to be used.

Cloth pinned down on the back grey. *Above:* correct tension. *Below:* too much tension bows the cloth between the pins.

needed for test purposes than of a plain cotton because it often needs to be seen in quantity, and draped, for the results to be assessed.

Because of this economy it is obviously necessary to plan carefully, and to extract as much information from as little wastage as possible. Initially, therefore, colour tests can best be done by printing simple rectangles on a small strip of the material, including overprints, and only when these are considered to be correct in colour and tone, finally using the actual set of screens to print a small sample in the manner of the final length – in other words, a true 'strike-off'. Just as a printworks prints several metres as a final trial before embarking on several thousand metres, so it is important for students to realize that even perfectly executed small-scale testing can give results different from those obtained from a final 5-metre length steamed in a larger steamer a day or so after drying, and subjected to rope-washing instead of hand treatment. In fact the near-impossibility of getting results in a test steamer identical to those obtained by steaming in bulk is the reason why many printworks do finally steam strike-offs in the large steamer.

Sequence of steps

1 Having decided (ideally, at the stage of making the positives) on the type of fabric, its quality, weight and – most important – its fibre, take a strip about 60–75 mm ($2\frac{1}{2}$–3 in.) wide and long enough to take prints of several colours, and then either pin it to a back-grey which is already gummed down on to the print table, or gum it down directly on to the surface of the table, whichever is to be the method ultimately used.

Small test steamer of the 'turret' type.

Arrangement inside the turret steamer. The sample of printed cloth is laid inside a piece of plain clean cloth, about 10 to 12.5 cm wide, and festooned over the strings.

*A reduction thickening is made by adding all necessary chemicals in correct proportion to the thickening agent.

2 Consult the manufacturer's shade card of the dyestuff class to be used, and decide whether the colour wanted is standard, or whether it can be obtained by mixing proportions of two or more colours at full or reduced strengths. This initial visual assessment of the dye or dyes required, and the likely percentages, should not be too difficult, particularly for design students who are used to mixing designer's gouache, inks and, latterly, Procions.

3 Mix 100 grams of the recipe decided on, and repeat for all the colours needed, unless there are simple tones, when quicker results are obtained by reducing with a reduction thickener* by a half, a quarter or any suitable percentage.

4 Print small, neat rectangles of each colour on the prepared strip of cloth, taking care to leave plenty of white cloth around the edge of the shapes. If colours are also to be used as overprints, when the first prints are dry overprint on a half of the initial shape.

5 After drying, the printed cloth must be fixed by steaming or baking. Laboratory steamers of various kinds are smaller versions of factory models, designed to simulate factory conditions as closely as possible. Some, for use in schools, are very simple and easily made. If a steamer is not readily available it is possible to steam samples adequately by laying the narrow printed strip of cloth inside a slightly bigger strip of plain cloth, rolling both up into a fairly loose tube, and inserting this into the neck of a laboratory flask half-filled with water which has previously been brought to the boil. It is essential to push the tube of fabric down far enough to prevent it from flopping over sideways, but not so far as to let the lower end get wet. The water must be kept boiling gently, and the correct time calculated from the first wisp of steam coming out of the top – *through the centre of the tube.* If steam issues from the sides, the cloth is not set into the neck of the flask tightly enough. If, on the other hand, no steam gets through, the roll is jammed in too tightly.

It is always necessary to protect any cloth being steamed from 'marking off', and plain cotton (or an old back-grey) is used for this purpose. Drips of condensed water will often cause trouble, too, and the printed sample of cloth must be further protected if the steamer is one which tends to cause this. However, in the effort to protect the cloth it is important to remember that the steam must pass evenly through the sample, and so it must not be too tightly fastened up. Examination of the sample when it comes out of the steamer is also important. It should not feel too wet, and if there are any bleed marks on it, showing that water has dripped on to the colour, that print at least should be discarded and another test made. A piece of cloth that has been in the steamer, or which has been washed, must never be used for a dye test.

6 Finally the test strip should be washed with as nearly as possible the same treatment as the final length will receive: thus reactives on cotton should be well rinsed in cold water, washed vigorously with several changes of very hot water

(90–100 °C, 190–212 °F) containing detergent, and finally rinsed. As the test will be hand-washed it is important to rub the sample well to simulate the later mechanical process of rope-washing, if this is to be used.

If all, or some, of the colours are satisfactory, these can be prepared in bulk in sufficient quantity for the yardage to be printed. If the colours are seen to be unsatisfactory on comparison with the original design, then a new sample of 100 grams is prepared in the same manner, incorporating adjustments.

It should be easy at this point for the student to see the value of keeping a careful record of recipes and sample prints from the start, and in this way building up a personal file of colour information which, particularly if there is no good technical help available, will be of immense value in learning and, for the future, in saving time.

A simple way to steam sample prints, suitable for dyestuffs whose steaming is not too critical.

There are those who maintain that it is of no real use to understand, by practical experience, the production of printed cloth. As a professional designer and teacher, not over-interested in handicraft textiles (a very different field indeed from small-scale exclusive production), I should say that there are two main and important fabric influences.

Firstly, after a design is sold and put into production, the result can be good either because it has been carried out exactly, in colour and style, as designed, or because it has been used in ways not foreseen by the designer but as visualized by an imaginative producer. Alternatively, it can be unsatisfactory either because it has *not* been carried out in colour and style exactly as designed, or because it has been used unaltered in ways not foreseen by the designer but as visualized by a producer.

The Werner–Mathis laboratory steamer.

Secondly, during a student's course he can have the opportunity – under technical guidance but not technical take-over – to exploit to the full the possibilities of design and fabric change and development by practical means: an opportunity which may not come again, but whose influence, if fully absorbed, will be of continuing value later on. At this point he has the ability and opportunity to make decisions himself. Incidentally, from both of these sources of fabric influence, the most disturbing, and therefore potentially the most enlightening, is the discovery that the design, unchanged from the paper idea either by oneself or by the producing firm, is very disagreeable on cloth and in use – a humbling but salutary experience! But his own practical knowledge may help him not only to be more imaginative but possibly in some cases to sort out his ideas into a simpler form, thus making them more practical to a producer.

The other extremely valuable outcome of practical work is the comparative ease with which one can learn to produce colourways – renderings of a design in differing sets of colours – and indeed this method is often used in industry instead of painting out colourways on paper in the studio.

The recipes in the chapters that follow are elementary and fairly simple. Like all 'outline' recipes for guidance only, they show some of the ingredients as variable, and it is for the user to formulate from them – and record – a precise recipe after due consideration of specific requirements: percentage needed, less or more water and/or thickening, whether moisture-inducing ingredients are needed such as urea or glycerine, and so on.

It is usual to combine the ingredients in the order given, that is, the dissolved dye and the other chemicals are stirred into the thickening. It is absolutely essential to ensure complete homogeneity and for this purpose it is best to use a high-speed mixer.

Earlier it was mentioned that in industry a 'stock' thickening is always prepared, so that only the dissolved colour (or the dye in powder form, as often with reactives) needs to be added. These standard preparations are then used in the mixed or reduced form. In colleges, however, the turnover – certainly in any one range of dyestuffs – is often not large enough or consistent enough to ensure that the thickening and its contents do not deteriorate, so the recipes are probably best mixed with a basic prepared thickening, with chemicals added at the time of making up the complete recipe.

Printing styles

There are four main styles of printing: 'resist', 'dyed' or 'mordant', 'discharge' and 'direct' – although there are (or were) a number of others, some no longer practised and some (e.g. flock, *devoré* and crimping) which will be described later.

These styles were listed in my *Manual of Textile Printing* in the chronological order in which they developed, whereas the one I am adopting now is that of their current order of importance. For many years (since the decline in use of the mordant range of dyes) the direct style has been the one most used, with discharge and resist work amounting to only a small percentage of the total output and being practised only by specialized firms, while the dyed (or mordant) style is virtually restricted to such fields as African printing.

Of course it is true that direct printing can be done very accurately these days, and even at considerable speed, by those printers who have a high standard of work, and certainly resist printing – and more particularly discharge – is more expensive to produce; nevertheless, imaginative designers and producers will always recognize that certain styles of design are more or less impossible to produce, or at any rate completely spoiled and changed, if one or other of these methods is not employed. One example of this is designs using fine, light-coloured line detail and light, bright colours on darker backgrounds.

One valid reason for studying the textiles of the past, and particularly those of the industrial era before the First World

War, is to observe the immense variety in styles of printing, the breadth of chemical knowledge, and the superb skills in engraving, and to note the effects these had on printed textile design. We are in very grave danger of losing the knowledge that was gained through so much hard work and study by not applying and developing it to our modern needs.

Perhaps matters would be helped if producers, instead of insisting that 'it can't be printed', would make a more careful study of the many beautiful fabric effects that have been printed in the past and could be printed again: designers would rejoice in this change of attitude. In this context it can only be helpful for students to learn something of other ways than that of direct printing by reactive dyes or pigments.

While writing this chapter I came across the following interesting support from a chemist. Dr Erich Fees wrote in *Melliand Textilberichte* vol. 2 (1970):

> There is one final reason why the knowledge of resist styles should not be completely lost; the thought training on the interrelated aspects of chemistry and coloristics provided by the resist technique is far more rigorous than that which other techniques provide. The outcome is a better familiarity with the dyes and chemicals, which then proves of use in the solving of other [print] problems.

Again, fabric producers are now at least realizing that the varied technical knowledge needed by printers for the African trade is extremely useful in helping them to achieve interesting fabrics for the European market.

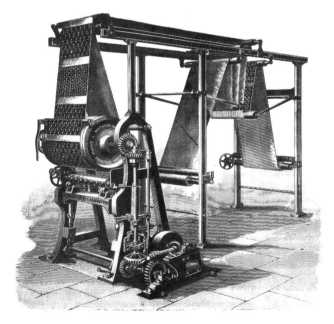

A nineteenth-century sample-printing machine by Mather & Platt.

6 The direct style

CELLULOSIC FIBRES

Woven and knitted cotton, linen or viscose cloths, unless, like organdie for example, so fine and transparent as to need a back-grey to absorb surplus printpaste, should be stuck directly on to the waterproof covering of the print table. A thin solution of gum arabic can be used for this (with the addition of 1 to 2 per cent of glycerine if the print room is likely to be very hot and dry) or, more often, a product such as Solvitose H.

Pour 1 part of Solvitose into $2\frac{1}{2}$ parts of cold water, stirring as you pour. Continue to stir until the solution is homogeneous, and leave it for about 15 minutes. For cellulose fibres it is usual to dilute further, to about 1 : 4. The adhesive is evenly and thinly applied by means of a squeegee and allowed to dry, which it does rapidly. The cloth to be printed should then be ironed down immediately, to prevent excessive drying out. It should be obvious that the ultimate success of the printing depends very largely on how carefully and firmly the cloth is stuck down. If it does not adhere securely, large areas of wet print may cause it to lift and contract, and colours subsequently printed will be thrown out of register.

It is because of this contraction (or alternatively stretching) that nowadays even very fine cloths are usually stuck down rather than pinned, to make control easier. Thermoplastic adhesives are often used and are much recommended for difficult fabrics. Knitted fabrics must be specially carefully treated because it is so easy to distort stretchy cloth. All fabrics must be laid down with the warp and weft parallel to the length and width of the table – 'on grain', as it is called.

However, if pinning is to be attempted, short T-headed textile pins can be obtained, or good-quality, fine steel dressmakers' pins used instead. These should be inserted at approximately 75 mm (3 in.) intervals, taking care to slide the pin along under the back-grey and to avoid damaging the table top. Pin the selvedges first and then the two other ends. Because most selvedges are woven more tightly, greater tension is needed along them in order to ensure that the body of the cloth is taut enough. A good test for tautness is to run the flat of the hand over the cloth from selvedge to

THE PRINCIPAL STYLES OF CALICO PRINTING, 1886.

PRINTED (DIRECT) COLOURS.

I.—STEAM OR EXTRACT STYLES.

(a) COAL TAR COLOURS.

Alizarin.—Reds, Pinks, Purples, Chocolates, Browns, &c. Galloflavine Yellow, Anthracene Blue, Orange, Anthracene Brown, Galleine Violet, Cerulein Olive, Gallocyanine Violet, Dinitroso-Resorcin Olive.

Basic Aniline Colours.—Magenta and Safranine Reds, Aniline Blues (prepared paste colours), Methyl Violets, Methyl and Direct Greens (Malachite, &c.), Methylene and Aethylene Blues, Auramine Yellow, Victoria Blue, Induline Paste.

Acid Colours.—Soluble Aniline Blues, Azo Colours, Eosines.

(b) DYEWOOD EXTRACTS (*Natural Organic Colouring Matters.*)

Logwood.—Blacks, Purples, Olives, Browns, &c.

Quercitron Bark.—Yellow, Orange, Combinations.

Sapan and other Red woods.—Red, Pink, Brown, Chocolates, &c.

Catechu.—Browns and Combinations.

Annatto.

Cochineal.—Pinks, Reds, Scarlets.

(c) STEAM MINERAL COLOURS.

Prussiate Blues, Chrome Yellow, Cadmium Yellow, Chrome Orange, Canarin (Persulphocyanogen) Yellow, Manganese Brown, Copper Phosphate Green.

II.—PIGMENT STYLES (*Fixed by Albumen*).

Vermilion Red, Ultramarine Blue, Chrome Green, Chrome Yellow, Chrome Orange, Olives, Browns, Buffs, Chocolates, Blacks, &c.

III.—OXIDATION COLOURS.

Aniline Black, Naphtylamine Puces and Greys, Phenylen and Toluylen Diamine Browns or Bronzes, Persulphocyanogen Yellow, Colours with Amines on Manganese Brown, Buffs, Cutch Colours, &c., Colours requiring Chroming for their development.

IV.—DIRECT INDIGO PRINTING.
ALKALINE STYLES.

China Blues, &c.

Artificial Indigo.

Glucose Process.—Blue and Red, and other possible combinations.

Alkaline Mordants.—Annatto.

DYED COLOURS.

V.—ALIZARIN DYED STYLES.

OLD MADDER STYLES (*Dyed on Printed Mordants, either Alumina or Iron, or mixtures of both*).

Reds, Pinks, Browns, Purples, Chocolates, Blacks.

MODIFICATIONS OF ALIZARIN DYED STYLES {
Reserved Styles.
Padding Styles.
Dyeing with Dyewood or Coal Tar Colours on printed or padded Mordants.
}

VI.—TURKEY RED STYLES *with Discharge.*

White, Yellow, Blue, Green, Black, on Red ground.

VII.—INDIGO STYLES *Dipped in the Vat. Designs produced by resist or discharge.*

White, Yellow, Orange, Green, Red, Olive, &c., on Blue ground.

VIII.—MANGANESE BRONZE STYLES.

White, Yellow, Blue, Green, Red, Black, on Bronze ground.

selvedge: if it is insufficiently stretched the cloth will be pushed up. But it is equally unsatisfactory to stretch the cloth too tightly, which will be shown by bowing of the cloth between pins.

The two main styles, direct and dyed, including subdivisions, as listed by Antonio Sansone in 1886.

Dyes

From the design student's point of view, *reactive* dyes are not only simple in application: they have a good and varied colour range, are fast to light and washing (even though washing off can sometimes be a little troublesome) and, particularly important, if steaming or baking equipment is unavailable, reactive prints can be fixed by simple dry ironing or by hanging in as warm an atmosphere as possible for a period of hours or days until tests prove reasonable fixation.

Direct dyes also are extremely simple to apply (and very much cheaper than other dyes), but do require a fairly long steaming time and careful cold washing.

Recipes for using *vat* dyes by both the 'all-in' and 'two-stage' methods are included although these dyes require even more skill and experience than reactives do for their successful use; and being very expensive and having such high light- and wash-fastness they possess qualities not usually

needed in student work. However, the methods of working are of interest, largely because they are used by all high-class producers of furnishing fabrics and bed-linen. An added difficulty from the student point of view is that the 'all-in' method, while being in essence like other direct printing methods, is not really recommended for screen or block printing because of the time-lags in these processes. Industrially it is the 'two-stage' technique which is used for these hand methods.

Reactive dyestuffs

Recommended thickenings are
 1 alginates, e.g. Manutex RS:

> 40–50 g Manutex RS
> 950–940 g cold water
> 10 g sodium metaphosphate (Calgon)
> _____
> 1,000 g

Agitate the measured quantity of cold water with the high-speed mixer and gradually shake in the Calgon. Then slowly add the Manutex, but fast enough so that all the powder will have been added before the viscosity has risen appreciably. Continue stirring for 5–10 minutes, until the particles are swollen and have formed a thick suspension. Allow it to stand about $1\frac{1}{2}$ hours.

If printing fine lines, particularly in wet-on-wet conditions, and also for level blotches, Manutex F is recommended, made at 10–12 per cent concentration.
 2 Locust-bean gums, e.g. Indalca, Meyprogum
 3 Half-emulsion, e.g. (using Manutex F):

> 600 g Manutex F stirred into
> 6000 g cold water
> 60 g Calgon

Take

> 3000 g Manutex (made up as above)
> 115 g Diphasol solution
> 975 g hot water
> 3750 g white spirit
> 150 g Resist Salt L

and stir in the high-speed mixer for about 20 minutes.
 The printpaste recipe is:

> 0.25–3 g dyestuff
> 10 g urea
> 30 cc hot to boiling water
> 50 g thickening (to which 2–3 g Resist Salt
> has been added)
> 2–4 g sodium bicarbonate
> _____
> 100 g

Dissolve the dyestuff and urea in hot water, after first thoroughly dry-mixing them together;* allow this to cool, and add it gradually to the thickening. Finally add the sodium bicarbonate, first crushing it to ensure freedom from lumps.

Alternatively – if a high-speed mixer is available – the water can be omitted and the dyestuff, urea and sodium bicarbonate added to the thickening while stirring (with suitable adjustment of thickening viscosity and percentage).

Print, dry and steam for about 8–10 minutes. Rinse thoroughly in cold water, followed by soaping at or near the boil with a detergent such as Lissapol ND (2 cc per litre). Finally rinse in cold water.

Alternatively the cloth can be baked at 140–150° C (285–300° F) for 5 minutes, or if nothing else is available it can be ironed (on the back of the cloth) for about 5 minutes. With either of these methods, doubling the urea content will give better colour yield.

Reduction thickening:

> 10 g urea
> 39–37 g water
> 50 g hot to boiling water
> 1–3 g sodium bicarbonate
> ———
> 100 g
> ———

Direct dyestuffs

Recommended thickenings are:

1 Alginates, e.g. Manutex RS. This is especially good for absorbent fabrics and simple designs.

2 Gum tragacanth 7–8 per cent; 70–80 grams of gum tragacanth powder are stirred into enough water to make up 1000 grams. Allow to stand for an hour or so to ensure an even swelling-out. Straining is usually unnecessary.

3 Etherified natural gums, e.g. carob seed, locust bean, Indalca (very economical), Meyprogum or Printel.

> 35–40 g Indalca S
> 965–960 g water

Add the gum carefully to the cold water under agitation from the high-speed mixer, taking care to avoid the formation of lumps. Then stir it for 15–20 minutes and, preferably, leave it overnight. Alternatively, Indalca can be mixed hot – in which case it is added carefully to the cold water while stirring, and then brought to the boil and simmered for 15–30 minutes, still stirring. Leave to cool to 50–60° C (120–140° F) without stirring (to avoid the introduction of air into the mixture). Indalca U types give better washability, but Indalca S is more economical on heavier-weight fabrics.

* This dry-mixing is particularly important with turquoise, as it aids solution.

0.5–3 g dyestuff
5 g urea
32 g hot to boiling water
60 g thickening
1 g sodium phosphate

———

100 g

Mix the dyestuff, urea and hot water together until dissolved, then add them to the thickening. Finally add the sodium phosphate. The mixture can safely be boiled before being added to the thickening, to ensure even solution, or if preferred the beaker of mixture may be placed in a container of boiling water and stirred until thoroughly dissolved.

Print, dry and steam for about 45 minutes to 1 hour. Rinse well in cold water only, as direct colours are not very fast to hot soaping. The fastness of the colours can be enhanced by passing the cloth through a bath containing 1–2 g per litre of Fixanol PN.

Basic dyestuffs

Recommended thickenings are:

1 Gum tragacanth – now available in pre-prepared powder form so that soaking and boiling-up are no longer necessary. Stir 70–80 grams of tragacanth powder into 1000 grams of water and allow it to stand for an hour or so to ensure an even swelling-out. Straining is unnecessary.

2 Crystal gum (e.g. Nafka crystal gum or Karya gum). This is used in a 20–25 per cent solution and can be easily made by scattering it carefully into cold or slightly warm water and stirring thoroughly. If possible, leave it for a few hours before use.

3 Alginates are not suitable for use with basic dyestuffs as they are liable to gel if the printpaste has a pH of less than 4 (i.e. if it is fairly strongly acid) – neither are those thickenings derived from locust beans.

Basic dyestuffs are little used now. The printpaste recipe is:

0.25–2 g dyestuff
5 g Glydote B (or glycerine or Glyezin A)
5 g acetic acid 30–40%
9–10 g hot water
70 g thickening
5 g tartaric acid 1:1
5 g tannic/acetic 1:1

———

100 g

———

Dissolve the dyestuff in Glydote B, acetic acid and hot water and add it to the thickening. Add the tartaric acid. Allow it to become cold before adding the tannic/acetic;* this needs to be added carefully while stirring.

* If not allowed to become cold, the dyestuff will be liable to precipitation owing to mordanting action.

112

To print basic dyestuffs successfully the printpaste must be kept acid during the fixation process. This is the reason for the inclusion of tartaric acid (a non-volatile acid), as the acetic tends to be driven off by heat.

Print, dry and steam for 40–45 minutes and then pass through a fixing bath (for approximately 30 seconds) containing 10 g per litre of tartar emetic at 50° C (120° F). Rinse and dry.

Tannic/acetic is made by dissolving equal parts by weight of dry tannic acid in acetic acid 25 per cent. Tartar emetic is a listed poison and must be so labelled. Powdered chalk in the proportion of 5 g per litre can be added to the fixing bath to prevent fabric damage by excess acid.

Vat dyestuffs (the 'all-in' method)

It is usual to make up an alkaline stock thickening first, using as a base gum tragacanth, British gum, Solvitose C5 or Nafka crystal gum.

> 80 g sodium carbonate
> 125–185 g Formosul
> 30–75　g glycerine, all stirred into
> 600 g thickening
> Bulk to 1000 g

Vat dyestuffs for printing are usually sold in paste form but, even so, give the best results when the required quantity is stirred into a very small measure of neutral thickening before their dispersion into the final quantity of alkaline stock thickening. The reason for this procedure is that 'specky' pastes often result from immediate contact with the alkali.

So the final mixture is made up:

> 5–15 g vat dyestuff pasted with
> 15–5 g thin British gum or other neutral
> thickening, stirred into
> 80 g alkali stock thickening
> ‾‾‾
> 100 g
> ‾‾‾

Pad-steam process

Provided that one has the use of a padding mangle and wants to produce only vat styles – not discharge or any other style using other classes of dyestuffs alongside – this method has many advantages in conjunction with the slow process of screen printing. Because the necessary chemical reagents are applied (after printing) by padding the cloth, it is possible to store it for any length of time before steaming. It is essential to use a thickening which is coagulated by alkali, such as locust bean or cellulose derivatives.

65 g wheat starch mixed with
900 g cold water. Stir, and add to this paste
10 g locust-bean flour (e.g. Indalca S60)
10 g ethanol

Boil the mixture for about 20 minutes, cool, and finally add

1 g acetic acid 40%
10 g mineral oil
Bulk to 1000 g

In order to make the thickening still more sensitive to alkali, 3 grams per litre of borax may be added.

5–25 g dyestuff paste is mixed with
25–5 g water
5 g glycerine. Then add, with constant stirring,
65 g stock thickening

100 g

After printing, the cloth is padded in a liquor which contains the alkali and the reducing agent. The alkali serves to coagulate the thickening and to dissolve the dyestuff, but it is also usual to include about 20 per cent of Glauber's salt or common salt to help to prevent bleeding.

100 g Formosol
50 g sodium carbonate and
100 g common salt (or Glauber's salt) dissolved in
750 g water

1000 g

After padding it is usual to steam the cloth immediately, without intermediate drying; this steaming should last for about 15–25 minutes in both methods of working.

The prints must be developed by washing in cold water and then be passed through an oxidizing bath consisting of 2 grams per litre of hydrogen peroxide and 5 grams per litre of acetic acid 30 per cent at 50° C (120° F). Finally the cloth must be soaped at the boil for 5–10 minutes. This soaping at the boil is an essential feature of the after-treatment of vat printing as it develops the depth of shade. (However, in the case of vat discharge prints on direct-dyed grounds, as described later, it does have to be abandoned in favour of a cold-water developing and lukewarm washing.)

PROTEIN FIBRES (SILK AND WOOL)

The sticking down or pinning of cotton or linen should be a fairly simple job, but silk particularly, because it is usually woven into fine and delicate cloths, often presents more of a problem. If it is open and transparent, like silk chiffon or georgette, a back-grey is absolutely necessary to absorb sur-

plus printpaste; in industrial practice these cloths are often gummed to such a backing before this in turn is laid on the print table. However, even fine cloths like 'Habotai' and foulard are far better stuck down directly without a back-grey, provided that the surface of the print table is in good condition, because silk tends to relax and stretch out when wet, drawing in again more or less as it dries. It follows that strong adhesion to the table has a far better chance of keeping the cloth in register than even the most careful pinning. If pinning is used it is essential to pre-print fairly large samples in order to observe the behaviour of the cloth under wet and drying-out conditions and thereby ascertain the tautness required. The same difficulties apply to wool but to a lesser degree.

'Grandex' gum, which is a quick-drying adhesive, is good for this purpose, either on its own or added to Solvitose H. (It is also suitable for synthetics.) Used by itself it should be dissolved in hot or cold water in the ratio of 4 parts of Grandex to 2–3 of water. Dissolved in hot water, it is ready for use in about 45 minutes (and needs to be stirred from time to time); in cold water 2–3 hours are needed. An even, not too thick layer is applied and as it dries quickly the cloth can be ironed down immediately. If it is further diluted it can be sprayed on.

Grandex gum can also be added in powder form (100–300 g) to the already prepared 20 per cent solution of Solvitose H and the best results are obtained by giving the table several very thin coats before ironing on the silk. Both these adhesives are easily removed from the table and the cloth with cold or warm water. If dyestuffs sensitive to reduction are used (e.g. reactives or disperse dyes in the case of synthetics), it is best to add 1 per cent oxidizing agent to the adhesive or the printpaste, for instance Resist Salt L (ICI), Ludigol (BASF) or Albatex (Ciba-Geigy).

Another recommended adhesive product is Solfarex A 115, but this has to be boiled in a 20 per cent concentration with the addition of 2 per cent sodium nitrate.

For both silk and wool printing it is essential that the thickening agents be easily removable from the cloth by cold or warm water, leaving a soft handle and no staining. Washing off direct and acid dyes is difficult because hot water cannot be used and staining of the ground is sometimes difficult to avoid, particularly with some of the bright colours. Starch-based thickenings are not good because they leave the cloth feeling very harsh to the touch. Traditionally, gum arabic was always the silk printing thickener, followed by the very good Nafka crystal gum. Latterly also locust-bean derivatives such as Indalca are being much used, and these are particularly good for 'fall-on' colours (overprints), which are used quite frequently in hand screen printed fashion silks and wools.

As far as fine silk is concerned it is very important that the thickening has sufficient solids content to enable the print-

paste to resist the capillary attraction of the fibres; gum arabic is extremely good in this respect. Its one disadvantage is that it tends to crack on the cloth and may damage it while it is being handled before steaming. Nafka combines in a unique way the better qualities of arabic with the less viscous character and lower solids content of the locust-bean derivatives. Conversely, some silk cloths, such as chiffon and georgette, because they are woven from tightly twisted yarns need to be printed with a wetter printpaste to avoid uneven and grainy prints.

Both acid and direct dyestuffs are suitable for silk and wool printing and both classes have colours which are difficult to bring into solution. This can be assisted with urea, glycerine, Glydote B or a proprietary product such as Solution Salt SV. Penetration can also be aided by wetting-out agents (e.g. Perminal or Silvatol).

It is important to remember that both silk and wool printed with acids and directs need saturated steam, but because silk is a lighter fabric it does not need to be conditioned by being hung in a damp atmosphere for several hours so that the dried cloth does not take too much moisture out of the steamer during that process. Industrially wool is often steamed between damped grey cloth, and this can reduce the steaming time to about 20 minutes instead of the 45–60 minutes otherwise needed for many colours.

Reactive dyestuffs can also be printed on silk and chlorinated wool; on the latter, sodium bicarbonate is not required, although in some instances the addition of $\frac{1}{2}$–1 per cent of sodium bicarbonate does give the best results.

Acid and direct dyestuffs

Recommended thickenings are:

1 Nafka crystal gum. Scatter 250–330 grams of Nafka crystal gum into enough warm water to make 1000 grams. Stir while pouring, and allow it to stand for a few hours.

2 Locust-bean derivatives such as Indalca PA30, of which 90–100 grams are added carefully to enough cold water to make 1000 grams. Agitate vigorously with a high-speed stirrer, taking care to avoid the formation of lumps. The thickening is then stirred for 15–20 minutes and ideally should be left overnight. The use of warm water makes for a more rapid swelling-out.

Alternatively, after careful mixing with cold water, the thickening can be brought to the boil and simmered, with stirring, for 15–30 minutes. Cool to 50–60° C (120–140° F) and then discontinue stirring to avoid air bubbles.

Indalca U/ST (18–20 per cent concentration) is specially recommended for excellent colour yield and brightness and for sharpness, levelness and penetration. If used with acid dyes of poor solubility the printpaste should contain 10 grams of urea, 8 grams of Glyezin A and 2 grams of phenol.

Printel FP855 and Printel FP860 are both good with acid

dyes – 855 especially for levelness and colour yield, and 860 for prints requiring good definition.

3 Gum arabic is still, in the first grades, unsurpassed for cleanness and brightness of shade, although very expensive. It should be prepared as a 50 per cent solution.

The printpaste recipe is:

 0.25–3 g dyestuff
 5–7 g glycerine
 25–20 g hot water
 60 g neutral thickening. To this can be added
 2 g wetting-out agent (e.g. Perminal) and either
 2 g ammonium oxalate (with acid dyes) or
 2 g sodium phosphate (with direct dyes)
 dissolve in water and bulk to 100 g

If difficulties arise in bringing the dyestuff into solution, 1–2 grams of Solution Salt can be added; alternatively, urea with Glydote B can be used instead of glycerine (these two having greater solvent action). If the printpaste is kept for any length of time the dye may come out of solution, causing a 'specky' appearance, especially in the paler shades. This can be avoided if, as well as the Solution Salt, the recipe is made up with 2–4 grams of Resorcinol with the addition of 1–5 grams of acetic acid and 1 gram of ammonium oxalate to the thickening.

After printing and drying (but not too fiercely), steam in damp conditions for 45–60 minutes.

Both wool and silk must be rinsed very thoroughly in cold water. The faster dyes (see manufacturers' shade cards) can be washed off in mild detergent such as Lissapol, 2–3 grams per litre at no more than $40°$ C ($105°$ F), with a final rinse in cold water.

Most acid and direct dyes will retain fastness only to four or five mild, warm washes.

Reactive dyestuffs

Basically the same printing recipes as for cellulosic fibres can be used on silk and chlorinated wool, with the one change that sodium bicarbonate is often omitted on the wool.

Thickening agents must of course still be alginates, such as Manutex F which has low viscosity and a high solids content, or emulsion or half-emulsion types.

The printpaste recipe is:

 0.25–5 g dyestuff
 10 g urea
 22 cc hot water. Stir this solution into
 30 g sodium alginate thickening (e.g. Manutex F)
 30 g emulsion thickening
 1 g sequestering agent (e.g. Calgon)
 1–2 g sodium bicarbonate (omit for chlorinated
 wool or reduce to $\frac{1}{2}$–1 per cent)
 ―――
 100 g
 ―――

While this type of recipe can be good on wool and on silks such as chiffon and georgette made from tightly twisted yarn, alginate and alginate/emulsion thickenings can be difficult on fine silks of the Habotai type; bleeding often occurs, even if only slightly. The urea can be cut right down and some of the water content also reduced, while gentle warm-air drying during printing is very necessary in helping to alleviate some of the difficulty.

MAN-MADE FIBRES

These cloths, very often knitted, are industrially often fastened down with a thermoplastic adhesive; this is a resin previously coated on the backing blanket which, when subjected to heat from a unit placed near the cloth entry point at the front of a screen printing machine, will become tacky enough to fix the cloth to the backing as they both pass between rollers. These adhesives can be used many times before the backing needs to have another application.

Synthetics are often best laminated to cotton back-greys with adhesives such as Dextrin 1:1, or Vinarol ST (Hoechst). After lamination the cloth must be passed immediately over a drying cylinder or the back-grey will absorb the adhesive and reduce the adhesion. Heavy, closely woven fabrics, such as Dralon velvets, may be pasted directly on to the print table.

A gum of the Grandex type can also be used but, because of the difficulty of controlling the heat of an iron sufficiently well, students will probably find that pinning down to a back-grey is a better method for most synthetic fibre cloths. Extra care, however, is needed with stretchy knitted cloth, which should be tested to determine how much relaxation will take place when it is wet.

Because synthetic fibres are generally hydrophobic, resisting the intake of moisture, it is essential that the thickenings used on them adhere to the fibres as well as allowing good penetration. Thickenings with a high solids content (such as Nafka crystal gum 33 per cent) give sharp outlines but they dry to a hard film and are sometimes difficult to remove in washing. Often a combination of Nafka (or a burnt starch product like Diatex SL 30 per cent) with a locust-bean derivative such as Indalca PA30 at 6 per cent concentration or Indala SR/C/60 at 12–13 per cent, is good. Alginates may be used with disperse dyes but cannot be used with modified basics as they gel when in contact with acids.

While acid dyes, as already mentioned, can be used on nylon the two important classes developed for synthetics are disperse, which can be used on all synthetics although on acrylic fibres colour yields are often not very strong, and modified basics, the use of which tends to be confined to acrylic fibres.

Disperse dyestuffs

These are used with polyester (Terylene), secondary acetate and tri-acetate (Dicel and Tricel), and polyamide (nylon).

> 1–20 g dye (liquid, powder or paste)
> 25 g water
> 0.5 g tartaric 1:1
> 50 g thickening
> 1–2 g wetting-out agent
> (e.g. Perminal KB or Silvatol I)
> Bulk to 100 g

This basic recipe can be used on all the above-mentioned fibres but a good colour yield is obtained on polyester only with pressure or HT steaming. For HT steaming a fixing aid is needed, such as 2–3 grams of Irgasol P or Invalon P.

On nylon it is useful to add 1 gram of sodium chlorate to prevent the reduction of the dye.

Suitable thickenings are Manutex F, Nafka crystal gum (not for HT steaming), and Indalca PA30; also half-emulsion, using Manutex or Indalca PA30 as a film-former. Alternatively, 5 grams of urea can be included, and half a gram of sodium phosphate substituted for tartaric acid. Steam for 30 minutes and wash off in cold water.

Modified basic dyestuffs

These are recommended for acrylic fibres (Courtelle, Acrilan, Orlon and Dralon).

> 0.5–5 g dye
> 25 g Glyezin A
> 2.5 g acetic acid 30%
> 30–25 g hot to boiling water
> 0.5 g citric acid
> 50 g thickening
> 2 g Luprintan PFD
> Bulk to 100 g

Dissolve the dye in the Glyezin A, water and acid at about 80–90° C (176–194° F). Stir into the thickening and add the Luprintan PFD just before printing (this ensures strong prints even with low steam pressure). Do not overdry the printed fabric. Steam for 30 minutes.

Rinse thoroughly in cold water. Soap at 40–50° C (104–122° F) with 2 grams of detergent (e.g. Levapon TH, Ultravon AN or Lissapol ND) per litre and 2–3 grams of acetic acid 30 per cent.

The printpaste must be acid all the time during the fixing process and it is for this reason that it is sometimes necessary to include a non-volatile acid like citric or acetic. But if Indalca thickenings are used it is not good to use citric or

tartaric acids in the printpaste; instead, 1 gram of ammonium sulphate 1:3, along with 3 grams of Glyezin A and acetic 50 per cent, and 1.5 grams of Luprintan PFD. If the dyestuff has a tendency to recrystallize, 1.5 grams of benzyl alcohol or cyclohexanol is sometimes added but both of these attack screen lacquer. Finally, fabrics can be softened, if desired, by adding 1–2 grams of Sapamine OC per litre.

Acid dyestuffs

These can be used on polyamide fibres (nylon). Certain acid dyestuffs, such as Nylomine Acid P (ICI), Erionyl and Tectilon (Ciba-Geigy), and Lanaperl (Hoechst), can be printed on nylon but it is not always possible to get deep shades; difficulties can also sometimes arise where acid dyes are intermixed or overprinted on each other.

> 3–6 g dye
> 5 g Glydote BN
> 35 g hot water
> 45–50 g thickening to which have been added
> 5 g thiourea
> 2 g wetting-out agents (Perminal or Silvatol)
> 3 g ammonium sulphate
> Bulk to 100 g

Steam for 30 minutes, and rinse for about 5 minutes in cold water containing 1 gram of sodium carbonate per litre. Wash the cloth in water at 60° C (140° F) containing 2 grams of Lissapol per litre and 1 gram of sodium carbonate.

ALL FIBRES

Pigments, in the proportion of up to 10 parts pigment colour to 90 parts binder, are suitable for all fibres but not good for large areas of printing, particularly on delicate fabrics. They are also impossible to use on pile, or highly textured or hairy cloths. In spite of great improvements in binders, and therefore in the handle of pigment-printed cloths, pigment systems still do not give the quality obtainable from dyestuff – with the exception of some fine line work.

Binder may be purchased ready made up but is very expensive indeed. It can be made up easily as required by using a high-speed mixer, e.g.:

> 3 parts Hi-fast carrier SE (Tennants)
> 50 parts water
> 5 parts Hi-fast Binder NJ
> 42 parts white spirit

Place the water in a container. Add the carrier and mix with a high-speed mixer until smooth. Add Binder NJ and continue mixing. Finally add the white spirit slowly and mix for a further 5 minutes.

Opposite: some African-style prints. *Left to right, top to bottom:* direct-printed azo style; brown wax resist style; indigo wax batik style; green ground style; alizarin mordant style; indigo discharge + orange; cover style; blockprint style + discharge rainbowing; conversion style.

7 The resist and discharge styles

In the resist (or reserve) style (*réservé* in France), the aim is to produce a pattern on a coloured ground by first printing the white cloth with some substance which will prevent the fixation of the colouring matter or mordant which is afterwards dyed, padded or printed over it. The resist style is the oldest means of patterning cloth with dye, and in the earliest examples, such as the fourth- to fifth-century Coptic cloths, and later Javanese batiks, pastes of clay, rice or wax were used to protect the pattern areas from the colour when the cloth was subsequently immersed in a dye bath of woad or indigo.

As well as the usual wax painting, good effects can now be achieved by screen printing with gum arabic and overprinting with dye. This type of resist is a 'mechanical' one, and of much earlier origin than the other type, the 'chemical', which was not used until the very end of the eighteenth century and the early years of the nineteenth, when interest was first shown in chemistry in all its forms. Almost all classes of dyestuffs may be resisted in some way or other and the resists in this group consist of acids, alkalis, reducing agents and neutral salts. And whereas a mechanical resist can produce superb effects – as in Javanese batiks – by hand methods it is impossible to produce fine effects industrially.

When one looks at an industrially produced nineteenth-century or modern cloth printed by chemical resist, there is often no difference in the appearance from that of a discharge pattern (although if the backs of the two cloths are examined, undischarged dyestuff of the ground shade will often be seen on the one, especially on cotton); but even this effect is little different from that seen on the back of a reserved pattern, where the chemical printing has sometimes not sufficiently penetrated through to the back of the cloth, thus allowing tinting by the padded colour.

However, in some ways the resist style is easier, mainly because many colours are difficult to remove once fixed on the cloth, and also because registration is always a problem in the discharge style, particularly on deep-dyed cloth where sighting is virtually impossible, although 'sighting colours' which will subsequently wash out can be employed in the discharge paste. At present, although there is some revival of discharge work in Europe, several dye companies and

Opposite, above: Two examples of the different qualities which it is possible for students to achieve on cloth, using disperse dyes in the form of pastes and crayons.

Opposite, below: A superb example of a photogravure transfer-printed acrylic pile velvet. This design, 'Chambord', was realized by Sublistatic SA from an original design by Comercial Sert of Barcelona.

pigment producers are encouraging interest also in modern resist styles, using pigments under reactive prints or pad-dyeings.

RESIST WORK TODAY

There are many interesting opportunities for resist work in a modern form which are (or could be) taken up industrially and by colleges. With careful thought and consideration it is possible to produce a series of quite different design variations by a very economical use of screens or rollers – a very good design exercise indeed in co-ordination and inter-related fabrics.

Reactive dyestuffs are particularly suited to experiment because of their ease of application. This class of dyes, as we have seen, are fixed on cellulose fibres only in the presence of alkalis, and many of the dyes, particularly the reactive systems such as Levafix P (Bayer) and the Remazols (Hoechst) which have no, or very little, affinity for the fibre, wash off very easily when unfixed and leave a clean white.

So resist styles can be achieved in two main ways: by using the traditional method of pre-printing with an acid resist paste (e.g. tartaric acid) and overprinting with reactive dye containing the necessary alkali; or by printing thickened reactive dye without alkali and then overprinting with thickened alkali. Strictly speaking, the latter is not a true resist method, but can be included here.

The choice of a thickening agent is very important indeed. For the acid resist it is necessary to use a thickening which is resistant to coagulation by acid, therefore alginates cannot be used: cellulose-derived thickenings such as Celacol (Courtaulds), Tylose H 300 (Hoechst) or Natrosol (Hercules) are suitable. The resist print can obviously be dried before the reactive fall-on when hand screen work is involved, but wet-on-wet printing can be successful. In this case the ability of alginates in the reactive printpaste to coagulate can be used to enhance mechanically the chemical resist of the acid, because if a wet-on-wet technique is used a slight thickening takes place.

It must be stressed that not all dyes, even in the Remazol and Levafix ranges, will wash off completely; some, in fact, can be used to give an interesting half-tone effect in this way which could be enhanced by ensuring that the cloth is weakly alkaline (instead of completely neutral) before printing.

Reactive dyestuffs over coloured pigment resists

This sytem is much recommended by several companies (e.g. Bayer, Hoechst, and Tennants) as an easier alternative to the discharge process, in view of the increasing interest in the latter field.

Again non-volatile mild organic acids are recommended, such as tartaric or citric, mixed with a cellulose thickener such as Celacol, or a combined thickener – for instance, about $\frac{2}{3}$ Meyprogum to $\frac{1}{3}$ wheat starch. The coloured resist is made up of the reduction binder, resist paste prepared beforehand, and colour. After the resist printing the cloth can be thoroughly dried (2–3 minutes at 105° C (220° F)), padded or printed with the reactive dyestuff and dried and steamed for 6–8 minutes. However, Bayer recommend a wet-on-wet printing with fixation, after drying, by steam for 8 minutes (not baking, as tartaric requires moisture).

White resist printing on cotton under reactive dyes

Recipe: 5 g tartaric or citric acid dissolved in
 25 g water and stirred into
 100 g acid-resistant thickening
 (e.g. Celacol or Tylose)

Print resist and while still wet overprint the reactive colour made up in the usual manner with an alginate thickening and 1–2 per cent Resist Salt (or Ludigol). Not only is this time-saving but the fact that the resist print is still wet helps to prevent the penetration of dye through the resist paste.

After steaming and an initial wash in running cold water, many thorough boiling-water washes containing a detergent such as Lissapol ND are needed to clear the white; this takes about 15 minutes. Some colours do not give good whites although many of the Remazol and Levafix dyes have very good washing-off properties because they have little or no affinity for the fibre. (There is also a trade product, Bascal S – a mixed organic acid by BASF – which is recommended instead of tartaric or citric acid.)

Special effects with reactive dyes overprinted with alkali

The normal reactive recipe is used except that the sodium bicarbonate content is left out. After printing with the dye, the fabric is dried and then overprinted with a colourless alkali paste. In each case a half-emulsion is considered the best. Hoechst suggest three equal parts of the following: a 70/30 emulsion of white spirit and 3 per cent aqueous emulsifier DMR solution; 5 per cent Tylose H300 thickening; and 5–10 per cent alginate thickening. The colourless overprinting paste should contain 3–4 per cent of sodium bicarbonate and also 5–10 per cent of urea.

It is also suggested that because the goods to be printed will often have a weakly alkaline reaction it is advisable to add 1–3 per cent of monosodium-di-hydrogen phosphate to the printpaste to counteract this effect. While some colours do leave clean whites easily, others leave paler tints; these pale tones are reasonably fast and again can give a good effect if used with imagination.

The following Remazol dyes can be relied on to wash clear in full shades if printed on neutral fabric: Yellow G,

Brilliant Orange RD, Brilliant Red B, Brilliant Violet 5R, Brown 3G, Brilliant Blue R (the last two only in medium shades).

Coloured pigment resist under reactive dyes

Prepare resist paste:	500 parts 4% cellulosic thickener (e.g. Celacol)
	500 parts tartaric acid
Prepare reduction binder:	230 parts pigment binder (e.g. Aquarine 1612)
	200 parts 2% cellulosic thickening
	20 parts emulsifier (e.g. Emulsifier KW 25%)
	550 parts solvent
Print paste:	80 parts reduction binder as above
	5 parts pigment colour
	15 parts resist paste as above

100

Combine in a high-speed mixer until uniform. It is often necessary to add the colour to the reaction binder and then to add the resist paste; this prevents separation.

After printing, dry at about 105° C (220° F), or iron when the print is dry. Print or pad the reactive colour over and then steam for 6–8 minutes in the usual manner. The reactive dye is better fixed by steam, as if fixed by dry heat it tends to stain the pigment binder. This can also happen if the pigment print is insufficiently cured.

Half-tone effects under reactive dyes

A reasonable half-tone can be obtained – particularly on certain colours – by printing a simple alginate thickening under the dye, but the following is also suggested:

50 g Tylose MH 300 4% (or Celacol $2\frac{1}{2}$–3%)
45 g water
5 g Glyezin A

100 g

A more positive effect can be achieved by adding Matt White W or Matt Discharge White BASF 4019 and titanium dioxide to the paste:

50 g thickening
10 g titanium dioxide 1:1
5 g Glyezin A
10 g Matt Discharge White
25 g water

100 g

or alternatively 25 g Matt White W, 6 g tartaric acid and 9 g water. Overprint the reactive dye (which is partially resisted) and dry at about 90° C (194° F); this fixes the resist.

Obviously with this method (as with all printing requiring a calculated result), careful tests are needed to check the consistency of the thickening, the number of squeegee strokes, the amount of drying necessary etc. If there is no outline to the pattern, or other colour already printed to enable good sighting for registration purposes, then a trace of some dye which will not fix on the fibre can be included in the otherwise colourless paste.

A further simple, but this time half-resist, method can be used with most dyestuffs to give a paler tone of any fall-on colour. This is an adaptation for screen printing of the old 'water' or 'gum roller' method, much used in roller-printing furnishing fabrics (particularly with a surface roller). If reactive dyes are to be used, for example, then a screen is prepared containing areas of pattern which will print under any of the fall-on colours requiring a paler tone, and used to print on to the white cloth with only an alginate thickening as a half resist, or a solids-rich thickening which coagulates under alkali. When the subsequent colours are printed the pre-printed areas will partially stop the colour from penetrating the cloth, so giving a lighter colour.

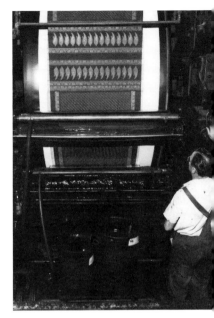

The 'sari' or 'jumper' machine used to print borders as well as an all-over pattern. The set of rollers which prints the main pattern moves out of contact while another set moves forward to print the border.

AFRICAN PRINTING

The trade in 'African' or 'West African' prints (as the industrially produced native-styled cottons are termed) is a very specialized one indeed – at the present time the large Dutch printing organization Vlisco, and Brunnschweiler (the African printing division of Tootal) are the only two textile firms outside Africa itself which produce the 'wax prints', although there are firms in France and Japan printing other African styles. The Dutch have a long history of African printing, as they have also of supplying the Javanese with resist-printed fabric. Their industry started in the early middle of the nineteenth century and because of their connections with Java they at first sold surplus 'Javanese batiks' to the Gold Coast, even before they began printing designs based on the native African 'tie-dye' and painted and stencilled resist styles. As a result the Javanese batik-style designs became a very important feature of the West African trade, with motifs like butterflies, scorpions, fish and trailing leaf forms, and fabrics displaying strong diagonal bands or large triangles, often integrated with the native tribal forms.

The British African print trade is not of quite such long standing, although it goes back some ninety years. About 1880 Britain did good business in plain dyed indigo with Madagascar and when this became a French colony it was feared that that would be the end of the African trade. However, when Britain financed the West African railways and

acquired the Gold Coast as a colony, greater textile oppor-
tunities opened up which could not be fully met by the
Dutch. This led to the real start of the African print industry
in Britain.

As time went on, symbols of Western culture gradually
began to appear in African prints – umbrellas, radio sets,
portraits of King George VI (still selling), and the alphabet,
all treated decoratively in ways which conformed to one of
the many styles.

In the earlier years of the twentieth century various dis-
coveries were made which further influenced the styles
produced. It was found, for instance, that chrysoidine brown
could be discharged to white when after-treated with diazo-
tized p-nitraniline; this allowed styles formerly printed only
in blue and white to be executed also in brown and white. A
printer named Costabadie, of Mottram in Cheshire, devel-
oped a method of printing a para red (azoic colour) or a
claret red and a paste resist for indigo at the same time; this
tended to lead to a cutting out of expensive block printing
in some designs.

The Africans always preferred the blue and white style
printed by the Perrotine block-printing machine to that
printed by roller, and Germany continued this type of print-
ing until the Second World War when the last factory having
this machinery was bombed.

About ten to twelve years ago the trade in African styles
was declining as various states gained their independence and
westernized ideas began to spread. But in the last five years
or so it has revived considerably, although it is still a good
deal less prevalent than formerly. This revival was largely
brought about by President Mobutu of Zaire (formerly the
Belgian Congo), who, when he was elected in 1970 for a
further seven-year term as President, commenced a gradual
process of de-Westernization by decree. Everyone who had
been baptized with a Western name had to change it for an
African one, and towns such as Leopoldville (now Kinshasa)
were renamed. Western dress was forbidden (even citizens
travelling abroad had to conform), the wearing of wigs by
the women was stopped, and the traditional tightly plaited
hair styles which, although still worn in the villages, had
been discarded by people living in the towns and cities, were
once again to become the rule. The bringing back of the
native costumes naturally meant that suddenly big yardages
of wax batik and other native styles of cotton were needed.
The obvious step was to establish printworks in Africa
itself, and this the Africans were very keen to see. About nine
to ten years ago the first, not too successful, attempts were
made and now there are five factories in operation in Senegal,
the Ivory Coast, Ghana, Nigeria and Zaire, owned and
organized by different countries, often also partly African in
ownership.

Setting up a printworks in Africa was a difficult under-
taking because whereas in most Western countries it would

always be possible to get a hard core of workers familiar with textile printing in some form, in Africa a start had to be made with several hundred workers who had never before seen a machine or even the inside of a factory. So the first types of prints carried out there were the easier imitation wax prints, 'Imiwax' – direct prints made to look like wax resists with mock crackling. These were roller printed on naphthol grounds using azo navy (instead of indigo), a lighter navy crackle-effect roller, azo red, and a chrome yellow if yellow or green overprint was required. Now, however, true wax-printed batiks are also printed in Africa.

There is a very big market available. Nigeria alone has a population of fifty million, and Africans are strongly fashion-conscious. In the towns and suburban districts there are changes of preference for and against certain styles, colours and motifs, similar to the fashion changes of the West. Up to a few years ago certain motifs and styles were frowned on and impossible to sell in some districts while being perfectly desirable in others, these preferences being probably related to taboos. Nowadays, with the opening up of the continent, the villages tend to prefer traditional styles, and in the towns there is a desire to try newer colours and different motifs.

Over the years many attempts have been made to replace indigo in the wax styles because synthetic indigo has a very bad fastness record on all counts. It has poor resistance to rubbing and fades easily with washing and exposure to light; it does, however, tend to fade to a bright, clear blue, rather than a dull, lifeless one, and attempts to replace it have not been favoured by the African buyers, who admire this fade quality very much. Even more do they like the marking-off quality of indigo, because it stains the body.

Basic indigo is the poorest vat dye, having the smallest molecular structure. Other vat dyestuffs developed from it – e.g. Ciba Blue 2B, which is a brominated indigo and a very close derivative – are very fast and very like true indigo, but still not so acceptable.

Vat dyes, as we have seen, are of two types, those developed from indigo (the indigoids) and the anthraquinone derivatives, which are the fastest dyestuffs known. But in the non-wax styles systems have developed using many different dyes to produce an 'indigo' colour: examples are Phthalogen Brilliant Blue IF3G, Phthalogen Deep Blue DB and Phthalogen K (Bayer).

Not all African printing is of the 'wax batik' style: some use chemical resists and some are not even resist styles at all. Nevertheless, because the resist style has tended to become (at least to those outside the trade) synonymous with African printers and because it will be less confusing, the various types of prints in this field, both resist and non-resist, will be dealt with together in this chapter. One of the many fascinating things, in fact, about visiting an African printing works is seeing the amazing wealth of printing styles: wax resist, chemical resists and discharges of many kinds,

mordant styles and even direct prints using reactives and pigments. One can clearly see the importance of understanding something of the history and development of cotton printing, of dyeing and mordanting techniques, and the chemists and technical experts feel that they have the most excitingly interesting and varied jobs in the industry.

With the advance of modern techniques and particularly the efforts to streamline and rationalize the textile industry, we are in danger of losing much of the expertise gained over the last century or so. Fabrics today do not so often display instinctive use of subtly shaded colours, fine stippling and line drawing and other features of the past, partly through lack of money but increasingly because some of the old craftsmanship is slipping away. But in the field of African printing, although changes do take place (some of the dyestuffs are becoming increasingly difficult to obtain, which makes changes inevitable), the older ideas and skills are still needed and used and could well be adapted for Western use. This has been superbly done in the Tootal 'Samedi soir' ranges of fashion cottons, and there is also room for adaptation in styles other than African to enliven the field of fashion fabrics.

African styles of printing, and their patterning and motifs, are partly controlled by the desires of the various areas to which they are exported, but they are also the result of using the mechanical and chemical characteristics of the various dyes and textile assistants, skilfully and with imagination, to turn a seeming failure into a strikingly beautiful print. The restricted palette of naphthol ground styles is one example; another is the tendency of acid discharging agents to halo.

It would obviously be impossible to categorize all the styles; broadly speaking, they fall into two main groups:

The *wax batik prints*

 Those waxed to resist indigo
 Those waxed to resist other colours

The *non-waxed styles*

 Alizarin mordant style
 Conversion style (a combination of chemical resist and discharge)
 Direct-printed azo style, often plus chrome yellow (imitation wax batik style)
 Green ground style
 Indigo discharge (often plus orange)
 Cover styles, with mill-engraved backgrounds and isolated motifs over, in a variety of colourings
 Various block-printed discharge indigo/mordant techniques combined with rainbowing

Although, from the designer's point of view, African prints are very much variations on recurring themes, each style preserving its characteristics although the design ele-

ments may be changed, many new examples of these varia-
tions are produced each year to add to the ever-popular
prints which carry on from year to year. Designers working
in this field have to learn to work as imaginatively as they can
within closely prescribed limits. As far as the wax prints are
concerned it is essential, in the majority of designs, to break
up the inside of a motif or part of the background decora-
tively into small, almost textural areas such as fish scales,
small diamonds, pebbling, feather markings and so on. A
great deal of this treatment is Javanese in style. The reason
for the markings is that after the indigo dyeing these small
waxed areas will not be easily removed, as will the larger
pieces, and will remain as small beads of wax to resist any
subsequent colour.

The wax resist styles

Firstly it should be noted that although these are always
referred to as 'wax resist' or 'wax batik' styles it is a tree resin
which is used. In Holland, too, resin is used, combined with
paraffin wax in different proportions, for the production of
varying effects.

To make a straightforward indigo resist (blue and white
only), the wax patterns are produced from a pair of engraved
copper rollers which print the back and front of the cloth at
the same time. Special wax-printing machines are made
which have electrically heated colour boxes to hold the
resin; the rollers are internally steam-heated. The resin is
naturally dark brown in colour and so the print as it comes
from the machine is clearly seen in its negative form. Resin,
unlike paraffin or beeswax, does not become a liquid on
heating, but on application of controlled heat becomes
treacle-like in consistency. Thermostats are fitted in the
boxes, because the temperature has to be kept within fairly
narrow limits. As the cloth comes off the machine after
printing it is sprayed with cold water to cool the resin
quickly. One of the characteristics of African wax prints is
the veining of indigo (or other colour) into the white parts
of the pattern; this is known as 'crackling' and is produced
by cracking or crazing the resin before dyeing. One way of
crackling is to drag the length of cloth, crumpled together,
through a 'pot eye', a narrow round opening about six inches
in diameter. This method produces long fissures in the wax,
mainly parallel to the selvedge. The cloth can also be crackled
irregularly by hand.

The cloth is then taken to the indigo dyeing range. It
passes into the indigo vat for a time and on slowly emerging
is yellowish-green in colour. It immediately starts to oxidize
as it slowly passes over a series of 'creepers', or slatted moving
racks. Gradually, as it moves forward, the cloth becomes
greener still, and then bluer. The combined process of dip-
ping and a passage through the air to re-oxidize is repeated
four times to develop the full deep indigo shade.

Close-up of the resin trough.

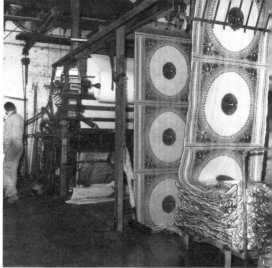

The cloth coming from the printing machine after having the resin applied.

Cloth which has been indigo-dyed awaiting the washing off of the resin.

Printing colour by hand block.

Routing out a wooden block pattern with an electrically operated cutter.

If the finished print is to be simply blue and white it is washed at this stage to remove the wax, and finished.

If other colours are to be added to the indigo after the waxing and indigo vat, the cloth is again separated into bundles of 120 yards and loaded into washing machines. During the half-hour or so of washing in cold water, the larger areas of resin become detached from the cloth, breaking into small platelets which are further eroded at the edges. But small round or elliptical areas in the centres still remain and the smaller beads (so carefully placed in the design, as previously described) remain as well, simply because they are small and therefore less easily dislodged. These remaining spots resist the subsequent colours and impart to the finished cloth a very characteristic, detailed white pattern which is entirely random and non-repetitive.

The cloth is then taken out of the washers and opened out on the floor, stretched into its full width and passed over rollers into a bath of mild caustic to remove the 'scummed' areas carrying the powdery wax residue left after washing – but this process does not remove the quite thick 'beads' of wax.

The next process consists of drying the cloth and 'sealing' the wax. Because the wax is applied to the back and the front of the cloth each bead consists of two parts and a certain amount of heat is needed to seal the two parts together, so that in the subsequent naphtholating process the naphthol liquid does not creep underneath and cause the small remaining white shapes to become dyed.

After being padded in a solution of Naphthol AS the cloth is wound up into batches to await its turn for block printing.

In the printroom the cloth is laid quite loosely over the tables and the printing from simple wood blocks is done comparatively quickly. The fast colour salts printed on to the naphtholated ground produce the diazotized colour. Formerly 'coppered' blocks were used but now they are made of wood and felt; recently, in an attempt to make them even lighter and easier to handle, experiments have been made with blocks cut out of thick felt and stuck to plywood. Afterwards the cloth is washed to remove the reactive products and resin with dilute caustic solution and then finally rinsed, dried and calendered.

For cloths which are to be waxed to resist other colours, there are two main methods. In the first one the cloth is naphtholated and then printed with resin, dry – that is, no water is sprayed on the resin print, but instead the cloth is immediately padded in a bath of azoic dyestuff. The wax resists the penetration of the azo colour to the naphthol, and after washing and removal of the wax a coloured design results according to the particular azo combination used.

The wax can also be printed as described for the indigo and then the cloth is immersed in cold dilute substantive naphthol. This dyes the exposed portions of the fabric, and it is then passed into a bath of azo dye, whereon coupling

Top: sample of cloth printed with resin. *Above*: the same cloth after indigo dyeing and before the resin has been removed.

Two types of block used in African printing: *below*, a wooden block infilled with felt; *bottom*, a block made of felt alone.

takes place on the naphtholated areas. The wax is finally removed and the cloth washed and finished.

The non-wax styles

The alizarin mordant style produces patterns in black, brown and orange by printing aluminium acetate for the orange and aluminium or iron for the brown, leaving oxidation to make black. After drying, the mordant is fixed by a passage through dilute ammonia solution and the cloth is dyed in Alizarin Orange; after washing the colour appears only on the mordanted parts.

The conversion style is produced on cloth dyed in Chrysoidine Brown (Para brown salt R). When after-treated with p-nitroaniline the brown colour may be discharged with Formosul. If the discharge paste is made acidic with the addition of sodium citrate, the acid swells further than the Formosul and on the cloth being padded in aniline black, a brown halo results around the discharged pattern. Usually a great deal of stipple engraving is used in the design, to enhance the shaded effect.

The direct-printed azo style in imitation of wax prints consists of direct printing from engraved rollers on naphthol grounds, of azo navy, a lighter navy crackle-effect, and azo red, often with the addition of a chrome yellow (now almost always a reactive yellow instead) which, because it is unaffected by the naphtholated ground, gives yellow on the unprinted areas and green where it overprints the navy.

For the green-ground style, again the cloth is naphtholated with naphthol ASG and dried. Afterwards it is printed with azo yellow and azo claret (fast black salt which on the ASG gives claret). The cloth is printed also with a sodium thiosulphate resist both on the printed areas to retain the original colour, and on the ground to produce white ultimately. Afterwards the cloth is padded in Indigosol Blue (the nitrite method), developed in dilute sulphuric acid. This results in the characteristic print of green, blue, yellow and claret.

Indigo discharge styles: indigo being a vat colour, the hydrosulphite formaldehyde (Formosul) only reduces it, and does not discharge it. It is therefore necessary to use Leucotrope W, a compound produced from benzyl chloride and patented by the Badische Anilin- und Sodafabrik in 1910. When brought into contact with the reduced indigo-white produced by the hydrosulphite, this gives a full white discharge. Another of the benzyl compounds, Leucotrope O, produces a yellow-orange discharge on the indigo.

Cover styles have close-textured grounds printed from finely mill-engraved rollers. After naphtholating, the cloth motifs (usually fairly isolated ones) are printed in a solid colour. Then all over the cloth, including the motif, a second colour is printed from the mill-engraved roller. This cannot reach the naphthol ground because of the previously printed motifs, so no texture is retained in these areas.

There are also various block-printed discharge indigo or mordant techniques which combine with 'rainbowing' and other effects.

Naphthols: bleeding styles with Fast Colour Salts and reactive dyes

Many interesting types of print can be obtained by using naphthols – which are much used in the African styles previously touched on.

When a Fast Colour Salt printing paste is mixed with a Remazol printing paste, the compatibility of the individual representatives of both dye classes must be considered. When printed on naphtholated fabrics, such a mixture would normally produce sharp prints. However, many thickening agents give ill-defined outlines, owing to the ability of the thickening to lose its property as a water-binding agent when subjected to the action of the alkali of the prepare. On coagulation, the thickening releases a large amount of water. Part of this water and the dissolved Remazol dyes contained in it flow on to the unprinted areas. The Fast Colour Salts have by this time coupled and therefore produce sharp prints. Consequently, a halo in a shade of the Remazol dye will be obtained around the mixed shade which results from the combination of Fast Colour Salt and Remazol dye.

Pad the cloth with the following liquor at 80–90° C (176–194° F):

> 15 g Naphthol AS
> 10 g Monopol Brilliant Oil
> 30 cc caustic soda solution 38° Be (72° Tw)
> 7.5 g trisodium phosphate (as additional alkali)
> 40 g Leonil PAT★
> 60 g Glauber's salt calc.
> Bulk to 1 litre

Suggested colour printing:

> 4 g Fast Red Salt TR
> 4.5 g Remazol Printing Green 3GT
> 10 g urea
> 31 g water
> 0.5 g Remol AS
> <u>50 g thickening (e.g. Tylose MH 300 5%)</u>
> 100 g

or alternatively

> 2.5 g Fast Red Salt TR
> 3.5 g Remazol Printing Green 3GT
> 10 g urea
> 32 g water
> 0.5 g Remol AS
> 0.1 g citric acid
> 50 g thickening
> Bulk to 100 g

★ This gives uniform bleeding of the Remazol dye and ensures that the bleeding will stop at a specific point with a darker outline.

In screen printing the brown shade which occurs in roller printing from this mix is not seen because in screen work the transfer of colour is irregular and more alkali binding agent is being applied with the Fast Colour Salt. This compensates for the alkali of the naphthol prepare and prevents the Remazol dye from being fixed. If more acid is added to the printing paste, fixation of the Remazol dye is no longer guaranteed.

The Fast Salt and Remazol are first mixed with the urea and dissolved in about 30 grams of water. Half a gram of Remol is added and the solution is poured into the thickening and stirred till it is homogeneous. It is then printed, dried, and steamed for 5 minutes in the ager. The fabric should not be too dry when it is printed, as the salt on the fabric will then take too long to begin dissolving.

To get a good flow effect it is advisable to incorporate as much Glauber's salt as possible. Make the thickening in a 1–2 per cent solution of the salt; on cooling, the Tylose dissolves. The printpaste prepared in this way breaks down more easily on the absorption of more Glauber's salt from the material, since it has already been close to the coagulating point. In screen printing the length of time between printing and the ending of the flow process by drying is sufficient to produce bleeding-style prints.*

DISCHARGE PRINTING

By 'discharge style' is meant the production of a pattern on a pre-dyed cloth with a printpaste containing a suitable reducing agent – in other words, a paste which 'bleaches out' the dyed ground, leaving a white pattern. A 'colour discharge' is one in which a new colour, unspoilt by the reducing agent, is printed at one and the same time, so giving a coloured pattern on the pre-dyed cloth. So we have the terms 'white discharge' and 'colour discharge', the colour being known as the 'illuminating colour'.

Discharge has many advantages over direct printing, the main one being that it enables a light, bright colour to be obtained on a dark ground. The printing is sharp and fine and, of course, unspoilt by overprint edges where two colours touch. Again, and very importantly, it is easier to dye a level ground shade than to achieve it with a printed 'blotch'. From a designer's point of view discharge prints are often much more interesting in character than direct work. However, it is also more costly, partly for the obvious reason that much expensive dyestuff is subsequently destroyed, and partly because there is the additional cost of a reducing agent and the dyeing operation. Nevertheless, in Italy particularly, but also in other European countries such as France and Austria, a great deal of discharge work is produced and the quantity is increasing rapidly year by year. In Italy, where so much silk is printed, some companies' output

* This technical information, in its entirety, is gratefully acknowledged to Hoechst (UK) Ltd.

of discharge is as high as 80 per cent or even more, although the national average is quoted as being 25 per cent of silk, cotton/viscose and acetate/polyamide, and about 30 per cent of acrylic. The Italians have been responsible for much of the current experimental work in the field of discharge on silk and on synthetics; they have achieved exciting new effects, sometimes leaving only as little as 10 per cent of dyed ground, and they consider that even on polyester the figures will rise greatly from the current level. In silk in particular, couture fabrics, men's ties, dressing gowns and scarves are produced by this method.

Because there is so much exclusive hand screen work on silk there is an interest in exploiting all the many strange and exciting effects that occur in discharge work when things go wrong. Designer/printers deliberately experiment with haloing, bleeding, the putting together of dyes which will and will not discharge, and utilizing qualities in their designs which students often wish could be put on cloth. It must, however, be emphasized that this type of work is only possible in small-scale production because, no matter how skilled the chemist, he cannot easily reproduce exactly, time and time again, under controlled conditions and in greater bulk, the qualities brought about by such experiments. But it is useful to experiment and the lessons learnt encourage ideas for other, more conventional, designs on paper.

Discharge printing (termed *enlevage* in France) was first practised in the very early years of the nineteenth century when the method of Turkey red dyeing had been more or less mastered and when many of the new mineral colours were in use. One of the first to be successful was a Scotsman named Monteith in 1802. What became known as the 'Monteith process' consisted of the direct application of a solution of chlorine to dyed fabrics. The Turkey red dyed cotton was smoothed and placed in folds between two thick cast lead plates, both of which were perforated with the pattern to be produced, the perforations exactly coinciding. The plates were tightened down very firmly, bleaching liquor (consisting of bleach in powder, with the addition of acid) was poured into the upper plate and it then seeped down the perforations. Because of the closeness of the fit of the upper and lower plates the bleach was kept in control within these pattern areas. Afterwards the cloth was well washed in cold water. These cottons were mostly patterned with spots and were, in fact, the workman's handkerchief in which lunch was wrapped, and so they became known as 'bandannas' because of their similarity in pattern to the genuine Indian 'tie-and-dye' work (*bandhnu*).

However, the credit for successfully dyeing cotton Turkey red and printing a discharge in white and colours indisputably belongs to Daniel Koechlin of Mulhouse in Alsace, who in 1810 first produced samples of cotton dyed with the red, and having a white pattern. This last he obtained by overprinting the cloth with a strong acid (tartaric and, later,

arsenic), and passing it through a solution of chloride of lime, which discharged the colour by the action of the liberated hypochloric acid. He also discovered that at the same time he could dissolve Prussian blue in acetic acid and add it to the print because it resisted the acidulated chloride of lime. If the tartaric acid was omitted he made black and then he printed in yellow from a block, getting a five-colour print.

At the present time, although the method is spreading greatly in Europe, in the UK it is still a specialized section of the industry, used only for high-priced silks and wools and fine cottons such as Liberty 'Tana' lawns. Silks and wool use direct, acid and pre-metallized dyes, and cottons use directs, with vat illuminating colours where the sulphoxylate reduces the direct and the vat.

It is a field where great expertise and experience are needed and each printer has his own ways of solving the many problems involved. There are a great many variables, such as timings, temperatures, humidity, steaming conditions and strength of reducing agents, and the interrelationship of these can affect the finished fabric to a very marked degree, therefore much testing and strict control of conditions are needed. It is one of the main aims of a discharge printer to be able to control the print so that no vestige of halo can be seen beyond the illuminating colour. And if it is possible to do this, then it is also possible, by varying the proportions of reducing agents and other chemicals, to produce varied effects by controlled 'flushing' and thereby to change the character of the print completely. This is done superbly by some Italian companies.

Discharge dyestuffs

These are the dyes which are reducible and are therefore used to pre-dye the desired ground shade. They include colours to be found in various ranges – directs, acids, reactives, disperses and modified basics. In the dye manufacturers' literature they will be graded '1' to '5' for their dischargeability to a good white, '5' being the best. Obviously if a colour discharge is to be printed it is not always necessary to have perfect dischargeability, but only sufficient to allow a good print; in discharging black with a green, for instance, a good enough colour may be achieved even with a residue of ground shade remaining. If, however, the design has white areas also, this is not satisfactory.

Illuminating colours

These are dyes unaffected by the reducing agent used, and they too are found in the dye ranges mentioned above.

Reducing agents

In simple terms, a reducing agent is a substance which will, fairly readily, withdraw oxygen from or add hydrogen to

This beautiful early twentieth-century printed silk velvet is a devoré or 'burn-out' print.

Two warp-printed furnishing cottons of the 1930s.

Crimp print.

Orbis print.

A design for chiffon by a final-year
student, showing the paperwork and
the excellent translation on to cloth.

other substances. For the purpose of discharge printing there are two in use, stannous chloride and sulphoxylate (stabilized with formaldehyde).

Stannous chloride ('tin salt' or 'tin crystals') was used much more widely many years ago but has been largely abandoned in favour of the sulphoxylates because it has a tenderizing effect on silk and wool and also on cotton. (For this reason sodium acetate was added to the printpaste recipe.) The sulphoxylates are more powerful discharging agents and can be used to reduce a wider range of colours; they are cheaper and far less deleterious to cloth and also to equipment generally. With stannous chloride, during the steaming process hydrochloric acid is formed, with obvious degradation to the metal steaming equipment if it is not specially resistant; in certain cases equipment has virtually worn out in two or three years. But in recent years experiments have been carried out in discharging on polyester, polyamide and acrylic fabrics, and where coloured discharge is desired stannous chloride is used.

The *sulphoxylates* are usually hydrosulphates stabilized with formaldehyde, and they are marketed under various trade names – 'Formosul', 'Rongalite' and 'Redusol'; the last is stronger, with a zinc additive. These substances decompose at temperatures above 80° C (176° F) and so must not be dried at too high a temperature.

Note: Both these types of reducing agent can be potentially dangerous and should be handled and stored with care. They should be kept in airtight containers, away from heat and damp conditions. Formosul and similar brand products should not have water added to them and if left lying around exposed to dampness, in certain circumstances they can be explosive.

Thickening agents

In direct printing the choice of thickener is very important, but there are additional aspects to consider in the production of discharge prints. Not only must the thickener have sufficient solids content to prevent bleeding, which is one of the troubles most often occurring in discharge work, and causes a white 'halo' round illuminating colours; it must also be one which is suitable for the particular dyestuff being used, and unaffected by the reducing agent. Stannous chloride, being a metal salt, has a coagulating effect on certain thickenings such as alginates (which are anionic, or negatively charged); among these are Manutex and certain of the carob-seed gum derivatives, e.g. some of the Meyprogums and some of the Indalcas. However, other Indalcas are highly recommended, notably Indalca PA/3-R, Indalca SRC/60, Indalca SRM/60, and Meyprogum NP 16. Others are being developed especially for discharge work. Traditional thickenings for discharge work for both types of reducing agent are gum arabic and gum tragacanth.

DISCHARGE PRINTING ON SILK
AND WOOL

Silk and wool are dyed with those dyes from the acid and direct ranges which are dischargeable with Formosul, or other discharging agents such as Rongalit. The direct or acid dyes are used in conjunction with acetic acid (or Glauber's salts when directs are used on cellulose fibres).

The quantity of dyestuff needed is calculated as a percentage of cloth weight: if a 2 per cent concentration is required, 2 grams will be needed to dye 100 grams of cloth. Acetic acid is used in the ratio of 5 to 10 per cent of cloth weight.

The cloth is first wet-out thoroughly in cold water and entered into the cool to warm dyebath in which only the dyestuff, added after being thoroughly dissolved in a small quantity of boiling water, is present. The cloth is worked at 30–38° C (85–100° F) for about 10–15 minutes, before it is lifted out and the acid is added. The cloth is then returned and the temperature raised gradually to 82–88° C (180–190° F) over half an hour. Note that the quantity of water in the dyebath must be about 30 times the cloth weight. After dyeing, the cloth must be thoroughly washed and dried.

Some direct dyestuffs suitable for dischargeable ground shades are:

Durazol Yellow 6G	Solophenyl Brown BL
Durazol Orange 4R	(medium depths)
Chlorazol Scarlet 4BA	Solophenyl Green 5GL
Durazol Red 2B	Solophenyl Grey NGL
Chlorazol Red BK	(medium depths)
Durazol Violet R	Solophenyl Red 6BL
Durazol Blue G	Solophenyl Yellow 5GL
Durazol Blue 4R	Diphenyl Black NGL
Durazol Grey RG	(medium depths)
Chlorazol Black GF	Solophenyl Violet 4BL
Solophenyl Blue 200°	(medium depths)

These colours will all discharge well in medium shades and for coloured effects, and many will discharge at full shade and to a clean white.

For faster shades Cuprophenyl direct dyes (Ciba-Geigy) are useful: Cuprophenyl Red FGL, Brilliant Blue 2BL 200 per cent, Navy Blue RL, Green 2BL, Yellow Brown RGL, Black RL. These dyes, after being dyed with the addition of 0.5 grams of tetrasodium pyrophosphate and 10–20 grams of Glauber's salts per litre, need an 'after-coppering'. This consists of treating the dyed cloth in a bath of 1–3 per cent copper sulphate crystals and 1–3 per cent acetic acid 40 per cent for 30 minutes at 70° C (160° F).

Many acid dyestuffs can also be used as dischargeable ground shades on silk and wool. The dyeing methods vary according to colour and reference should be made to the manufacturers' literature but, broadly speaking, on wool 10–20 per cent Glauber's salt crystals with either 2–4 per cent

sulphuric acid (89° Be (168° Tw)) or 2–4 per cent acetic acid 40 per cent is used and the cloth is boiled for approximately 30–40 minutes. Silk is treated similarly.

A recipe for white discharges (neutral):

> 15 g Formosul
> 5 g glycerine
> 10 g water
> 70 g thickening (Indalca or Printel)
> ___
> 100 g

The Formosul (crushed with a pestle and mortar if purchased in lump form) is mixed with the glycerine and water and added to the thickening. For printing on fine silk the print-paste must be made thin enough to penetrate the cloth evenly but viscous enough to avoid bleeding, either directly after printing or during steaming. Steam for 5 minutes in conditions as air-free as possible and then wash it in cold water.

If haloing occurs this can be due to too much moisture in the steaming (in which case the glycerine can be cut down) or to too high a concentration of Formosul.

The following acid dyes can be used as illuminating colours: Lissamine Fast Red 4B, Lissamine Yellow FF, Lissamine Yellow A, and Coomassie Blue GL, as can those directs which resist the action of Formosul. Basic dyes can also be used, and in this case Glydote B is often a more effective solvent. Suitable colours are Auramine Yellow, Acridine Orange, Acronol Sky, and Rhodamine.

Recipe:

> 0·5–2 g dye
> 2–5 g glycerine
> 12–15 g hot or boiling water
> 65 g thickening
> 15 g Formosul
> Bulk to 100 g

Paste the dyestuff with the glycerine and add the hot water. After cooling, add the Formosul and when thoroughly dissolved add the mixture to the thickening. Alternatively, add it to the powdered Formosul as a last ingredient. Steam for about 45 minutes. This timing is very often necessary to fix the illuminating colour, but can be cut down with some colours. The discharging action is complete in 5 minutes, as before. Wash in cold water.

It is important to dry the cloth carefully at a moderate temperature and then cool it before entering it into the steamer. Steam it as soon as possible. Steaming cloths need to have a fairly open weave, to allow the passage of steam. If it is not possible to steam straight away, the cloth must be covered up and kept away from direct sunlight in a cool, dry place. At no time during or after printing must the cloth be exposed to direct sunlight.

It is also possible to use selected *reactive dyes* as illuminating colours for printing on to direct-dyed grounds. Examples are the Cibacron dyes Brilliant Yellow 3G-P, Yellow R-A, Brown 6R-P, Brilliant Red 3B-P, Violet 2R-P, Brilliant Blue 4G-P, Turquoise Blue GF-P, and Brilliant Green 4G-A.

Recipe:

> 3 g dye
> 10 g urea
> 5 g soda bicarbonate
> 50 g alginate thickening
> 28–29 g hot water. Cool, and add
> 2–3 g Rongalit FD or Formosul
> 1 g anthraquinone powder
> ___
> 100 g

The addition of anthraquinone powder will often help to produce a cleaner discharge.

Fine black outlines can be printed alongside discharge work with pigments, or, if using reactive dyestuffs as illuminating colours, the following reactive dyestuff recipe is suggested:

> 8–10 g Cibacron Black BG-A
> 5 g urea
> 5 g sodium bicarbonate
> 50 g alginate thickening
> 5 g Albatex BD
> 2.5 g sodium dichromate
> 22–24 g water
> ___
> 100 g

Some dyed grounds are discharged to a purer white by the use of an *alkaline discharge paste*:

> 15 g hydrosulphite FD conc. (Formosul)
> 15 g water
> 5 g urea
> 3 g potash
> 5 g Uvitex 2B 1.40
> 57 g thickening
> ___
> 100 g

DISCHARGE PRINTING ON COTTON OR VISCOSE

Cloth can be dyed with direct dyestuffs but substituting 10 per cent Glauber's salts for acetic acid.

The traditional illuminating colours for printing on cotton are vat dyestuffs but, as we have already seen, these are fairly difficult to use and control, especially in slow hand screen printing. Pastes should be used instead, such as QF pastes (ICI) or micropastes (Ciba-Geigy).

An *alkaline stock thickening* can be made from gum traga-
canth, British gum, Solvitose C5, gum arabic, or Nafka
crystal gum.
Recipe:

> 200 g potassium carbonate★
> 150 g sodium carbonate
> 125–185 g Formosul
> 75 g glycerine, all stirred into enough
> thickening to make 1000 g.

Printpaste

It is easier to paste the dye (but even better to use it in paste
form) with a similar quantity of thickening; this gives a
more even suspension of colour.
Recipe:

> 5–20 g dye, pasted with
> 5 g thickening, then strained into
> 90–80 g alkaline stock thickening
> ———
> 100 g

Cloth may also be dyed with reactive dyes; these give a
very colour-fast result and Hoechst Remazols are particu-
larly recommended. These are used in conjunction with
50 grams of Glauber's salts per litre and at temperatures of
40–60° C (110–140° F). After half an hour add 5 grams of
pre-dissolved sodium carbonate per litre and dye for a fur-
ther 20 minutes before rinsing and washing.
White discharge:

> 20 g Formosul
> 8 g Leucotrope W
> 40–50 g thickening
> 20 g caustic soda 38° Be (72° Tw)
> 0.5 g optical white
> ———
> 100 g

Coloured discharge: as for direct-dyed grounds although the
use of sodium carbonate is preferable. Add 20–50 grams of
caustic soda 38° Be (72° Tw) and up to 100 grams of Formo-
sul for deeper shades.

After printing, the cloth must be dried at a moderate tem-
perature, away from sunlight, then cooled and steamed with-
out delay for 5–10 minutes in saturated steam. For those
cloths with direct-dyed grounds a copious rinse for about
15–20 minutes in cold water is generally sufficient to develop
the shade of the vat dye. Washing should certainly be no
hotter than 50–60° C (120–140° F) owing to the very limited
fastness of the ground. Experience will show the direct-
dyed grounds which may be more severely treated.

For the Remazol grounds the same cold-water treatment
is necessary; a little acetic acid may be added, but no oxidiz-

★ Potassium carbonate is expensive
and sodium carbonate much
cheaper; also, less is required in
recipes.

ing agents. Then these reactive-dyed cloths can be safely
soaped, or treated with detergents, for 5–10 minutes at the
boil. A suitable detergent is 3 grams of Lissapol ND per litre.
This soaping at the boil, which is good for reactives, is
usually an essential part of the after-treatment of vats for it
develops the depth of shade, but it should not be used on
direct grounds. Note that it is essential to ensure that
steaming is air-free, otherwise the time needed to ensure the
correct reduction of the dye will be too short. (Formosul
decomposes very quickly if oxygen is present in the steam.)
It follows that printed fabric must be stored in dry, low-
temperature conditions (not humid).

N.B.: reds, pinks, oranges, browns, violets and blacks are
affected very much by daylight after steaming.

Reactive dyestuffs can, of course, be used as illuminating
colours on direct-dyed grounds, as previously mentioned.

Here is a suggested list of vat colours to give a varied
range:

producer	trade name	paste
ICI	Caledon Yellow GK	QF
ICI	Caledon Yellow GN	QF
ICI	Caledon Jade Green XBN	QF
ICI	Caledon Navy Blue AR	QF
ICI	Caledon Purple 4R	QF
ICI	Caledon Blue GCP	QF
Ciba–Geigy	Cibanone Orange 3R	micropaste
Ciba–Geigy	Cibanone Red 4R	micropaste
Ciba–Geigy	Ciba Blue 2B	micropaste
Ciba–Geigy	Cibanone Printing Brown 2R	micropaste
Hoechst	Indanthren Pink 3B	2PH
Hoechst	Indanthren Red Violet RRN	2PH

DISCHARGE PRINTING ON SYNTHETIC FIBRES

The Italians have contributed a great deal of research in this
field and are currently producing quite a high percentage of
cloth in this style.

Typical recipes for discharge printing on polyamide, poly-
ester and acrylic fibres follow. It must be emphasized, how-
ever, that these do present a great number of difficulties in
that disperse and modified basic dyes are hard to destroy
when fixed. They are therefore given mainly for interest
and experiment. They use stannous chloride, which is very
damaging indeed to steaming equipment because hydro-
chloric acid fumes are given off.

FOR POLYAMIDE FABRIC (white discharge)
12–18 g sulphoxylate
50–60 g thickener
water to make 100 g

FOR POLYAMIDE FABRIC (coloured discharge)
<div style="text-align:center">

up to g acid dyestuff
4 g thiodiglycol
1 g butyl carbythol
55–60 g thickener
15–20 g stannous chloride (1:1)
water to make 100 g
</div>

or up to 10 g disperse dyestuff
<div style="text-align:center">

55–60 g thickener
15–20 g stannous chloride (1:1)
water to make 100 g
</div>

Print, dry, steam for 20 minutes at 102° C (216° F), and wash.

FOR POLYESTER FABRIC (white discharge)
<div style="text-align:center">

10–20 g sulphoxylate
1–2 g citric acid (1:1)
4–8 g carrier
50–60 g thickener
water to make 100 g
</div>

FOR POLYESTER FABRIC (coloured discharge)
<div style="text-align:center">

up to 10 g disperse dyestuff
4–8 g carrier (this can vary, depending
on the type of carrier used)
50–60 g thickener
10–20 g stannous chloride (1:1)
water to make 100 g
</div>

FOR ACRYLIC FABRIC
<div style="text-align:center">

up to 5 g cationic dyestuff, liquid
(i.e. modified basic)
55–60 g thickener
2 g citric acid (1:1)
1.5 g Luprintan PFD
10–16 g stannous chloride (1:1)
water to make 100 g
</div>

Print, dry, steam for 10 minutes at 100° C (212° F), and wash.

DISCHARGE-RESIST STYLES ON SYNTHETICS

As far as the discharge printing of acrylics is concerned, a much easier method, and one which has the advantage of using less stannous chloride, has recently been suggested by Bayer, Ciba-Geigy and others. This is, in effect, a discharge-resist style in which the ground shade is printed on a rotary screen machine from two screens of different mesh size, for example first a 60-mesh, then an 80-mesh. The fabric is printed without gumming down, dried, and either rolled or plaited to wait for the printing of the coloured discharge. After this has been printed, the fabric is dried (at low temperatures, not more than 100° C) and steamed for 30 minutes at atmospheric pressure or slightly higher, and at or slightly

above boiling point. This will fix both the ground shade and
the discharge print. Wash off as for normal printing with
modified basics (see p. 119). This style can be quite success-
fully operated by hand screen.

GROUND SHADE

0.5–3 g dye
2 g glycerine A
2 g Luprintan
0.5 g citric acid (1 : 1)
40 g thickening
water to make 100 g

Some dischargeable dyes for ground shades are: Astrazone
Orange RRL, Red BBL, Red RL, Bordeaux BL, Blue GL,
Blue FGGL, and Yellow Brown GGL; Maxilon Orange
2GL, Red 2 GL, Red 3 GL, Bordeaux 2 BL, and Blue GRL.

COLOURED DISCHARGE

3 g dye
2 g Luprintan PFD
0.5 g citric acid
60 g thickener
5 g stannous chloride (1 : 1)
water to make 100 g

For thickenings, carob-seed gum ethers of a medium-solid
type are recommended, such as Indalca PA3, or alternatively
a methyl cellulose such as Tylose MH300. Some suitable
dyes as illuminating colours are: Astrazone Yellow 7GLL
liquid, Golden Yellow GL liquid, Orange 3R liquid 50 per
cent, Brilliant Red 4G liquid 200 per cent, Pink FG liquid,
Red 6B liquid, Red Violet FRR liquid, Blue 5RL liquid,
Blue FRR liquid, Blue G liquid 50 per cent, Brown MD
liquid 50 per cent; Maxilon Brilliant Flavine 10GF, Yellow
6GL, Brilliant Red 4G, Brilliant Red 3B, Blue BL, Blue
3RL, Blue 5G.

I have mentioned the difficulty, particularly on polyester
fibre, of destroying a fixed disperse dye by discharging
because the dye, being deeply fixed in the fibre, is not easily
accessible to the discharging agent. So here, too, it is sugges-
ted that a discharge-resist technique be employed. After
padding, or printing, the ground shade and subsequently
drying it, the discharge is printed on before fixation and
while the dye is, therefore, still on the surface of the fibre.
Because of this the discharge paste need contain no swelling
agent; this greatly improves the definition of the discharge
print and reduces the danger of haloing. The cloth is padded
in up to 5 per cent disperse dye, 10 grams per litre Primasol
AMK or other aid to dyeing polyester, and 1–2 grams per
litre alginate, with enough tartaric acid added to bring the
pH down to between 5 and 6. It should then be dried at
100° C (212° F) with circulating air.

WHITE DISCHARGE

15–20 g zinc formaldehyde sulphoxylate
(e.g. Redusol 2 or Decrolin)
55 g locust-bean gum thickener 8%
2 g Sol Developer D
0.2 g anti-foaming agent
0.5 g optical brightener
water to make 100 g

COLOURED DISCHARGE

4–8 g stannous chloride (1 : 1)
55 g thickener (locust-bean)
0.5 g anthraquinone powder
up to 10 g disperse dye
0.2 g anti-foaming agent
water to make 100 g

Dry carefully; after printing steam at 100° C (212° F) for 15 minutes at 2–2.5 bar in the star steamer, and then give the cloth a cold rinse.

Some discharge-resistant disperse dyes are: Terasil Brilliant Flavine 8GFF, Yellow 6G, Pink B, Violet BL, Blue 3RL, Blue G. Dischargeable disperse dyes include: Terasil Yellow GN, Orange 3RL, Brown 5RL, Cibacet Brilliant Scarlet RG, Terasil Red 2GL, and Serisol Blue 3RD.

Completed West African prints baled and awaiting export.

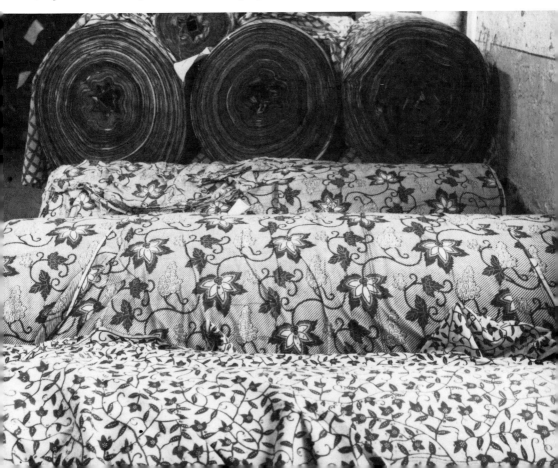

8 Other special styles

DEVORÉ

The 'burn-out' or devoré style used also to be called *broderie chimique* in Europe, because it can be used to give the effect of machine embroidery and this effect is achieved chemically, In fact, it is produced by the burning-out or dissolving away of one of the fibres in a mixed-fibre cloth, which results in the cloth being patterned in open and more solid areas.

The style has had a revival in the last few years, particularly in Britain in 1972–73, partly because of the greatly increased use of polyester/cotton blends. Some delightful lingerie and blouse fabrics have been produced in the lower and medium price-brackets, many printed in the Far East. As well as having a burn-out pattern, the effect can be enhanced with colours; in polyester/cotton these would be disperse colours.

But in the forty or fifty years before the Second World War, although the style was too specialized to be widely used, nevertheless many original and beautiful effects were obtained, particularly with silk/cotton or silk/acetate velvets and also with finer plain cloth mixtures to produce lacy effects. At present these velvets, often patterned by hand printing, are being produced again in the Lyons area for a very exclusive market, often retailing at £30 or £40 per metre.

Louis Diserens, in his *Chemical Technology of Dyeing and Printing* (translated into English 1948), lists three types of burn-outs using cellulose acetate:

1 burning out the cellulose and leaving the cellulose acetate and animal fibres.
2 burning out the cellulose acetate and leaving cellulose and animal fibres, and
3 burning out the cellulose as well as the cellulose acetate and leaving the animal fibres.

There are other combination cloths with which the method is possible.

Where the cellulosic fibre is to be burnt out, as in polyester/cotton lawns, sodium hydrogen sulphate or aluminium sulphate is commonly used, in which case a typical recipe would be:

15–20 g sodium hydrogen sulphate
(or aluminium sulphate 15%)
72–77 g thickening (e.g. Indalca PA30)
8 g glycerine
Bulk to 100 g

There is also an increasing interest in the development of devoré furnishing cloths. These are being produced in small quantities in Britain, and also in West Germany, Spain and Sweden.

CREPE (CRÊPON OR CRIMP)

This style, much used in the past in a variety of ways, is based on the action of strong caustic soda on cotton (see mercerizing, p. 50), a thickened caustic solution being used to print simple areas such as stripes. The caustic shrinks the fibres, 'cockling' or 'crimping' the untreated rest of the cloth. Colour can also be introduced into the style, for example by adding direct dyestuffs (which are unaffected by caustic) to the paste, so producing smooth, flat-coloured prints against crimped white areas. Alternatively a heavy gum resist such as arabic or British gum can be printed along with the dye, and the cloth, after the required steaming, can then be padded in a caustic solution; this results in a crimped coloured print. The best possible results are obtained by printing at least half the fabric with caustic.

This creping style has almost completely disappeared but an interesting modern version of it, which may help to re-introduce crêpon printing into fashion fabrics, has been developed by Hoechst, based on the discovery that many of their Remazol reactive dyes deepen considerably in shade as a result of being overprinted with caustic soda.

After the fabric has been dyed or printed with Remazols it is overprinted with a thickened caustic soda solution (a crystal gum is considered to be the best as it will not encourage reduction of the dyestuff). A suitable recipe is:

75 g caustic soda solution 50° Be (106° Tw)
25 g crystal gum thickener 1 : 2

When the cotton cloth has been printed with the creping liquor, it is plaited down for a 'dwell' time of about 30 minutes, but up to one hour will not spoil the shade. It is then well rinsed, continuously or as open as possible, and neutralized in an acetic acid solution. Finally the cloth is rinsed, first in hot water and then in cold, and dried without tension. The following Remazols, among others, deepen considerably with the creping: Brilliant Yellow 7GL, Golden Yellow G, Golden Orange 4G, Red B, Red 3B, Bordeaux B, Navy Blue RR, Turquoise Blue G, Brilliant Green GGL, Grey G, Printing Black BG, and Brown GR.

An example of modern devoré fabric.

Alkaline creping on cotton

On white or dyed cloth the following recipe can be printed:

75 g caustic soda solution 50° Be (106° Tw)
25 g crystal gum thickening 1:2

After printing, the cloth (released from its back-grey) must be left for at least 30 minutes; any time up to an hour will not cause deterioration.

Finally the cloth must be given a continuous cold rinse neutralized with acetic acid, rinsed again in hot and then cold water, and dried without tension.

Some reactive dyes, when printed on completely neutral cloth or cloth dyed with selected reactives, experience quite a marked change of shade. To avoid this, the cloth can be creped first and then dyed. To arrive at the best results, the cloth must be free from any impurities, such as starch.

Dyes suitable for use in creping include the following Remazols: Brilliant Yellow 7GL, Golden Yellow G, Red B, Red 3B, Printing Bordeaux B, Turquoise Blue B, Brilliant Green 6B, Grey G, and Brown 3G.

TRANSFER PRINTING

This method (sometimes known, from one registered process, as 'Sublistatic' printing, or alternatively as 'heat reprint') can be defined as the printing of textile fabrics by contact through heat and pressure with a paper web previously printed with dyestuffs which will sublime. Its use has increased beyond all expectation since its introduction in its present form in the early 1960s. There has also been a significant increase in up-dated forms of the much older type of 'hot-pressing print' (particularly used on tee-shirts), but this method must not be confused with the sublimation method, as in it the whole printing colour film, including the adhesive, is pressed on to the cloth by heat, the resulting design being rather stiff and liable to be partly rubbed away after a few washings.

By far the most interesting transfer printed effects, from the student's and designer's point of view, are those made possible by the use of gravure and lithography. These production techniques allow designers to explore the possibilities of shading and tonal effects generally, and also of finer drawing and more precise matching up of colour areas, which are less easy to arrive at by conventional textile engraving.★ Transfer printing therefore has produced a marked change of style over the last three or four years in the fabrics of those firms sufficiently interested in it and aware of its scope. Notable in this respect have been the work of Sublistatic S.A., and some Japanese cloths.

In recent years, work has also progressed in the field of transfer for use on wool, silk, cotton and viscose, as well as

★ In Europe, over the last 8–10 years, the textile trade has gone over to 'cell' engraving for textile cylinders because this gives much greater accuracy and better tonal effects.

on suède and leather, by the 'wet transfer' method known as Fastran (Dawson International Ltd). Although this allows transferring on to fibres other than merely man-made, it entails four extra processes:

1 padding the cloth or garment in a viscous paste made with Fastran powder,
2 passing through the 'nip' of a mangle before being put into contact with the transfer paper, which is printed this time not with disperse dyes but instead with reactives for wool, silk and leather, modified basics for acrylics, and directs (or reactives) for cellulosics,
3 a contact time of 4–6 minutes, instead of just seconds, and
4 finally, conventional scouring and milling processing.

So this 'wet transfer' method is altogether a much more elaborate one, although it does not necessarily require any greater skills on the part of the operatives, simply care and attention. Particularly noteworthy (again to designers) is the very successful use of the process on suède.

The Fastran technique is now being developed for the transfer of various chemicals to cloth in order to convey properties such as flame-retardance, and water and moth repellance, and it is also being used to create interesting emboss effects by chemical means and heat combined with pressure.

Development of aqua systems

Up to very recently, transfer printing has been in the hands of paper-printing firms and a few printing-ink producers, so the systems were based on organic solvents, as printing inks are. Now, however, some textile printers employing rotary screen printing machines are beginning, with these machines, to print transfer paper for themselves using an aqua system not appreciably different from the normal direct fabric printing, possibly from the same screens. This is only in the early stages, although many companies have developed disperse dyes and recipes specially suited for use in this way.

There are three main sources of difficulty. Firstly, paper has a tendency to 'cockle' and stretch when printed with water-based colours and it is therefore essential to use a paper which, while being coated (preferably on both sides as in solvent-based printing), is still slightly absorbent so that it can dry quickly. Secondly, paper will only accept about one-third as much colour as it is possible to get on to cloth, so in order to produce colours of comparable depth to those obtained by direct cloth printing, manufacturers' pastes contain 30–55 per cent colour for use in printing paper by textile machines. Thirdly, disperse dyes for transfer use have been developed to disperse easily in water, but as little as possible must be used; thickenings are needed with high viscosity but small quantities of solid particles – for instance, starch ethers or locust-bean gums. The successful transfer of the

Fabric embossed by means of the wet transfer process.

colour depends largely on the thickening agent, and only the minimum is needed for swift transfer of the colour to the cloth.

Over the first few years of progress in transfer printing, there tended to grow up a mystique around the 'secrets' of the trade. One was constantly told of the necessity, for example, of having 'special transfer paper' – but this is in effect no different from the coated papers already in use for other purposes. One was told that the constituency of the thickening/binding agent was vastly secret and all-important – but these are virtually the same as those used in normal textile and paper printing fields. Depths of engraving for photogravure transfer work were clouded in mystery: again, although experiment was needed, fairly standard depths of 40 microns can be and are used. But very largely, while it is true that suitable papers are essential, that the colours must be evenly dispersed (and for litho and gravure very finely milled before dispersion), and that engraving depths leave room for experiment, much of the secrecy has been fostered because of patent rights. Manufacturers of disperse dyestuffs, in order to market a suitable range for transfer use, have largely been able to redevelop older dyes which had been discarded on account of their unacceptably high tendency to sublime. In ordinary textile printing this caused staining, 'marking-off' and unevenness of shade. Now the aim has been a selection of colours which are compatible (and therefore mixable) and which all sublime at the same rate.

Application of transfer printing to college work

For use in the screen printing of transfers the disperse dyestuffs, in powder, grain or paste form, can be either dispersed in as little water as possible or combined with a simple half-emulsion directly in a high-speed mixer. Alternatively made-up transfer-printing colours for screen printing can be bought from a supplier and used at standard strength, or reduced with an emulsion purchased as such or made up as indicated on p. 110. The design advantages of screen-printing transfers are not very great because it is the normal direct printing method used in colleges and therefore little can be learnt in change of style and design techniques; however, the process has some practical advantages relevant to industry, such as

the ease with which pattern and colour areas can be accurately matched up on paper,

the possibility of producing finer detail on paper unaffected by the surface texture of the cloth,

the comparative ease of ironing (or hot-pressing) a patterned piece of paper on to a stretchy fabric, as opposed to pinning the fabric to a back-grey (or sticking it to the print table) and accurately positioning screens on it, with all the likelihood of some movement between printings, and

the absence of any after-processing, such as washing, drying and pressing.

However, from the standpoint of learning the designer's craft, painting designs on paper in transfer inks and hot-pressing these one or more times on to cloth is an invaluable way of learning the possibilities of this sophisticated method. From it can come an understanding of how techniques previously used mainly in the field of illustration can be excitingly adapted to fabric.

ONE-ROLLER POLYCHROME PRINTING

There are a variety of patents involved in this style of work – Orbis, the Englander process, the Sark Chromostyle and others. The USA, France, Japan and the USSR have all been cited as the originators of the idea of making up a patterned roller from plasticized coloured pieces; it has roots in work dating from before the Second World War, and the main developments came in the middle to late 1950s. Various types of dyes can be used (though mostly, at present, those used for synthetic fibres) and these are mixed with specially prepared thickening agents and heated under pressure to produce strips of plasticized colour. These strips are cut up and stuck together or marbled and swirled together while hot and malleable, and in this way is built up a sheet of pattern curved into a cylinder, which is then laminated on to a metal shaft. The cloth to be printed is wet-out in the chemical solutions which are appropriate to the class of dyestuff being used (acids, directs, vats and pigments), using such ingredients as wetting-out agents, urea, alkalis, hydrosulphite and resins; it then passes through the nip between a plain metal cylinder and the patterned one and so the design is transferred.

The various methods allow of the printing of 3,000 to 25,000 metres of cloth. Because the surface of the colour roller is worn away as printing continues – and thus its circumference decreases – the design must be of a free type, unspoilt by this gradual diminution in repeat size.

It is easy by this means to produce all manner of marbled and swirled colour effects, using, if desired, hundreds of colours and tones. It is in the exploitation of these possibilities rather than in attempting set repeats, that the interest lies.

FLOCK PRINTING

In this method cut fibre (usually viscose nowadays) is applied to Terylene or nylon cloths to form a raised velvety pattern in white or colour. The flock is fixed to the base cloth by means of a resin binder previously printed on to it, usually by flat or rotary screen but also by roller printing.

The flock can be applied by one of two methods. In the first, the flock is activated in an electrostatic field so that each

of the fibres adheres to the base cloth end-on, thus making an even and dense vertical pile. The other method, not nearly so effective, is that of mechanically shaking the flock over the printed adhesive. The resulting print is not so even and does not adhere so firmly.

Flock printing is used very much to decorate Terylene curtain nets, and also for nylon and Terylene dress goods, particularly bridal wear. Certainly as far as the sheer curtain cloths are concerned fastness to washing is very important, and if the adhesive is not 'cured' correctly the flock will tend to wash off very quickly in normal washes. Wash-fastness tests are insisted on by ICI for flocked Terylene, as a result of which gradings are given, 1 being good and 6 being the grade given to fabric which loses all flock in one or two washes. Only cloths meeting standards 1 and 2, and sometimes 3, are considered acceptable.

WARP PRINTING

This is the industrial development of the *ikat* – a style of patterned cloth in which portions of either the warp or weft threads or both are tied with a plain or waxed thread to prevent that area becoming coloured during subsequent immersion in the dyebath. The warp threads so coloured, or partially coloured, are entered into the loom and then plain, coloured or partially coloured weft threads are woven across to produce a soft-edged pattern.

Industrial warp printing is practised very little today, and in Britain, not at all. But in the nineteenth century and the first half of the twentieth it was used as a means of producing fine, softly patterned dress goods in silk and wool, and also for a style of cotton furnishing fabrics very popular between the two wars. In the latter, the warp was printed by engraved roller, surface roller or block, and then woven into a complete fabric afterwards.

Discharge on natural silk and cotton

White discharge on silk dyed with Chlorazol Black GF 1.5%.	White discharge on silk dyed with Durazol Blue 4R (dischargeable) and Durazol Brown R (non-dischargeable).
Silk dyed with combination of Durazol Red 2B, Durazol Yellow 6G and Durazol Blue 4R. Printed with Black line (pigment), Lissamine Yellow A and Lissamine Red 4B (illuminating colours).	Silk dyed with Chlorazol Black GF. 25% Pale green: Lissamine Yellow FF + Coomassie Blue GL. Orange: Lissamine Yellow A + Lissamine Red 4B. Good alternative illuminating colours from Hoechst are: Lanaperl Fast Pink R; Lanaperl Fast Violet 6R; Lanaperl Golden Yellow R (good tinctorial strength); Amido Rhodamine G extra (less blue red for scarlet mixtures); and Remalan Fast Orange R-LL conc.
White discharge on silk, dyed ground. Direct printed in Coomassie Blue GL.	Dyed ground direct stipple printed with Coomassie Blue GL and then white discharge.
White discharge on dyed cotton.	Colour discharge using vat dyestuffs – Cibanone Green and Scarlet micro paste.

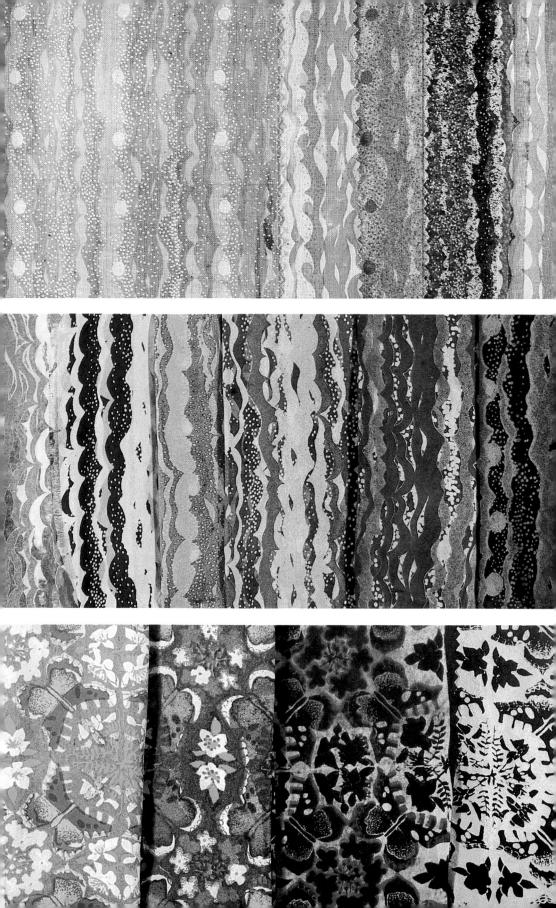

9 Fixation

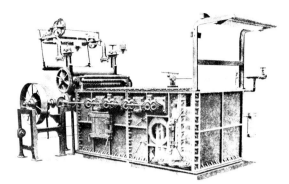

Mather & Platt atmospheric steamer of 1913 vintage.

After the fabric is printed and dried, it must be subjected to some sort of fixation process to ensure that the dye, which at this stage is only superficially adhering to the fibre, becomes permanently bound to it. By far the most important method is undoubtedly steaming, but fixation processes also include the use of dry heat (baking or 'thermosoling') and wet fixation treatments.

From the early days of printing in Europe it was found that it was necessary to expose the mordanted fabrics for long periods to the action of warmth before they passed through the madder bath. This knowledge originally came from the East, where fabric was spread out on bushes to take advantage of the warm and often moist atmosphere. In Europe, for a long time, the period needed was judged by trial and error and it was not even realized that moisture was also necessary. This exposure to warmth, and then warmth and moisture, became known as 'ageing' and it did take a long time. Also, of course, not only did warmth and moisture help to fix the mordant successfully, but they were also used as aids in clearing the tinted ground after 'maddering'.

Very soon, however, large ageing rooms or chambers began to be constructed, and after 1828, when Daniel Koechlin of Mulhouse established beyond doubt that moisture was an essential feature in the ageing of mordants, steam as well as hot air was circulated in the chambers. Over the years experienced printers realized that just as good results could be obtained by passing the cloth through hot steam for longer or shorter periods, and so the term 'ageing' has come to include all methods of fixation by steaming.

In 1849 the first machine in Britain for continuous ageing was built by John Thom of Mayfield and improved versions were produced by Walter Crum, a scientifically minded calico printer from Thornliebank, near Glasgow. Crum's process took place in a building 48 feet long inside and 40 feet high, with a central wall forming two compartments, each 11 feet wide. In one of these the goods received the moisture they required. The cloth travelled on rollers and was exposed to heat and moisture coming out of rows of funnel-shaped openings producing temperatures of about 38°C (100°F). Two hundred pieces, each 25 yards long, could pass through in an hour, each thus having an exposure

Opposite: Students' experimental prints. *Top and centre:* two samples by second-year students show how simple screens can be used in conjunction with direct and discharge printing techniques and colours to give almost unlimited variations on a theme. *Bottom:* tile-type scarf prints.

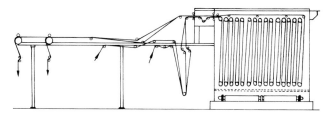

The Mather & Platt rapid ager, known universally as the 'Matherplatt'. The fabric passes vertically between guide-rollers through a box-shaped steaming chamber.

time of about a quarter of an hour. The purpose of the ageing was at this time considered to be the decomposition of the mordant and the liberation of acetic acid to leave an insoluble oxide on the cloth. The process was completed by leaving the cloth in bundles in a warm, moist condition for anything up to three days.

The ultimate development in ageing, paradoxically named the Rapid Steam Ager, was introduced by Mather & Platt in 1879. New models are still widely used in printworks throughout Europe and elsewhere and the latest version is described on p. 162.

In the early years of the nineteenth century, as we have seen, 'steam' colours first appeared – that is, those in which for the first time the various colours were actually mixed with a mordant, other chemicals such as tartaric acid to aid fixation, and a thickening, and printed directly on to the cloth, finally being fixed by exposure to steam for about 20–25 minutes.

The first reference to these colours and to the use of steam for fixation (in the records of the Chemical Committee of the Société Industrielle de Mulhouse) is in 1813 – the printing of merino wool with colours fixed by steam, by Georges Dollfus of Dollfus, Mieg et Cie of Alsace. Originally, 'steam colours' had a bad reputation for lack of fastness and for crudity of colour, and they did not in any way match up to the dyed style.

Andrew Ure, in his *Dictionary of Arts, Manufactures and Mines* (2nd ed., 1840), states that there were five types of steamer in use at the time of writing – the Column, the Lantern, the Cask, the Steam Chest, and the Chamber. These were all fairly primitive; made out of wood, they were capable of taking only comparatively small yardages. Their continued use was concerned with the fixation of block-printed wool and silk, whereas the continuous types previously mentioned were necessary installations for the large-scale production of roller-printed calicoes.

Introduced in 1879, the Mather & Platt Rapid Steam Agers – known all over the world as 'Matherplatts' – are still the most widely encountered rapid ager. By the mid-1930s they were considered to be an indispensable piece of modern printworks equipment.

They were 'roller agers' (i.e. the cloth was run over rollers). The machine consisted of an iron chamber fitted inside with a series of top and bottom rollers. The top of the chamber originally had a wooden hood which carried off

the gases released during the ageing process. The cloth passed into and out of the chamber by the same opening and low-pressure steam was supplied to it from a perforated pipe below the lower carrying rollers. Condensed water which ran down the walls was syphoned off at the bottom. It was essential to keep the chamber as hot as possible and so it was often boarded in to prevent excessive condensation.

It is absolutely essential that in any steaming operation the steam should pass evenly through the fabric, for vats particularly, and while being subjected to condensed steam there should be some superheat maintained to prevent water spots. The Matherplatt had a high rate of production and produced excellent work.

Before dealing in detail with steamers in use today it will help to clarify the meaning of terms used to describe various steam conditions. Dr Diserens, in his book *The Chemical Technology of Dyeing and Printing*, writes:

> Steam is water changed to a gaseous form by the application of heat. It may be either *saturated, superheated, dry or wet*. *Saturated steam* is that which is in the presence of, and at the same temperature as, the water from which it was evaporated. There is always a definite relation between the pressure and temperature in the case of saturated steam. For example, saturated steam evaporated under atmospheric pressure always has a temperature of 100° C . . . Steam evaporated under a pressure of 5 pounds (gauge) has a temperature of 100° C; under 10 pounds pressure, 116° C, etc. *Superheated steam* is that which has been heated to a temperature above that due to its pressure. Steam is superheated by passing it through pipes or coils exposed to the hot gases from the furnace, after it leaves the steam space of the boiler . . . *Dry steam* is that which contains no moisture. It may be either saturated or superheated. *Wet steam* contains more or less moisture in the form of spray; in other ways it does not differ from saturated steam, having the same temperature at different pressures.
>
> *Steam quality*: The percentage of dry steam in steam containing moisture is called the quality of the steam. For example, if a pound of a given sample of steam contains 0.04 pound of water, the quality is said to be 96 per cent . . . The proportion of moisture in steam is found by means of a device called a calorimeter.

FIXATION BY STEAM

Several different types of steamer have been developed for different dyestuffs, different fabric constructions, varying rates of production at different printworks, and for other conditions. All types, however, are either discontinuous, for small-scale operations, or continuous, for large, high-speed production. To illustrate these points we shall consider in detail the Mather & Platt continuous festoon steamer, the

Arioli high-temperature continuous festoon steamer, a Star
steamer, and a 'flash' ageing system.

The Mather & Platt continuous festoon steamer

In using the 'festoon' system, in which the cloth is carried
through the chamber on poles rather than over rollers,
Mather & Platt (and other firms too) have reverted to an
older method of cloth propulsion.

Although the 'Matherplatt' was so widely used and so
highly regarded, it did have some disadvantages for print-
works with a very high production rate: as it only steamed
prints singly, several roller agers were often needed. This
raised production but lowered the efficiency with which the
steam was employed. The roller method also has a tendency
to soil the cloth.

The Mather & Platt festoon steamer, using a new method
of steaming, can replace several roller-type agers because its
consumption of steam is much lower though its output is
high. It gives a greatly improved colour yield and because its
design allows steaming times of 10 to 70 minutes most classes
of dyestuff can be efficiently fixed. This steamer, in its
modern form, embodies most of the features which, over
the years, have been considered as essential by practical
printers processing big yardages. Its advantages are:

1 the absence of air in the chamber and the ability to main-
tain either dry steam at 108–110° C (226–230° F) or satura-
ted steam according to the chemical constituents of the
colours;
2 the elimination of marking-off, which was often a source
of trouble with the roller-type ager;
3 a uniform and rich colour yield, leading to an obvious
economy of dyestuff consumption;
4 low cloth tension (essential for many fine and delicate
fabrics);
5 economy in the use of steam in comparison with several
roller types.

In structure it consists of a rectangular chamber in sizes
ranging from 3.86 m to 10.21 m in length by 3.92 m to
9 m in height, formed from rolled-steel sections and steel
plates, which are protected before and after assembly with
linseed oil and paint. The chamber is insulated and there are
several doors and windows for access and inspection.

The ends of the poles on which the fabric is festooned are
held by an endless chain and they rotate as they pass down
the chamber so that no part of the fabric remains stationary
on the pole. In order to form the festoons an automatic
device is installed which holds each layer of fabric against
each pole as it enters until the required drop of fabric is
reached. It then passes to the next pole with a controlled
swinging movement and forms the next festoon.

To obtain and maintain the temperatures of 108–110° C

(226–230° F) necessary for dry steaming, perforated pipes inside the chamber are used. The problem of producing and maintaining the saturated steam needed for the solution, reduction and absorption by the cloth fibres of vat colours is a far more difficult one, solved by using four different sources of steam. It is often difficult to keep the chamber sufficiently saturated throughout because unwanted heat from condensing steam and other sources raises the temperature and dries the printed fabric, impeding correct development and fixation.

Sources of steam are: (a) water boiled in a tank at the bottom of the chamber by closed heating coils (this is the principal source); (b) the second principal supply is provided by blowing steam through special saturators submerged in the tank, which cause such intimate mixing of steam and water that the incoming supply of steam is thoroughly saturated at the required pressure; (c) perforated pipes situated above the water tank and near the roof provide two extra sources, needed for starting from cold and for certain special processes. But as well as these extra supplies of steam other features are necessary to get rid of unwanted heat generated in the areas where maximum reaction occurs; and for this purpose ventilators are placed high up in the walls of the chamber to induce an upward flow of saturated steam into this normally hotter zone. The dried steam is therefore led away to an economizer or to the atmosphere.

One of the great problems in the manufacture of any steamer is how best to prevent the formation of drops of water in places where they are likely to splash down on to the printed fabric. Mather & Platt solve this by building the roof of low-pressure cast-iron steam chests with steam-feed and trapping arrangements, but also placed at such a height that they do not cause drying of the moist steam near the poles. Further precautions take the form of double screens of perforated metal and gauze to stop water splashing up from the tank on to the fabric; protective covering to the lower perforated pipes; and the provision of heating for the two entering rollers and the guide and delivery rollers.

Another serious problem can be the danger of 'marking-off' from deposits of thickened colour which may adhere to the nip rollers at the entry point. Here the rollers are equipped with 'doctor blades', steel blades which scrape off deposits on the surface of the roller, as in an engraved roller printing machine. The steamer entry apparatus can be made to process two, three or four pieces of cloth at a time but if the fabric is heavily printed, it is considered best to admit the fabrics back-to-back or even with an intermediate back-grey. As for the passage of the cloth inside the chamber, the 'festoon' principle makes for much less danger of smearing.

To sum up, then, for printworks with large-scale production, particularly in vat colours, Mather & Platt festoon steamers, or the older Matherplatt roller steamers, are possibly the most widely encountered. For smaller works

The Arioli high-temperature
continuous-festoon steamer.

handling hand-screen printed vat colours which need con-
tinuous steaming the printer often has a small tower steamer
built to his own requirements. These are usually about 9 m
high and can take only about 20 metres of cloth. If it is to
allow an adequate steaming time – 15–20 minutes – it obvi-
ously will have to run extremely slowly. But because of the
slow running there is little or no danger of over-heating, and
very good colour yields are possible. But for screenprinters
using vats, versions of the 'Star' (see p. 166) are probably
more used.

The Arioli high-temperature continuous-festoon steamer

High-temperature (HT) steaming has developed in recent
years very largely for the fixation of prints on synthetics in
disperse colours, since disperse dyestuffs on polyester give a
very low colour yield indeed with atmospheric steaming.
Originally this high-temperature steaming was accom-
plished only batchwise in a pressure chamber such as a 'Star'
steamer, and was costly and time-consuming, but continu-
ous steamers have now been developed which operate with
water vapour at atmospheric pressure, and temperatures
above 100° C (212° F). Such a steamer is the 'Arioli'. There
are tremendous advantages in processing knitted fabrics, for
instance, continuously and without tension, instead of
wound up in batches.

The Arioli steamer is manufactured by Arioli & Co. of
Gerenzano in northern Italy, and although when developed
in 1960 by Signor Piero Arioli it was designed for only the
saturated steaming processes it was nevertheless a highly
original, fascinatingly simple solution to the problem of
steaming fabrics. Arioli (to whom must go the credit of
being one of the first engineers to make practical use of the
fact that steam is lighter than air) designed the machine in a
bell-shaped form. The steam is injected through a reservoir
of water within the hollow walls and after flowing through
them passes into the chamber through a central opening.
The ingenious use of the bell shape and the lighter-than-air

principle means that the air is forced out as the amount of steam increases, so leaving – what is always striven for in a steamer – an air-free chamber. To quote Mr Peter Shaw,

> With this method of steam circulation Signor Arioli asked himself, why build this steamer like other steamers as a completely enclosed system? His conclusions resulted in the first open-bottomed steamer, which did away with the necessity for seals and also enabled the fabric to be observed at all times during the process. It is, therefore, easy for the operatives to see any problems that may arise within the chamber during steaming.

So, as we have seen, by its very design it was automatically air-free and had a uniform temperature throughout. Next a system for tensionless transportation of the fabric was devised and when high-temperature steaming became possible it was only necessary to introduce a superheater – steam pipes embedded in refractory materials. Peter Shaw explains:

> The steam is supplied at a pressure of 8 atmospheres to the superheater passing through the coils and is superheated by means of a flame from the burner, which is directed through the centre of the steam coils. In this way the steam is superheated to a temperature of 350–400° C. The burner is a high/low burner which may be fired by gas or oil, enabling the Arioli steamer to be operated at temperatures from 100° to 180° C.

The steaming times are much shorter than those needed for pressure steaming; the following are the ones recommended:

polyester	4–8 minutes at 180° C and 165° C respectively
tri-acetate	4–8 minutes at 180° C and 165° C respectively
reactives on cellulosics	5 minutes at 150° C
nylon	15–20 minutes at 103° C
pigments	4–8 minutes at 180° C and 165° C respectively

For all high-temperature steaming of polyester and tri-acetate it is desirable to use special auxiliary products, such as Invalon P (Ciba-Geigy) or Levegal CA 33055A (Bayer), to increase the fixation of disperse colours.

Later models of the Arioli have a pre-chamber as an optional extra – the purpose of which is to improve still further the tensionless movement of the fabric by supporting it before its contact with the festooning device. Additionally useful is the fact that this pre-chamber is heated with saturated steam only, even when the main chamber is at high temperature. It is considered that fixation is improved by this uptake of moisture and it is also felt to be a good idea to heat up the material gradually (particularly as many knitted fabrics are textured or rather open, stretchy and fragile) from room temperature to 100° C and then to 170–

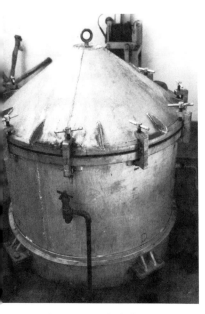

A star steamer built for small-scale use, as in colleges.

Winding the printed cloth round the 'star' frame. The steaming cloth which prevents the printed fabric 'marking off' is hooked on to the pins and the print is secured in a minimum number of positions or simply wound round without pinning.

180° C, instead of giving them the 'shock treatment' of immediate contact with high temperatures.

Summary of advantages and points of general interest

1 Completely revolutionary open-bottom design.
2 Automatically air-free and uniform in temperature.
3 Tensionless continuous fixation of knitted polyester at high temperature – until recently a big problem.
4 Any condensation which occurs does so within the hollow walls and so falls back into the water reservoir.
5 Fabric in full view all the time, so any problems can be seen immediately and dealt with.
6 Saturated or HT steam can be used.
7 No seals required in the main chamber.
8 The steamer can be erected on legs or be partially in a pit below floor level.
9 Large sizes: 130, 200, 360 and 520 metres in length and 220, 280, and 350 cm in width (425 ft, 650 ft, 1175 ft, and 1700 ft long; 7 ft 3 in., 9 ft, and 11 ft 6 in. wide).
10 Newly designed chain mechanism to cope with the extra weight resulting from the larger capacity.
11 Pre-chamber with the added advantage of some moisture and the less sudden introduction of high temperatures.
12 The later models have a photocell device. Should the chamber become too full of fabric the beam is broken and the outlet motor increased by 10 per cent until the capacity of fabric is reduced to a safe level, to prevent 'wrap-ups' occurring.
13 Much more economical running costs by comparison with pressure steaming: it has been calculated that the cost per metre in some circumstances could be reduced by as much as half. Cheaper to install, less electricity, one man in charge.
14 Steam *not* re-circulated because it contains chemical impurities.

Star steamers

This is a batchwise (or discontinuous) method which, while having the advantage that steaming times can be varied at will, has the disadvantage that output is low. Because of this factor, however, they are a type much favoured by hand screen printers. In the star steamer a back-grey of cotton or hessian is pinned by means of hooks on to a frame with radiating arms (the star). The printed cloth is then pinned to the back-grey (or sometimes simply laid against it) and so is wound round and hangs in a spiral. The star frame is loaded up away from the actual chamber and is then hoisted into it. The lid is tightened down and the steam, when turned on, enters the chamber from perforated pipes at the base. It passes through the spiral of fabric and out at the top. Often

it is difficult to ensure that the chamber is air-free (which, as we have seen, is essential for vats).

Often star steamers are heated to a higher temperature than in continuous processing in an effort to cut out the risk of bleeding; in screen printed fabric this is always a danger, because in this method of printing a much greater concentration of printpaste is likely to be deposited on the cloth than with engraved roller work.

Another difficulty with this type of steamer is the fact that, unless adequately protected, the cloth will be spoiled by drops of water which collect on the lid and drain down on to it. There are many variations of the star, often made specially to a printworks' own specification, and efforts to eliminate this drip problem vary from such ideas as heating the lid to lining it with specially absorbent felt.

Another important point, applicable to all steaming, is that completely free passage of steam must be possible. It is therefore essential to avoid packing the steamer too tightly (a temptation with the star). If this is not avoided, the steam goes round the easiest way and not through, which causes very shaded prints.

As well as steaming at atmospheric pressure (as in the case of vat colours or reactives), these chambers can be of much stronger construction and adapted for pressure steaming. Disperse dyestuffs used on polyester and cellulose tri-acetate need to be fixed by steam at pressures of 1–2.5 atmospheres (or alternatively HT steam) to obtain a high colour yield.

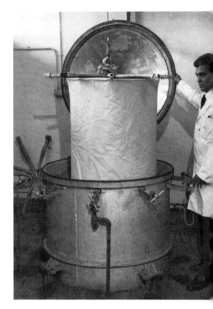

Lowering the star into the chamber by winch.

The 'Flash ager'

This type of ager was developed for the speedy fixation of vat dyestuffs but is now used for reactives also. It is essentially a 'pad-steam' or two-stage process.

Dyes which require special chemicals for their fixation, such as vats (needing an alkali and a reducing agent), and reactives (an alkali), sometimes tend to react too soon, either in the printpaste or on the cloth while lying on the print table. This happens particularly if the unfixed fabric (i.e. dried but not steamed) absorbs moisture. When this partial reaction takes place too soon it means that during the subsequent steaming process some of the dyestuff will be incapable of penetrating the fibre satisfactorily, and blotchy and irregular prints will result. The idea behind the two-stage process is that the colouring matter and the chemicals needed for fixation are kept quite separate. In the first stage the cloth is printed with only the thickened dye; in the second stage the chemicals are padded on to the cloth immediately prior to fixation by steam.

The two-stage process was first patented in 1927–28 when the then I. G. Farben brought out a new thickening agent, Colloresin DK, a methyl cellulose which was soluble in cold water but insoluble in hot water or alkali, so that when the cloth, previously printed in vat dye and so thick-

View inside a star steamer, showing how the cloth is positioned.

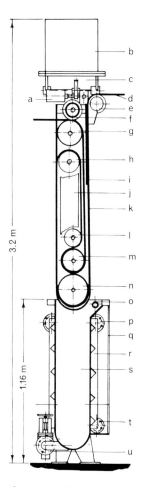

Wet fixation unit (Hoechst system):
a load for squeeze rollers; *b* housing
for compressed-air cylinders and
pulley system; *c* pulley; *d* fabric;
e reversing roller; *f* squeeze roller;
h reversing roller; *i* splash board;
j displacement box; *k* roller housing;
l–n reversing rollers; *o* feed pipe;
p steam inlet; *q* protective casing;
r indirect heating; *s* liquor trough;
t condensation outlet; *u* draining
valve.

ened, was padded in the reducing agent (Rongalite, which
is sodium sulphoxylate formaldehyde) and alkali, bleeding
was prevented. The idea was taken up in the 1930s by a few
firms who did not install new equipment but simply placed
a padding mangle immediately in front of a Mather & Platt
festoon steamer. *This is simply the 'pad-steam' process.*

But it was not till the early 1950s that the true flash ageing
system was really developed. At that time it was becoming
less desirable to print very big yardages always, and interest
turned first to hand screen printing which, as we have seen,
could be satisfactorily processed batchwise, and then later
to automatic screen printing machines which, while not
having the output of engraved rollers, were nevertheless
producing much faster than hand screen and certainly more
cloth than could easily be adequately dealt with by a batch-
wise steamer. These facts resulted in Du Pont and then ICI
working in 1955 on the idea of using the original reducing
agent, sodium hydrosulphite and caustic soda, which had a
far swifter action, in what became known as the 'flash
ageing system'. (This had been patented, in a slightly
different form, by I. G. Farben in 1927–28.)

ICI designed the first flash ager which could be built
cheaply and attached to a padding mangle; there have been
other shapes and sizes since then. This process not only
increases the time that unfixed fabrics can be stored but
often gives better prints and a higher colour yield while
cutting down steaming times to as little as 50–60 seconds.
So we have the ultimate paradox in textile terminology –
'ageing' in a 'flash' of mere seconds!

As the diagrams show, the cloth passes immediately from
the padding mangle into the ager and out again, into cold
water to remove the caustic soda, and then into oxidizing
baths and a soaping range.

FIXATION BY DRY HEAT (BAKING) OR 'THERMOSOLING'

The fixation of printed fabric by means of dry heat is of
comparatively recent origin. A baker consists of a metal
chamber, heated by gas or electricity to temperatures of
160–180° C (320–355° F) and having a series of top and
bottom rollers over which the cloth passes at speeds to
allow a retention time of between 2 and 5 minutes. Bakers
are most commonly used for pigment fixation and these
colours, as we have seen, require only drying and baking,
no washing.

There are, however, serious dangers in that for many
years pigment printing systems have involved the use of
hydrocarbon solvents such as white spirit, and these can
produce explosive mixtures.

The dangers involved and the necessary precautions,
briefly, are:

1 Because at temperatures of around 300° C ignition can occur, there must be *no potential sources of sparking* and *smoking should be prohibited*.
2 In order to conserve heat there is a tendency to plan only for very restricted ventilation, but again it is imperative that an exhaust fan be installed which will work at the rate of not less than 400 cubic feet per minute.
3 The baker must have a light roof, for instance an asbestos explosion panel.
4 The inside of the baker and its flue should be thoroughly cleaned regularly.
5 The fabric must be completely dried before fixation by baking.
6 All electric equipment should be explosion-proof and the rollers of the baker efficiently earthed.

Printworks, of course, are equipped with driers over or through which the cloth is passed before entering the baker, but where bakers are installed in colleges it is particularly important that the fabric be thoroughly checked for complete dryness.

In the interests of safety, pigment-printed fabric should not be baked in a domestic electric oven and *never in a gas-heated oven*.

WET FIXATION TREATMENTS

This treatment dispenses entirely with the use of heat or steam for fixation. Instead the fabric, in open width, is passed through the necessary chemical in a tank placed before the soaping tanks. This method is used for solubilized vat dyes where the printed cloth passes through a 2 per cent sulphuric acid bath, and also for some reactive dyes – particularly Hoechst and Bayer reactives, which are of a different type from those of ICI and Ciba-Geigy. Because Hoechst reactives are fast to hydrolysis they can be subjected to the wet-alkali padding without any danger of bleeding. This would not be possible with Procions and Cibacrins. This wet-fixation treatment is used in European countries, and in African printworks where no steaming equipment is available.

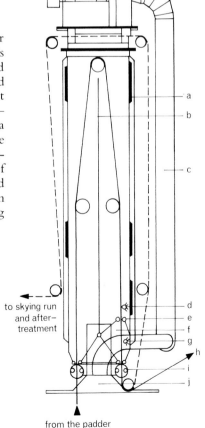

to skying run
and after–
treatment

from the padder

Flash ager (Hoechst system): *a* openings for assembly and cleaning; *b* dividing wall; *c* suction fan; *d* steam inlet pipes; *e* heated lips; *f* rear compartment; *g* steam injection for rear compartment; *h* steam exhaust pipes; *i* stand for mounting on padder.
At the time of going to press a new and more elaborate form of flash ager, developed by Hoechst in association with Bieger Apparate- und Maschinenbau KG of West Germany, is on the market and replaces this. It incorporates a steam superheater with the ager, and an intra-red pre-heater; applied to certain fabrics (particularly fine types), the latter prevents smudging or staining when the fabric is steeped in the fixation solution.

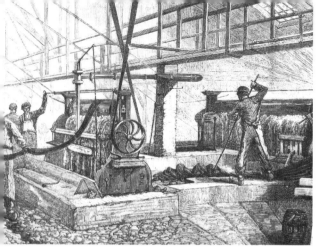

Washing machine for blacks. From W. J. Crookes's *Practical Handbook of Dyeing and Calico-printing*, 1874.

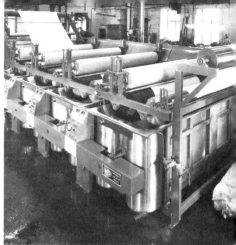

The Smith–Whitworth four-compartment S928 washer. The cloth passes between rollers and perforated drums situated in each of the four compartments.

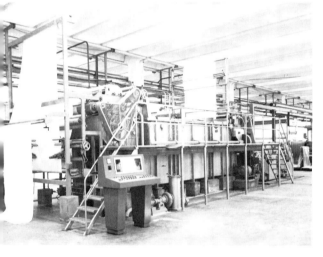

The new Mezzera VBM, specially designed for the scouring and washing of knitted fabrics in a completely relaxed and tensionless way, both widthwise and lengthwise.

The tensionless Mezzera washing range in use.

A nineteenth-century piece of drying apparatus: the cloth is passing over steam-heated cylinders.

Cloth passing through an electronically controlled stenter, so that it is slowly and permanently brought out to its desired width.

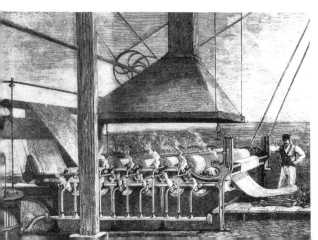

10 After-treatment

After printing and steaming or other fixation treatment, all fabrics (except those printed with pigment colours) have to be washed, dried and calendered and often given some sort of special finish also. These processes are sometimes grouped together under the term 'finishing processes'.

WASHING

Obviously, where a printworks is set up to do its own pre-treatments of scouring and bleaching, the same machinery, or part of it, will be used to wash the printed fabric. The Smith/Whitworth continuous bleaching/washing range is a typical example, although where small-scale production is carried on, rope-washing with winches is still much used. Reactive and vat dyestuffs particularly need very vigorous washing at the boil for about 15 to 20 minutes in order to remove all the residue of thickening and dyestuff and, in the case of vats, also to bring out the full strength and brightness of the colour. It is therefore essential in any completely continuous system operated at speed to be able to control very fully the different timings needed for the various jobs.

As an example of one of the latest systems built to cope with large-scale production runs, the Mather & Platt 'Aquatex' open-width washing unit claims to be extremely efficient in its economical use of labour, factory space, water and steam. In order to fulfil the necessary functions of thickening, swelling-out and removal (among its other functions), the Aquatex is equipped with 'wave' rollers to pump the water through the cloth and also to increase surface agitation. Delicate lightweight fabrics can be washed without damage, even at 150 metres a minute, and – very important – high temperatures, which are absolutely essential in many cases, can be maintained at speed. It is also possible to install a patented tension control device for specially delicate fabrics which are liable to weft shrinkage.

The Italian company Mezzera SPA have made a speciality of machinery for the pre- and after-treatment of knitted fabrics. All knitted fabrics tend to be difficult (particularly if fine and open) in that they must be washed, bleached and scoured without tension to avoid distortion, and during the

last few years there has been a great increase in the production and printing of wide-width knits. Mezzera have very recently brought out the 'Niagara' unit which can cope with production exceeding 2,400 metres an hour (woven as well as knits). There is a rapidly rotating specially shaped winch which causes the cloth, in rope form, to be energetically vibrated. After the rope has passed over the winch, it falls back into the washing liquor, and because of the high speed the fabric becomes opened out on impact, thereby getting a more thorough washing and impregnation with a complete absence of folds.

DRYING

Fabric can be dried after washing by passing the cloth in open width over a series of rotating large-diameter drums or cylinders, each heated internally by steam or hot oil – this is termed 'can' drying – or in a stentering machine supplied with heat, or batchwise simply in a hydro-extractor (like a large domestic spin-dryer).

STENTERING

First developed in the 1880s, stentering (or 'tentering') is necessarily performed at various stages of production and with several different added functions. Basically, it is a controlled straightening and stretching process. The selvedges of the cloth are attached to a series of pins or clips as it is fed through the machine (or stenter) and as the pins are gradually placed farther apart widthways, the cloth is slowly and permanently brought out to the desired width. There are different types of clip and pin attachments, designed to be suitable for fabrics of different thickness and fragility, and most modern stenters have electronically controlled guiding systems and edge detectors which completely automate the job. Combined with this process, the stenter can also be heated and used either simply to dry the fabric or (in the case of polyester, for instance) to heat-set it at the correct width after impregnation with resins and/or OBAs. It follows, obviously, that stenters are often placed at the end of a long range of other equipment.

SPECIAL FINISHES

Calendering

This is a mechanical finish – the industrial version of combined mangling and ironing. It involves passing the cloth between heavy rotating cylinders in order to impart smoothness and/or other mechanically achieved finishes.

A nineteenth-century calendering machine.

Calendering machines can have three, four or five cylinders ('bowls'), making use of the different effects that can be got from various combinations of unheated and heated metal bowls and 'pressed' bowls. When the metal bowl is to be used as a 'bottom bowl' it is usually made of close-grained cast iron but the heated bowls are of steel or chilled iron and can be internally heated by steam, gas or electricity, with accurate temperature controls. Pressed bowls have steel centres around which are built up layers of pressed cotton, paper, or bonded materials.

To take a single example, a three-bowl machine can be set up as (a) a plain finishing calender, with two cotton bowls and one centrally heated metal bowl, or (b) as a 'friction' calender, arranged with a middle bowl of pressed cotton, top one of heated chilled steel and bottom one of cast iron. Yet another combination (c) of three soft cotton bowls would produce a soft lustre without glaze.

Four-bowl calenders are used primarily for silk and rayon finishing. The fabric passes between the two central soft cotton or paper bowls, the two outer metal ones serving to give support and polish to the soft ones.

Pressures of up to 40 tonnes (40,000 kg) are needed for many fabrics, even as much as 100 tonnes for heavy cloth, and obviously careful handling and loading are required (hydraulic or pneumatic) to avoid damage to the bowls. It is also possible to fit automatic seam detectors which cause the bowls to be lifted when a seam passes through.

A *Schreiner calender* employs a bowl made of highly polished steel, its surface engraved with fine lines, of which the angle and pitch are calculated for the particular finish required. It is heated, and the surface temperature can be controlled up to 200° C (390° F). The bottom bowl in this instance is made from woollen-paper material or cotton.

Other mechanical finishes include embossing, which produces a visible, 'feelable' design on the cloth in relief, and pleating.

Resin finishing

Until comparatively recently, material has always had to be pulled and stretched, then ironed, in order to make it smooth again after washing and cleaning. About forty years ago, however, just before the Second World War,

the first attempts were made to improve washing behaviour by chemically modifying textiles composed of natural and regenerated cellulose fibres. At that time little interest was shown and the experiments did not get very far; but with the rapid development of synthetics immediately after the war, people soon became used to the idea of not having to iron or mangle after washing, because nylon and other synthetics did not shrink or stretch if correctly washed. So the 'easy-care' era was born.

It was believed, rather too emphatically, that cotton and regenerated cellulose would die natural deaths if an attempt was not made to give them, too, an 'easy-care' finish, and so resin finishing as we know it developed from those earlier experiments. 'Resin finishing' is a general term covering all finishes produced with cross-linking agents, and while they were developed for cotton and regenerated cellulose there are now types for blended fabrics and for cloths made entirely of synthetic and protein fibres.

There are two fundamentally different methods of finishing cellulose with chemicals. The first involves the deposition of an elastic synthetic resin on the fibre; with this type there is little or no formation of bonds between the resin and the fibre. Examples of this type are the self-cross-linking

Half-tone and creping on cotton

Spot-printed in Levafix Golden Yellow PR (without alkali). Over-printed stripes thickening + alkali only.	A selection of reactive dyes printed (without alkali), then overprinted stripes thickening + alkali only. Remazol Brilliant Yellow 7GL, Remazol Turquoise Blue B, Remazol Brown 3G, Cibacron Violet 2R-P. Experiments needed to determine which colours will give half-tone effects in this way.

Half-tone resist effects by printing thickening (Manutex etc.) first and over-printing reactive dyestuff. Cibacron Green 4G-A, Cibacron Blue 3G-A, Cibacron Golden Yellow 2R-A, Cibacron Violet 2R-P, Cibacron Brilliant Red 3B-P.

Manutex half-resist under Cibacron Green 4G-A (most easily obtained).	Alkaline creping on fine cotton (see recipe, p. 151).
Small geometric print distorted by subsequent creping.	Certain reactive dyes will give enhanced colour yield when over-printed with creping liquor, but it is difficult to achieve a significant change. Remazol Brilliant Yellow 7GL, Remazol Turquoise Blue B.

agents such as the Kaurit types (BASF) used on cellulosics and synthetics. The second method is deposition of a chemical which is made to react with the cellulose, causing modification so that a stable atomic bond is formed between different cellulose molecules. These are not eradicated by boiling washes and have hardly any influence on the handle of cellulosic textiles. Fixapret types (BASF) are of this kind. With these types of finish, however, cotton in particular loses some of its natural tensile and tearing strength, becoming more brittle while gaining the desired new qualities of crease-resistance and dimensional stability.

In the 1950s when resin finishing was comparatively new there were many instances of fabrics – cotton especially – that had been given the 'glazed' finish, in fashion at the time, being made so brittle as to rip in wear, particularly at stitch lines, with the slightest movement. So to achieve good finishing of this type the aim has to be to balance the various qualities, both inherent and induced, to give the best result for the particular end-use of the material. While the earliest finishes used formaldehyde, the products now used are made by reacting formaldehyde with various compounds – e.g. urea/formaldehyde.

As well as the resin-finishing product the recipe will contain a catalyst (a substance which speeds up the reaction without being permanently affected itself), and one or more

Discharge on acrylic fibres

Ground shade 3% Astrazone Blue GL, overprinted 0.5% Astrazone Blue 5RL.	Ground shades 2.5% and 3% Astrazone Blue GL, overprinted 3% Red 6B and 3% Yellow 7GLL as illuminating colours. Clearer yellow obtained by simply increasing the number of squeegee strokes.
Ground shade 3% Astrazone Orange RRL, overprinted 3% Red 6B as illuminating colour.	Ground shade 3% Astrazone Blue GL, overprinted 3% Red 6B and 3% Yellow 7GLL as illuminating colours. Orange produced from 'fall-on' of the two prints.

Resists under reactive dyes

Simple gum arabic resist producing batik-like effect.	White resist print from pre-printing cellulosic thickening + 5% tartaric acid. Overprint 2% Cibacron Dark Brown B-D.

Interesting 'bleed-out' effects from excess acid.

varied additives included to ensure good handle and wearing qualities: softening or stiffening agents, filling agents, gloss-imparting or anti-slip agents. In the finishing of synthetics, particularly knits, anti-pilling and anti-snagging ingredients are also necessary.

The most important and widespread method of applying resin finishes is by dry-curing, which can be done in the conventional sequence of padding, drying, curing, washing-off. Alternatively, it can be done by 'flash-curing', in which the drying and curing are done at the same time in a flash-ager (see p. 167) or a stenter.

As well as 'dry-curing', moist and wet cross-linking are used. In moist cross-linking the swollen cellulosic fibres are left with a percentage (6–16 per cent) of residual moisture, batched, left at room temperature for 16–24 hours, washed and dried. In wet cross-linking the material is padded and batched, and the reaction is allowed to proceed for 1–2 hours while the roll is rotating. It is re-batched to eliminate tensions arising from swelling, and the reaction then continues for a further 16–24 hours, the cloth being wrapped in plastic film to protect it from drying out.

Many permanent finishes can be produced by combining resin impregnation with the mechanical calender finishes previously described. As we have seen, it is possible to produce Schreinering, chintz finishing (glazed effects) and embossing using different calender bowls, and these effects can all be rendered permanent by the use of resins and by curing after calendering. But because rather large quantities of the resin compound are needed it is very important that the cloth has about 30 per cent more residual strength to compensate for the inevitable loss of tensile strength. After padding and drying it is usual to store the batch overnight to ensure uniform moisture content, and then to calender it.

From the standpoint of the dyer and printer a great deal of care is also necessary in dyestuff selection for use on fabric that is to be resin-finished in any way: quite appreciable changes in shade can occur, particularly in substantive dyes, but also in reactives and even occasionally in vats. Light-fastness ratings can be reduced but wet-fastness often improves, particularly in light shades, after finishing. Although rubbing-fastness can seem to be reduced, this is often an effect of inadequately singed surface fibres on the cloth face collecting extra finishing agent and thus giving an appearance of rubbing effects. Care has also to be taken in the choice of OBA.

Finishes have recently been developed for wool to promote freedom from felting, and for natural silk to prevent spotting. There are flame-proof finishes, water-repellent and oil-repellent treatments, and many others.

Lastly there are coated fabrics, such as PVC, which can be applied over printed cloth.

11 Colour-fastness testing

It is only comparatively recently that standardized testing for colour-fastness has been carried out on truly scientific lines, though there are a number of records showing interest in the fastness of dyestuffs to light and washing, even as early as the first century A D, when Plutarch commented on the lasting qualities of Tyrian purple.

In medieval times the guilds had very strict control over dyers, who were classed as either 'dyers of fast colours' or 'dyers of fugitive colours'. The only colours then considered to be fast were woad, kermes and madder; the terms *grand teint* and *petit teint*, for fast and fugitive colours, were first used in France at that time and are still in use today. Modern researchers, writing in the *CIBA Review*, attribute at least some of the insistence on prohibiting the printing of cotton in eighteenth-century France to the realization that standards of dye-fastness left a lot to be desired. This is supported by the fact that as soon as Colbert's Inspector of Dyehouses reported favourably on conditions the bans on printing were finally lifted. In the eighteenth and early nineteenth centuries clients demanded high standards: there was an instance in England of a dealer being forced to recompense a buyer of dress calico because it faded after two years.

During the hundred years or so between the early eighteenth and nineteenth centuries much work was done on testing the action of soap, acids and alkalis, and on the effects of weathering on samples of dyed fabric; it was Edward Bancroft who first scientifically established the influence of fibres on colour-fastness, in his *Experimental Researches Concerning the Philosophy of Permanent Colours* (London, 1794).

With the development of the synthetic dyes it was quickly found that these, while being bright and strong, were very fugitive indeed, and even Perkin's Purple, which Perkin himself considered very good, was in fact not at all fast by modern standards. In 1872 F. V. Kallab conducted a series of tests on printed cloth which he exposed for up to three months during the summer period July–September and he proved that while the madder series of colours remained virtually unchanged, indigo faded considerably and of the aniline colours only aniline black printed on wool had good fastness; all others were extremely poor.

Quality control: checking the finished cloth for imperfections. This is done under controlled simulated store lighting.

In fact until the discovery of the first vat dyestuffs the synthetics had a very poor reputation for fastness to light. James Morton, the son of Alexander Morton of the famous Scottish textile family, was an important figure in eventually bringing some of the initiative in dyestuff research back to Britain in the first quarter of the twentieth century. Just as William Morris had turned back to vegetable dyes because of the crudity of the new colours, so James Morton was inspired to develop fast synthetic dyes as a result of realizing how very fugitive the first ones were. It is said that he was walking down Regent Street some time in 1901 or 1902 when he saw, in one of Liberty's windows, a display of his own firm's tapestries. The condition of these fabrics horrified him because, the dyes having faded so badly, the carefully thought-out colour schemes were no longer interesting. But when he found, on enquiry, that they had only been on display for a week, he came to a decision which was to have immense importance for British dyestuffs and their fastness, and textiles in general.

Firstly he did simple tests on dyed fabric to see how quickly they faded, and then he set out, with the help of a young chemist at the United Turkey Red Company, to produce a series of colours (mostly alizarins) which were fast to light and washing. He added to these colours the new Indanthrene Blue and other anthraquinone vat dyes (the first fast vats) produced by the Badische Anilin- und Soda-fabrik (later I.G. Farben), and this use by an important textile producer greatly encouraged the bulk production of these dyes and research into further colours. He even went so far as to send the dyed samples to India, where they were exposed to sunlight for periods of up to three months. In 1906 Sundour fabrics were launched by Alexander Morton & Co. (later the firm became Morton Sundour Fabrics Ltd) and they were advertised as the first unfadeable fabrics. They were guaranteed against fading, carrying an undertaking on the part of the firm 'to resupply any goods found unsatisfactory in regard to fastness, within any reasonable period of purchase'. As well as plain dyed cloths of various types, block-printed cottons and linens were also produced.

In the first quarter of this century all the British and Continental producers did fairly strict tests on the dyes they put on to the market but each one did these in their own way. There was an obvious need for standardization, so that printers and dyers could make the necessary comparisons. The Germans were in the lead in their attempt to formulate standards which would be acceptable to a number of manufacturers in Britain. The Fastness Tests Committee of the Society of Dyers and Colourists issued its first report containing tests in 1934, and a second in 1948 containing testing methods for 33 agencies (see below).

In 1948 the Colour Fastness Subcommittee (ISO/TC38/SC1) was formed, under the auspices of the International Standards Organization which had been set up in 1947.

Since that time it has gradually endeavoured to replace all the varied systems operating in Britain, in Europe and in the USA.

After a period of discussion, trials and draft proposals, the term 'ISO Recommendation' was finally applied to those tests on which agreement had been reached on a world basis. Forty-four national standardizing bodies are members of the Subcommittee, but it has nevertheless no legal authority to impose its decisions – only to recommend them.

There is a useful definition in *Standard Methods for the Determination of the Colour Fastness of Textiles*: 'By colour fastness is meant the resistance of the colour of textiles to the different agencies to which textiles may be exposed during manufacture and subsequent use.'

Each test is concerned with fastness to a single agency and the type of test is chosen to correspond as closely as possible to 'treatments usually employed in manufacture and to conditions of ordinary use'. There are currently between 50 and 60 tests, including:

1 Those agencies encountered in manufacture, e.g. bleaching (by hypochlorite, peroxide or sodium chlorite), mercerizing, chlorination, pleating;
2 Those encountered in use, e.g. daylight (with or without humidity), artificial light, weathering, pressing, rubbing, sea water, dry-cleaning, washings of varying heat and severity, perspiration.

Methods of procedure, special apparatus, reagents and conditions of testing are all laid down in great detail by the ISO.

Colour-fastness to all agencies except light is expressed by the numbers 1 to 5, 1 being the poorest rating and 5 very fast. Colour-fastness to light is expressed by the numbers 1 (very low light-fastness) to 8 (very high). The fastness of a dyestuff is dependent on its depth, and so it is necessary to have specified standard depths. The main range is 1/1 Standard depth but for extra data a range is taken twice as deep – 2/1 – and a series of weaker ones, 1/3, 1/6, 1/12 and 1/25.

The dyed or printed sample, after being subjected to the particular agency with which the test is concerned, is assessed on the basis of a visual comparison between the original material and the test specimen.

In order to give a rating to the amount of change, 'grey scales' are used (a sequence of 5 pairs of grey colour chips in the case of testing for change in depth, and a pair of white and grey for assessing amount of staining of undyed material). To quote *Standard Methods* again: 'The fastness rating of the specimen is that number of the grey scale which corresponds to the contrast between the original and the treated specimen.'

Fastness to light is an exception: here, a series of 8 standard dyed blue wool cloths, each one being approxi-

Light-fastness tester. Samples of dyed and printed cloth are placed in the tester with the fader lamp on, and the results are compared with a standard.

mately twice as fast as the one below it, are exposed with the specimen and the number is noted of the standard which has undergone a similar change.

In order to save time in daylight testing a variety of fading lamps are in use; the same results are not always obtained, however, and some firms, such as Sanderson, still maintain samples exposed on the roof.

For many of the other tests special apparatus has been constructed: the 'Crockmeter', used in rubbing tests; the Wash Wheel (sponsored by the Society of Dyers and Colourists) and the Launder-Ometer (sponsored by the American Association of Textile Chemists and Colorists), used in washing tests of which there are five; and the American Perspirometer. There are also machines to test for shrinkage and tensile strength, and many others.

THE COLOUR INDEX

The *Colour Index* was established in 1924 and is published jointly by the Society of Dyers and Colourists in Britain and the American Association of Textile Chemists and Colorists. It is the leading publication in the field of colour classification and is recognized officially by many governments for both scientific and commercial purposes.

Because of the great increase over the last few years in the number of generic names of dyes and pigments, particularly in the field of reactives but also in basics, disperse, fluorescent brighteners and pigments, a third edition was published in October 1971, comprising five volumes:

VOLUME I	VOLUME 2	VOLUME 3
Acid Dyes	Developers	Mordant Dyes
Azoic Coupling Components	Direct Dyes	Natural Dyes
Azoic Diazo Components	Disperse Dyes	Oxidation Bases
Azoic Compositions	Fluorescent Brighteners	Pigments
Basic Dyes	Food Dyes	Reactive Dyes
	Ingrain Dyes	Reducing Agents
704 pages	Leather Dyes	Solvent Dyes
		Sulphur Dyes
	824 pages	Vat Dyes
		824 pages

VOLUME 4 C.I. Constitution Numbers *Over 800 pages*
VOLUME 5 Commercial Names Indexes *Over 600 pages*

Quarterly *Additions and Amendments* keep all sections up to date, and Vol. 5 is to be revised every few years.

There has also been an increase in alternative names to indicate suitability: for instance, names to show which reactives are suitable for wool, or which acid dyes for nylon.

In this third edition dyes are classified in two ways: by recognized classes and usage, and by chemical constitution.

Vol. 5 contains manufacturers' trade names, with code letters to identify the various manufacturers.

In Vols. 1–3 all the important usage properties of the colourants are listed together with current and obsolete generic names. Each colourant listed has information on its application, properties and methods; its fastness properties and reactions to other tests; and on other uses than textile.

Because manufacturers' trade names are very often not explicit enough, a very important part of this section of the *Colour Index* is the hue chart. This is hexagonal in form, each division being in three parts, e.g. greenish yellow – yellow – reddish yellow. Tertiaries are situated inside the area of the primaries, and secondaries inside and in association with the parent hues. Pinks are outside the hexagon and adjacent to the reds. An associated written chart supplies the formal descriptions of each chromatic area.

Each entry has a separate 5-figure number, known as the C.I. Constitution number, and in the volume dealing with the chemical constitution colourants are arranged on the basis of their chemical structures: for this reason those which are chemically related, but belong to different usage classes, may be found together, e.g.:

Azoic colourants	37000–39999
Indigoid colourants	73000–73999
Natural colourants	75000–75999

Each class is introduced by a description of characteristics, those with the simplest structures shown first and the more complex compounds afterwards.

So for each colourant there is

1 5-figure C.I. Constitution number
2 C.I. generic name
3 Structural formula
4 Methods of application
5 Chemical and physical properties
6 References
7 Patent numbers
8 If applicable, the classical names

The Martindale wear and abrasion tester. The cloth placed on the plates in the machine is subjected to controlled friction, intended to simulate the type of rubbing which occurs in actual fabric use.

Appendix: safety at work

It should be obvious that when one is handling chemicals and chemical products, care must always be taken. This concern is not always in evidence, as the numerous accidents reported in the press constantly show. In Britain, particular emphasis has recently been placed on safety by the implementation in April 1975 of the Health and Safety at Work Act, which, among other provisions, makes schools and colleges subject to legislation similar to that formerly applied only to factories. It is now a definite obligation on supervising staff to see that all those people working with potentially dangerous substances are made fully aware of the dangers, and given instruction in the right way of using them.

The dye and chemical companies have all issued their own information on the safe handling of their products in general and certain specific products of known hazard in particular.

The great majority of textile dyes and special products are harmless when they are handled with care and common sense, by staff and students properly instructed in their use, and where reasonable standards of working, storage and cleanliness are maintained and protective clothing provided.

In order to avoid the risk of ingestion, smoking should be prohibited, and food and drink should not be consumed, in areas where dyes and chemicals are prepared and used. Adequate washing facilities and personal hygiene during dye preparation, and immediately afterwards, are also essential.

Inhalation of any product in the form of dust or fumes should be avoided (if necessary by the use of masks), and where organic solvents such as cellulose thinners are in use good ventilation is important. In recent years, however, dye powders and similar products, which were apt to float around in the air, have been treated to eliminate much of this danger.

Dyes and chemicals which come into contact with the skin should be rinsed off very thoroughly and immediately with cold water and the skin should then be washed with soap or a mild detergent. However, harsh bleaching agents can do as much, and sometimes more, damage to skin tissue and should be avoided. Obviously it is essential to wash before eating, and also before using the toilet.

Eye shields should be provided where necessary, and if the eyes are accidentally splashed with a harmful substance they must be washed at once with a great deal of clear water, followed by immediate medical attention. It is also important to get into the habit of avoiding touching the face while working with dyestuffs, and with chemical products in general.

Another important point to remember is to keep the dye laboratory clean, tidy and free from obstructions on the floor and elsewhere. Any liquids or powders that are spilt should be wiped up immediately and spillages of sticky adhesives, particularly on floors, removed completely to avoid the risk of accidents.

These general considerations are simply common sense, and apply to the use of all products, but materials known to be specially dangerous – e.g. acids and strong alkalis – must be clearly labelled as dangerous,★ carefully stored and detailed instructions for use and storage sought from the manufacturers or the Factories Inspectorate.

It is very easy for college staff to assume that because most students are likely to have done some laboratory work in school they will have the right attitude of common sense and care in dealing with dyes and chemicals in their textile work. This is a false assumption which could lead to disaster.

Finally, in the intervening years since the first printing, environmental issues and those of health and safety in the workplace have become of major concern. It is therefore particularly important to stress that the safety information supplied with products is read and adhered to most carefully and, in cases where there is any doubt, the manufacturer contacted for further advice.

★ At the time of writing, legislation is being discussed in Britain to enforce the labelling of some 800 potentially dangerous substances with symbols and warning information; this is to bring the UK into line with the other countries of the EEC.

Further reading

DISERENS, L.: *The Chemical Technology of Dyeing and Printing*. 2 vols., New York, 1948, 1951.

KNECHT, E. and J. B. FOTHERGILL: *The Principles and Practice of Textile Printing*. 4th ed. London, 1952.

SANSONE, ANTONIO: *The Printing of Cotton Fabrics*. 2nd ed. Manchester, 1901.

STOREY, JOYCE: *The Thames and Hudson Manual of Textile Printing*. London, 1974 (published in New York the same year under the title *The Van Nostrand Reinhold Manual of Textile Printing*).

THURSTAN, VIOLETTA: *The Use of Vegetable Dyes for Beginners*. 4th ed., Leicester, 1943.

Much valuable information, otherwise inaccessible, can be found in the *Journal of the Society of Dyers and Colourists*, the *Ciba* (and *Ciba-Geigy*) *Review* and the *Bayer Farben-Revue*, as well as in the technical literature issued by the various dye companies.

Glossary

ALGINATES — Naturally occurring substances found only in brown sea-weeds. Sodium alginate is the principal product, and this dissolves in water to form viscous solutions.

ALIZARIN — The red colouring matter of the madder root (from the Arabic *al-açarah*, 'juice pressed out').

ANILINE — A chemical base yielding many colours, though itself a colourless, oily, aromatic liquid. Now obtained from coal-tar, originally made by distilling indigo with caustic potash.

AQUA — (or aqueous pigment printing system) A system developed in the last few years in response to the demands of ecology, using binders which do not contain hydrocarbon solvents.

AZOIC COLOURS — (or 'ice colours') Dyes which are produced in the fibre directly, by the combination of their constituents.

BACK-GREY — Plain cotton material used on top of the printing blanket to prevent this becoming soiled with excess dye.

BASIC COLOURS — The first coal-tar colours developed by Perkin and Hofmann. They are salts of various organic bases which are incapable of dyeing vegetable fibres directly, so need to be precipitated on to the fibre in an insoluble form.

BEAM-DYEING — A method of dyeing cloth while it is wound round a central shaft or 'beam'. The beam is then placed inside a sealed compartment and remains stationary while the dye liquor circulates.

CALENDERING — A rotary ironing process to produce a smooth finish. The use of embossed cylinders allows additionally of the production of special finishes.

CHAIN-STRETCHING — The method used to prevent shrinking of cloth in width and length after caustic impregnation.

COLOURWAY — Alternative colouring of a design on paper or cloth. Because it is usual to have an overlap or 'allowance' on paler colours where these print next to deeper shades, it is essential for an alternative colourway to retain the tone relationship – i.e. darker remains darker – although the distance between the tones can be changed.

CONVERTER — A firm which buys textile designs and organizes their conversion into printed fabric. Broadly speaking, the converter is to the textile trade as the publisher is to the book trade.

COUNT — Measure of fineness of a filament, differently calculated for cotton and various grades of wool, but based on the number of hanks of a given length that can be produced from 1 lb of the fibre.

A unit of weight establishing the fineness of silk or nylon. DENIER

The reaction between an acidified solution of aniline and DIAZOTIZATION
nitrous acid, producing a diazonium compound. Diazonium
salts combine with, for example, aniline and phenol in a
coupling reaction to give azo dyes. The prefix 'diazo-'
indicates that there are two nitrogen atoms per molecule of
benzene.

That in which dye is printed on to the fabric with all DIRECT STYLE
necessary chemicals, and on fixation directly produces the
whole printed pattern.

That in which the pattern is produced by 'bleaching out' DISCHARGE STYLE
or discharging parts of the pre-dyed ground shade.

Those which are insoluble in water but which are applied DISPERSE DYES
to the fibre as a fine suspension or 'dispersion'.

The removal of surplus mordant by means of immersion DUNGING
in a bath of dung.

That in which the cloth is only printed with the necessary DYED STYLE
mordant, the colour being subsequently developed in these
areas by immersion in the madder dyebath.

A thickening made from a suspension of white spirit in EMULSION THICKENING
water.

Treatment with one of a series of complex organic sub- ENZYMING
stances that cause chemical breakdown of the impurities in
cotton cloth.

Fixation by means of a swift passage through an inexpensive FLASH-AGEING
ager after padding in the necessary chemicals.

A style of maroon to red-brown prints produced by treating GARANCINE
the madder root with sulphuric acid. From the French
garance, madder.

Corruption of 'engine': in this context, the cotton gin, a GIN
machine used to separate cotton from its seeds.

Chemical decomposition of a compound by water, the HYGROSCOPIC
water itself also being decomposed in the process. Can be
brought about by hot or cold water, steam, or dilute acids
or alkalis.

Having a tendency to absorb water from the air. HYGROSCOPIC

A large J-shaped structure used as a bleaching tank. J-BOX

Machine used for dyeing, consisting of two batching rollers JIG
over a dye container. The cloth is wound on to one roller
and as the other one rotates the cloth is drawn through the
dye and on to the second roller.

A large container, once of wood but now of metal, in KIER
which cloth is boiled and bleached.

LAKE	An insoluble pigment obtained by precipitating various natural and artificial colouring matters on to a suitable base in the presence of alum or salts of magnesium, zinc, tin etc. In the textile field this is the principle of mordant dyeing and printing.
MERCERIZING	Treatment of cellulosic yarn or cloth with caustic soda in order to render it more receptive to dyestuffs.
MORDANT	A chemical substance, often an acetate of a metal, which has an affinity for both the fibre and the colouring matter and forms, with the colouring matter, an insoluble colour, or lake.
NAPHTHOL AS	The various substitution products of beta-naphthol, the coupling component with which the cloth is first impregnated. The colorant is only subsequently formed on the fibre after printing with the second component, a Fast Colour Salt.
NIP	The pressure area between two cylinders. In a padding mangle, for instance, the cloth passes through the nip to have excess liquid squeezed out.
OPTICAL BRIGHTENING AGENT (OBA)	Substance used to produce a brighter white without harsh bleaching. OBAs are white but in ultraviolet light give off a bluish-purple fluorescence. There is enough ultraviolet in daylight to stimulate this fluorescence.
PADDING	Cloth impregnation process executed through a padding mangle.
PIGMENTS	Insoluble colours which have no substantivity for the fibre. In textile dyeing and printing they are fixed by being enclosed in a binder which provides a bond between them and the fibre.
PILLING	The formation of small balls of loose fibre on the surface of a fabric as a result of friction, especially in a fabric made from a mixture of natural and man-made fibre.
POLYMERIZATION	The chemical union of two or more molecules of a compound to form larger molecules.
PRINTPASTE	Combination of dissolved dye, necessary chemicals and a thickening agent. This is the form in which colour is conveyed to the cloth in textile printing.
REACTIVE DYES	Those dyes (e.g. Procions) which combine chemically with the fibre on fixation.
REDUCTION	In textile technology, this term is confined to the removal of oxygen from a substance, or the addition of hydrogen.
REDUCTION THICKENING	A thickening specially prepared (with added chemicals in correct proportion) for the production of paler tones in colours already mixed, but usually containing a lower

concentration of the chemicals because the dyestuff concentration will be lower.

That in which the pattern is produced by dyeing after painting or printing the cloth with a mechanical resist (such as wax or clay), or a chemical resist (such as an acid).	RESIST STYLE

The preparation of flax by steeping or watering. — RETTING

The action of drawing out and twisting slivers of fibrous material such as cotton or wool. — ROVING

The dressing of fibrous material such as flax or cotton by beating. — SCUTCHING

Class of compounds which are effective in forming complexes with metallic salts. They are used in many fields, e.g. for preventing the deleterious effects of traces of metal. A condensed sulphate such as 'Calgon' (polymerised sodium metaphosphate) is used to soften hard water by removing the magnesium and calcium ions. — SEQUESTERING AGENTS

A continuous ribbon or band of loose, untwisted, parallel fibres of wool, cotton or flax. — SLIVER

A particular length and degree of fineness in the fibres of wool or cotton. — STAPLE

A steamer in which the printed cloth is wound round a star-shaped frame by means of pins. This frame is then lowered into a chamber, the lid tightened down and steam injected through perforated pipes in the base. — STAR STEAMER

A controlled straightening and stretching process. The selvedges of the cloth are attached to a series of pins or clips as it is fed through a machine (or 'stenter'), and as the pins are gradually placed farther apart widthways, the cloth is slowly and permanently brought out to the desired width. — STENTERING

One containing all the necessary chemicals, so needing only the addition of the dyestuff to form the complete printpaste. — STOCK THICKENING

Sample prints made to prove the accuracy of screens or rollers. — STRIKE-OFF

The chemical conversion of a solid substance directly into vapour by means of heat; on cooling, the substance re-solidifies. — SUBLIMATION

Those which need no mordant but instead have an affinity for the fibre. — SUBSTANTIVE DYES

Fixation by dry heat, or 'baking'. — THERMOSOLING

Abbreviated as ^0Tw. A scale for expressing specific gravity. ^0Tw $= 200$(S.G. $- 1$); S.G. $= 1 + {}^0$Tw$/200$. — TWADDELL SCALE

Dyeing process using a circular or elliptical roller (either fluted or slatted) over a dye container. The fabric, its two ends stitched together to form a continuous piece, is pulled out of the dye at the front and folded down into it at the back. — WINCH DYEING

Index

Page numbers in italic refer to illustrations

ILLUMINATING colours 136, 138, 143–4, 145–6
Imiwax 129
Indalca 110, 111, 116, 118, 119, 120, 141, 148
indigo 61–3, 66, 71; discharge resist 130, 134; resist style 129, 131–3; synthetic 62, 76–7
Indigosol 78

J-BOX 47, 48
jig dyeing 54–5

KARYU GUM 112
Kaurit 177
kermes 60–1, 64, 179
kiers 47
knitted fabrics, attachment to print table 108; washing 171–2

LANAPERL 84, 120
Lapotex 39
leather, transfer printing 153
Leucotrope 134
Levafix 95, 124
levelling agents 86–9
lichens 65
linen, bleaching of 38; description and production 14–17
Linron 16
locust beans 96, 97, 100, 111, 113, 116
logwood 65, 68

MADDER 63–5, 66, 67–8, 69, 73, 179
manganese bronze 71
man-made fibres, bleaching of 37; blends 29; description and development 22–9; direct printing 118–20; main types 9; non-woven fabrics 28; see also synthetic fibres and individual types of fibre
Manutex 96, 110, 111, 117, 119, 141
marbled effects 155
Martindale wear and abrasion tester 183
Mather & Platt continuous festoon steamer 160–1, 162–4
Maxilons 80
melt spinning 22, 24
mercerizing 50–3
merino wool 21
metal-complex dyes 78–9
Meyprogum 110, 111, 141
modal fibres 25
modified basic dyes 80; direct printing 119–20
Monastral Blue 83
Monteith process 137
mordant dyes 63, 75, 134

mordants, ageing 159–60; historical descriptions 58; recipes 66–8; thickenings 91, 92

NAFKA CRYSTAL GUM 94, 112, 113, 115, 116, 118, 119
Naphthol AS 79
naphthols 133, 135
Naphthylamine Bordeaux 79
Natrosol 124
natural dyestuffs 35, 58–68
non-woven fabrics 28
notebooks 70, 101–7
Nylomine Acids 84, 120
nylon, bleaching and scouring of 45–6; development 25–6; discoloration 29, 39; dyestuffs 84, 119, 120; easy care 174; flock printing 155–6; low absorption rate 29

ONE-ROLLER POLYCHROME PRINTING 155
optical brightening agents (OBAS) 37
Orbis print 139
orchil 65
Orlon 28, 119

PAD-STEAM PROCESS 113–14
Para red 79
peracetic acid 39
Perkin's Purple 69, 179
Perlon 26
pigments 82–4; direct printing 120; fixation 168–9
polyamides, discharge printing 146–7; production 25–6
polyester/cellulose mixtures 84
polyester/cotton mixtures, bleaching of 43–5; devoré style 150; dyeing and printing 55, 83, 84; easy care 27, 29
polyester/wool 84
polyesters, discharge printing 146, 147; discharge-resist printing 148; dyeing 55, 80, 83, 119; production 26–7
potato starch 92
Printel 111, 117
printing, bulk 100; industrial methods 98–101; sampling 101–5; styles 106; see also individual styles
print-tables, attachment of cloth 103, 108–9, 114–15, 118
Procilans 82
Procinyls 82
Procions 81–2, 95
Prussian blue 68

QIANA 29

RAYON see acetate rayon, viscose rayon

reactive dyes 81–2; creping 152; discharge printing 145; fixation 167, 169; illuminating colours 144; resist style 124–7; thickenings 95–6, 109, 110–11, 117–18; transfer printing 153; washing 171
reducing agents 77–8, 138–41
reduction thickening 111
Redusol 141
Remaron 84
Remazols 95, 124, 125–6, 135, 145, 151
resin finishing 133, 173–8
resist style 63, 123–36
retting, linen 15, 16
roller agers 160–1, 162
Rongalite 141

SAFETY 184–5
'Samedi soir' 2, 130
sampling, by students 101–5; industrial 98–100
'sari' machine 127
Sarille 25
Schreiner calender 173
scouring, historical methods 30, 32–5; modern methods 37–50
scutching, linen 15–16
Sea Island cotton 12
shade cards 99–100
shellfish 60
silk, 17–20, 21; bleaching of 38; direct printing 114–18; discharge printing 136–7, 138, 142–4; dyestuffs 79; finishes 178; scouring 46; transfer printing 152, 153
singeing 40, 41, 43, 44
sodium chlorite 38, 41, 42
sodium hydroxide (caustic soda) 40, 50, 53
sodium hypochlorite 36, 38, 40, 42, 46
sodium silicate 39
Solacets 80
Soledons 78
Solfarex 115
solid green 71
solvents 86
Solvitex 94
Solvitose 108, 113, 115
stannous chloride 141
staple yarns 24
starch thickeners 92–3, 97, 115
star steamer 164, 166–7
steamers, fixation 104, 159–60, 161–8
stentering 172
strike-offs 98
suede, transfer printing 153
sulphoxylates 141
sumac 65